Old and on Their Own

Robert Coles

with photographs by

Alex Harris
Thomas Roma

Old and on

Their Own

A DoubleTake Book

published by the Center for Documentary Studies

in association with W. W. Norton & Company

New York • London

Old and on Their Own
Text © 1997 by Robert Coles
Photographs © 1997 by Alex Harris
Photographs © 1997 by Thomas Roma

The text of this book is composed in Ehrhardt.
Manufacturing by Tien Wah Press
Book design by Mills/Carrigan Design
Typesetting by The Marathon Group, Inc.

Library of Congress Cataloging-in-Publication Data
Coles, Robert.
Old and on their own / text by Robert Coles :
photographs by Alex Harris and Thomas Roma.
 p. cm.
Includes bibliographical references (p.).
"A DoubleTake book."
1. Aged — United States. 2. Aged — United
States — Pictorial works. 3. Self-reliance in old
age — United States. I. Harris, Alex, 1949– .
II. Roma, Thomas. III. Title.
HQ1064.U5C533 1998
305.26'0973—dc21
97-36922
ISBN 0-393-04606-0

W. W. Norton & Company, Inc.
500 Fifth Avenue, New York, New York 10110
http://www.wwnorton.com
W. W. Norton & Company, Ltd.
10 Coptic Street, London WC1A 1PU

1 2 3 4 5 6 7 8 9 0

DoubleTake Books & Magazine publish the works
of writers and photographers who seek to render
the world as it is and as it might be, artists who
recognize the power of narrative to communicate,
reveal, and transform. These publications have
been made possible by the generous support of
the Lyndhurst Foundation.

DoubleTake
Center for Documentary Studies
at Duke University
1317 West Pettigrew Street
Durham, North Carolina 27705
http://www.duke.edu/doubletake/

To order books, call W. W. Norton at
1-800-233-4830.

To subscribe to *DoubleTake* magazine, call
1-800-234-0981, extension 5600.

To the memory of those who have gone before us, handed us along

Contents

Introduction

This book was prompted by the long-standing interest of the Commonwealth Fund in the various fates of America's elderly people in the last years of the twentieth century. In 1986 the officers of that Fund asked me whether I'd be interested in helping them to understand how certain individuals, well along in years, managed to get through the trials and hurdles of daily living—on their own, no matter their medical or social vulnerabilities. I had been working with older people for many years, visiting them in their homes—an offshoot, as it were, of my work with children. From the start of that research, done in the civil rights–era South, I had learned that if I was to be granted full, everyday permission to talk with the schoolchildren I hoped to get to know, I needed the sanction not only of their parents but of their grandparents, too. In several instances, the grandmothers, especially, were enormously influential figures—their thoughts and observations, their aspirations and worries, their memories a major presence in the moral and spiritual life of particular, extended families. Indeed, as I began to write up the documentary explorations I was pursuing, I found myself attending those senior folk with special interest, care—to the point that, one day, after I'd made a presentation (a description of the way certain families handled the stresses of school desegregation in New Orleans and At-

lanta) at a hospital's grand rounds, a colleague of mine wondered whether I wasn't going through a "career change": from child psychiatry to gerontology. I demurred—yet, a few years later, as I shifted my work to the West and began talking with the children of Spanish-speaking families in New Mexico and of Eskimo families in Alaska, I had many occasions to remember that wry comment, because I was once more in daily touch with a number of old-timers, whose authority in their families was substantial, even commanding. Eventually, Alex Harris and I, working together in those two states, would be able to offer portraits, verbal and photographic, of some of those aging individuals to others—in *The Old Ones of New Mexico* and *The Last and First Eskimos*. It was those studies that prompted the officers of the Commonwealth Fund to commission this further documentary inquiry into the way older Americans, from the North and the South, mostly urban, but some of rural background, have managed to get along—a look, really, at resiliency in people who were hard pressed more by the consequences of old age than by virtue of their social or economic background.

The inquiry that informs the pages to follow was done in Massachusetts, New York, and North Carolina. I initially found my way to the homes of elderly folks in Boston through the help of my Harvard college students, who have long sustained "service" initiatives directed at the young and old alike—people in one or another kind of jeopardy. I explained to those students that I was interested in getting to know older people who were attempting to live reasonably independent lives, no matter the burdens of illness that might weigh heavily on them. Put differently, this would not be a research project done in nursing homes, but in apartment buildings and residential neighborhoods. In no time, it seemed, I had met certain men and women, all over seventy-five, some approaching a hundred—the stated chronological confines of the initiative: that the individuals have lived over three-quarters of a century. Meanwhile, my longtime colleague Alex Harris was getting to meet elderly people in

North Carolina, and our friend and coworker Tom Roma was yet again taking the measure of his native Brooklyn, now in connection with its older citizens.

We intend here glimpses of individuals, glances directed at them—a narration of words and photographs that helps the reader enter somewhat the lives of people who have been witnesses to a century, and who thereby have achieved the detachment, and often enough, the wisdom that comes with having seen and heard and experienced so very much. We intend here the evocation of aspects of those lives—moments in them, moods that have befallen them: times remembered, daily rhythms of forbearance and fear, of amusement and apprehension, of jeopardy and continuing survival. These are not full biographies, by any means, but a presentation of particular men and women that is very much determined by them (their choice of topics, of what to say, their way of looking and talking). But, of course, we have brought cameras and tape-recorders to these men and women—and at times their feisty, willful selves have had to contend with our own determination to look and ask and wonder, our insistence on trying to learn how challenges are met, dangers confronted. Again and again I would ask, "How is it going today?"—and so often I would realize that there are many answers to that question that might be forthcoming on any given day, from the very same person, as one woman bluntly reminded me with this assertion: "It's ten o'clock [in the morning] and 'all's well,' but at ten-thirty, I could have another answer for you, because being old is like being on a swing: you go up, you go down."

She wasn't only talking about her emotional highs and lows, the variations in outlook that all of us experience. She was referring to a complex mix of the physiological, the neurological, the introspectively existential—the manner in which her mind and her body respond to the condition of her lungs, her central nervous system, her brain, her soul: the objectivity and subjectivity of old age as together they create an attitude, one that is revealed by words summoned, by a face's smile or frown, a

body's various postures. "I'm different people on different days, and sometimes during the same day, so I'm afraid I'm going to mess you up"—the words of a near centenarian who was letting me know that I'd better be careful about what I *conclude*.

In point of fact, we are not rushing headlong in the pages ahead toward definitions, absolute and exact formulations as to who is what and why. We are trying to catch sight of some people who manage, often with some difficulty, to *hold on*—to maintain considerably more than a semblance of their privacy, their independence, their personal sovereignty, their "home rule," one woman put it, delightfully, instructively. "I'm trying to run this little show called my life," she explained—and then this: "When you get to be my age [eighty-six] you're digging your heels in and hoping you'll not be swept away by the next storm. You're hoping that when the Lord calls you, it'll be swift and painless; He'll just lift you— and up and away it'll be. The worst is to be carried away by your family and friends, not the Lord—to a nursing home. That's my fight: to stay here, until I'm no longer earthbound."

Such affirmations, such declarations of determination, are no mere bombast, or frightened footnotes to the progression of disease, deformity, decay, disability—overall decline. Such spoken statements of intent as well as hope and wish cast a glow of light on lives inevitably darkened by all kinds of diminishment. "I get up and I talk to my eyes and my ears and my heart and my stomach and my hips and my knees and my ankles and my elbows. I say: with all the troubles, there's a *you* that's bigger than the *them*, the organs and the bones and the joints where they meet and make me say 'ouch.' I'm the one who is sweating it all out rather than surrendering."

Perhaps that is what this book aims to convey—the quiet perseverance, or the fierce insistence (and a range of dispositions in between), that has prompted these individuals to continue to be "on their own," even at times to go further: to anticipate the future, brief as it is, as well

as remember the relative immensity of the past; to smile and joke as well as to bemoan the losses endured, the insults and injuries visited by time; and not least, to enjoy a certain distinct sense of balance and proportion, of worldly perspective, of wisdom that come so commonly with old age —a knowing sense of how things go that is enabled by a remembrance of how things went. These, after all, are people who may have lost a lot, who may have stumbled, who may have plenty of regrets, but who have learned a thing or two from "the great teacher, experience," as a man a week short of ninety-five let me know, when I asked him about the pleasures (rather than the pain) of his daily life. He averred a pride in having such a "teacher" as an intimate—perched, he claimed, on his shoulder, ever at the ready to refresh his memory, jog it: "I'll fret, and the voice of my past says, 'Hey, it ain't so bad, not at all, compared to what you went through *then*, and *then*, and *then*'; and so, before long I will get a big, silent belly laugh out of myself, myself going back in time."

These are renderings of such memories and, inevitably, others that are less joyous. No question, to approach the end is to feel plenty of misgivings, and to sugarcoat that side of an aging mind's spoken life, or a face's, a body's message as the flesh silently conveys it, is to turn an earned stoic dignity into a spell of fatuous boasting. "I wink against the shadows," one of our elderly informants announced one late afternoon—a mere preposition, "against," challenging the conventions of language in the interests of making a clear case for ambiguity, a vivid, subtle, even lyrical case for the complexity of it all: the mood that a time of life prompts, the revelation that it offers.

The three of us, like these people who taught us so much (hence that word "informants"), were mostly "on our own," working with the particular men and women we'd met and found to be willing and able to hear our questions, respond to them, or endure the clicks and flashes of the cameras—though on occasion Alex Harris and I spent time together (in North Carolina) with certain individuals. Out of all those meetings,

two years of them with certain individuals in my case, repeated visits on the part of Alex Harris and Tom Roma, emerged our collective, growing sense that we had gathered some lessons well taught to us, by human beings versed thoroughly in life's twists and turns, their sum a mystery whose resolution, perhaps, awaits the last breath, after which survivors can begin to take final stock. So often these "oldsters," as they would sometimes call themselves, wanted us to keep in mind that they had built *a* record, an extended life, and now, with us, they were going *on* record: offering a witness to what was, but as well, a testimony about the time of departure, as it gradually descends upon people lucky, indeed, to have been so long in coming to this last of life's challenges.

At the end of *The Moviegoer*, a novel of soulful inwardness and charged with a comic energy that barely survives some tragic undertones, Walker Percy has his "moviegoer," Binx Bolling, speak of being handed along, of handing along—the human connectedness that makes us companions to one another on this journey, if not pilgrimage, and that turns an accumulation of days, years into quite something else: a destination, the sense of arrival that comes from being helped to mull matters over, give thought to what has happened. "I got this far," a man closing in on a hundred declared—and lest we all too predictably misinterpret the import of his four words, he called on more words to anticipate and clarify: "You may think I'm boasting, but I'm registering plain relief that I've *arrived.*" A pause, then a further, necessary explanation: "You see, all these years people have been keeping me company—it's them who got me where I am, and so they're here, too, right with me: *we* got this far!"

To hear such a retrospective view is to be boosted on a pair of shoulders and given some prospective vision—a sense of how we are, indeed, carried through time and space with the help of those many others whom we meet in this life, those men and women, for instance, who figure in the recollections that follow, and who inhabit the thoughts of the people we see in the pictures that follow: words and sights that tell of lives long

lived over *there*, back *then*, yet become for us three very much lives *here*, with us *now* in a strong, even urgent immediacy, which we felt privileged to experience and which we offer to others with a gratitude for what was given us, allowed to us to attend, to try to comprehend and to pass along for the consideration of others.

I. *I Talk to the Light, I Hear the Darkness*

Forty-one out of the fifty-two weeks in the year 1991 I came to visit her, so she told me early in 1992. When I wondered out loud about the precision of her testimony, she lifted a dish on a nearby table, produced a slip of paper, on which a series of marks had been carefully made, her own code, her own count. That occasion prompted a comparison: "You see, I can lift a piece of paper with my hand, but I'm not so good at lifting myself!" Thereupon, she looked down at her legs, moved her feet slightly, as if to show herself that her will still can come to bear successfully over them.

She is sitting in a chair that is designed to help her stand up—otherwise her severe arthritis keeps her down. She makes a joke of her situation in this explanatory manner: "I'm always on the alert; I'm ready to go: with the pillows and the [battery-driven] buttons. I don't get settled in, because if I do, that's it. I only half-sit! That way, I can stand up when I want to—I never put myself into this chair without thinking, at the same time, whether I'll be able to get out of it. *Semper paratus*! I remember taking Latin, three years of it, and we learned what those military slogans meant! Little did I ever realize that the day would come when I'd think of the Marines and their motto as I was getting ready to take a seat, or to stand up!"

She has a whole world near her on a table: the slips of paper, a pencil, a ballpoint pen with a Holiday Inn advertisement on it, a plastic calendar card, a small-size note pad, a phone, a dish filled with Hershey Kisses, which she always offers her visitors. Those silver-wrapped chocolates connect in her mind with Latin, with childhood, with her mother's sweet tooth become hers for a long lifetime: "If I didn't have those Kisses around, I'd never 'be prepared': they make me a good Marine. I wish I knew the Latin word for chocolate—oh, there probably was no chocolate back then, when Latin was spoken! Sometimes I forget that as ancient as I am, there were people around even before me! When I think of my childhood, I go back to another century—I was born early in 1897, and I remember my mother telling us that this new century, called the twentieth century, was just starting, and we had a 'clean slate,' she'd say, and we all had to do the best we can, so America would be a better and better country. I'd come home from playing outside, and she'd give me some chocolate, 'for energy.' I remember a big bar of it that she had, and a sharp knife, and she'd cut small pieces for us. Later Mr. Hershey gave us all his Kisses! Mother always carried some in her purse. I remember going to the grocer with her, and she'd look at those huge slabs of meat, and the butcher would cut her something, and add on a bit, 'for good measure,' he'd say, and mother would give him some chocolate! She came 'prepared,' always."

That word "prepared" obviously has enormous significance for her. She is worried not only about her body's responsive capability, but her mind's—what might all of a sudden slip her by. She doesn't even take her name for granted. Indeed, she is haunted by the thought that one morning she might awake and have no idea what others call her, what she has been called for over ninety years. Her account of that early-in-the-day brief moment is rendered quietly, solemnly: "I will wake up, and the very first thing I do is say to myself: 'You are Nellie, Nellie Benoit; you were born Eleanor Taylor, and you were called Nell by your mother, and

Nellie by Laurence Benoit, who you married on April 17th, 1921, when Warren G. Harding was the president of the United States. His middle name was Gamaliel.' If I get that far, I know I'm me—I guess I should say, I'm me, *still*!"

She smiles with satisfaction at her exclamation—as if actually saying it out loud made it truer. She also seems to be smiling at herself, a kind of knowing irony with respect to her situation that I have come to expect and appreciate. She doesn't waste much time, in that regard, moving from her morning habit to the rest of her day: "You know, I think I spend many hours proving it, those three words, 'I'm me, still' (or are they four?). I remember how my arms and legs used to work, and that is the standard [of what should be], and I fall further and further short, and so I am left to wonder: am I *really* me, still?"

She stops, lowers her head, looks at her legs, takes her left hand with her right, holds it: they are firmly clasped—and then, she lifts them both up a little, and smiles, and tells me that she ought not be too demanding of herself, that indeed, to be so is the worst possible strategy for one as old as she has become. She is being introspective, explicitly psychological, and yet I seem to be unknowing, or unresponsive. She reads my face, to judge me, rather than accuse herself, and with a kindly look, a forgiving tone to her voice, tries to be formally the educator: "You see," she starts—as if I need help in doing so, and then comes a vision to share about nothing less than aging itself: "Memory is a mixed blessing! That's what I heard a minister say once, and for the life of me, I had no idea what he was getting at. I was seventy or so, back then, when I heard him say that, and I wanted to go up there and tell him that for us who are getting on in years, memory is all we've got: if we lose it to senility, we're gone—so I'll take the bad memories. (I guess I presumed that's what he was talking about, those.) But he went on talking, of course— that's what ministers do, when they're of a mind to give you a sermon! He explained himself—he said we can use memory to connect ourselves

with ourselves, but we can also use memory to *disconnect* ourselves. Well, what in the world did he mean by that, I wondered! He knew we all were wondering, of course, and he explained himself to us with a few stories, the way Jesus did, with those parables—and pretty soon I realized what we were being told: that you can think back, and compare the way you are now to the way you were once, and pretty soon you're feeling about as low as you can, because we're all slowly going to lose our abilities to do things, as we get older, and why should we torture ourselves with accusations!"

She stops to see if I have got the point. I nod—then, out of some desire to muddy things up, I remind her that for young people, the point is not loss, but rather the gradual gain brought by the years: exertions that bring with them new heights of capability, competence, achievement. She appreciates that moment of reservation, if not objection, gently chides herself for not filling me in on all the facts: "I forgot to tell you that the minister was giving us a sermon on 'getting older,' a title something like that. He started out by saying he was over fifty, as I recall, and he wanted to—you know how they talk these days: 'share his feelings' with us. I still can recall what crossed my mind when he told us his age: Well, buster, stop your bragging!"

She would be the last one to summon self-consciously and abstractly the matter of "humor," *its* significance to "aging"—yet I can't help smiling when I'm with her, because she wants herself, never mind me, to do so. She keeps summoning a wry irony as her companion, a means (as she wonderfully put it once) of "keeping tabs on things by giving them the once-over with a twinkle in my eyes"—after which she dutifully observed that her eyes hadn't been working well for over a decade, due to cataracts (removed) and glaucoma. It is the vision within, of course, that she has in mind, her capacity to be amused (rather than outraged or moved to despair) by life's little indignities and jeopardies that are constantly awaiting her as she tries to negotiate the hours of a given day. All

the time she is conversing with herself, usually in quiet, but occasionally out loud. "The flies on the wall," she tells me, are privy to her every thought—and then a self-critical broadside: "I ought to change the subject, from me, me, me—it's not fair to them." When I foolishly take her literally, note that I see no flies anywhere in her quite small apartment (one fair-sized room, with a kitchenette and bathroom at opposite ends) she tactfully admonishes me for a lack of imagination and, too, a touch of condescension: "You have to let me have my fun—I try to keep things lively in here, but I don't think I let my mind go wild!"

Thereafter, for a second or two, she does seem somewhat introspective, maybe saddened. Her head drops a bit, and I notice her pulling on her left arm's skin with her right fingers. But quickly her head is lifted and, soon enough, I am reminded of what she regards to be her two central challenges: "Shadows are all I have left to keep my eyes busy. My mother would tell me when I was a girl that I should 'entertain my eyes,' so they wouldn't get bored, and fail me. She wanted us to be good observers! When you are young, there is so much to see, and we take it all for granted. Here I am, talking like a very old lady, regretting all the chances I had to see more and more of the world—I swore, I'd never get this way, become a moaner and a groaner. But maybe I was swearing, back then, that I'd never get old—the blind vanity of our younger years! Now, I *should* 'moan and groan'—why not! It's not as though I don't have my reasons. Every move for me is a big worry. I look at the floor and wonder when it'll finally catch me. The day will come, I'm sure, when I make the wrong move, and that'll be it! Maybe my 'wrong move' was to live this long! It's nice staying around, I'll admit, but there are days when I call out to the Lord. I try not to be presumptuous and demanding— surely He has others in greater need of Him! But here I am, and there He is, and my mother and dad, both, taught me to talk to Him, so I do! The other day, I talked to Him so long, even I got worried! I told Him that I thought it was time for me to say good-bye and clear out of here!

I could hear Him laughing at me—saying He just wasn't ready for me, so stop pushing on Him! We kept going back and forth, you know, until I decided that I was being a real big shot, and I should stop!"

I am not quite sure what she intends with that last comment. I don't speak, and she can't really see my quizzical face, but she listens so very carefully that I am surprised, taken aback when she resumes her remarks: "I heard you shift your feet—you must be wondering about me! I don't blame you! I'm telling you of my talking with the good Lord, and the fact of the matter is that I'm talking to myself. But don't worry—I still know the difference between me and my head looking for company, and me believing I have a direct pipeline to the Lord Almighty. That would be a sure sign that I've really lost my way. 'God is silent,' we were told when we were kids, and I guess that's the truth. But He does speak to us—somehow, I believe."

She has visibly exhausted this theological direction of talk, and smiles after her final modulatory comment. Missing scarcely a beat, she repeats those three words, the start of an altogether different train of thought: "Somehow, I believe that old age is meant to be a witness. I don't know for what. [She has anticipated my question.] Of course, I'm not a very good witness. I'm almost blind—I can see enough to get around, but I sure miss the details! But I sit here and think about life, and maybe that's the kind of witnessing I'm talking about. Every day I try to earn my keep here—I say, 'Try to think of what happened when you were twenty, or when you were thirty, or forty, or fifty, and then think about how you'd do things today, if you had a second chance.' Don't get me wrong—I'm not crying over spilt milk, or trying to rehash my life because I'm not happy how it turned out. It's just me trying to learn from what I've gone through, and if you asked me again what I believe, what I think about old age [many times I'd in one way or another done so] I'd say that I believe it's something more than my aches and pains and my dim, dim sight and my weak heart and poor blood and finicky stomach and wrinkled skin

and hair as dry as can be, what's left of it. There's this gift that has been given you, of all those hours, the days and days, the years and years, and the big question, I think, is what you're going to do with it when you have it—I mean, at the end, when everyone calls you *old* and you know you're *as old as can be*, but still you have this time, and will you just try to hoard it and show off with it, or try to get everyone to feel sorry for you about it, or get irritated with you because of it (when will she finally *go?*); or will you try to prove to yourself that you've worked hard to make good use of it. That's the phrase that I keep saying to myself: another day, for you to turn to good use!"

We talk about how she does so—the rhythms and habits of her mornings and afternoons, her evenings. I want her to be specific, spell out what she does, when. She smiles as I use those three divisions of time, those ways of thinking about it. She goes further, tells me what she knows I already know—chastises me gently, with an exact and minimum phrase: "It's all the earth, turning." I'm struck by her comment (maybe in two senses of that verb) and wonder whether she isn't telling me by indirection that I'm being didactic or insistently categorical in a bothersome fashion. But she has her own line of reasoning to pursue: "I think a lot about that—this earth spinning and spinning. I have fun thinking of God picking up this planet, after He made it, and giving it the biggest spin in the whole universe, so we're still going around and around! I guess I should have my mind on other things, but they say when you get old, you get down to fundamentals, and there isn't anything more important (is there?) than keeping going, through the light and the darkness."

No more words—indeed, the word "darkness" was spoken in such a way as to signify *period, the end*: an emphatic sound followed by a visible slump of the body, as if a great expenditure of energy now required a respite. Moreover, she was clearly interested in taking in some thought for a spell. I try to be as still as possible. I am, actually, stilled—I'm picturing the planet on which she and I are temporarily sitting, as it hurtles

endlessly, it seems, through the infinity of space. She, too, is immersed in that kind of reverie, as she eventually lets me know by breaking the almost audible hush of that small room: "I was just thinking—we're on a 'joyride,' that's what a life is, if it's been 'not so bad.' My dad and my mom, they loved to use that expression! They'd always give us those low-key, back-handed compliments: 'You're not so bad at this, or that!' Not so bad—what you just said, or did, or are suggesting! 'Life isn't so bad, not so bad at all, even if there are rough spots'—I can hear Daddy speaking right now, I can; and he's been gone almost a half a century! 'Rough spots,' that was one of his low-key phrases—it could include losing his shirt, practically, during the Great Depression, and his dad's death at the age of forty-six, and our dear John, my brother's death, at the age of nine, 'six months short of a decade old,' Dad said. But he held his head up high, and I guess that's what I'm trying to do, as the candle keeps flickering, down to the last smidgen of wax!"

She has been looking toward the window, I notice, not toward where I have been sitting, almost as if she is talking not to me, but to the great outside, the huge beyond, or maybe, talking in memory of her dad, in the hope (against hope) that somehow, in some way, she'll be heard by him, by whatever it is (if anything) he now is. I am mind-boggled as this train of thought races through my head, but her apparent placidity, her calm bemusement, commands my notice, pushes aside the enormous imponderables that bestir me, but seem no burden or threat at all to her, and no source, either, of confusion or puzzlement.

She turns her head, suddenly, toward me, as if she has reentered the room after an extended, important departure. I await her remarks and am not for long kept in suspense: "I hope I haven't been rude! I'm afraid I just went on one of my trips! You know us elderly folks—we're *confined*, but we've figured out a way to fly the coop! 'Your mind can take you anywhere,' my sixth-grade teacher, Miss Brooks, told us, and at the time I thought she was being silly, and so did my closest friend, Charlotte

Hill. Once, after Miss Brooks said that, Charlotte said she was going to tell her parents that she didn't want to take the train to New York and the boat to England because she wanted to explore Asia, instead, and she'd just go there 'by mind, not on the railroad, or over the ocean.' We laughed and laughed—we thought we were *so* smart, *so* much wiser than that poor teacher, who said such ridiculous things! Well, Miss Brooks took her 'last big trip'—I guess you could call it, the longest one there is!—decades ago, and here I am, remembering her words, and holding them up as the final guide to my every day left!

"A lot of the time I don't go wild with this 'travel' idea (in my mind), don't get me wrong! Usually, I'll sit here and realize that the blackness is giving up a little, and gray is coming upon me—so it's day. The shadows slowly take their form—the best my eyes can do. They say I'm 'legally blind,' with this glaucoma, and *all* I can see is 'forms' or 'outlines' of objects, but I say (to myself) that they are way, way offtrack. I can see a whole lifetime of scenes, people and places, all the details, in black and white and in color, even if their medical instruments say I can't!

"To tell the truth, I don't even try to 'see'—they're always worrying [the doctor she sees, the visiting nurse, her daughter, who lives two thousand miles away, but calls her once a week] about my 'vision,' but I say to them, 'Take it easy.' Here I go again: it's *not so bad*! 'What do you mean?'—that's what they're thinking. So, every once in a while, I'll tell them, I'll say, 'Look, I don't try to "see," not the way you folks are talking about. I just close my eyes, and I do my listening and my talking.' 'How nice,' they figure, the first time they hear me explain—'She's not being made too nervous by her "blindness"!' Then I'll add—I talk to the light, that's what I do; and I hear the darkness; and that's it, my hours thrown on the table in a bet that I'll go through one more 'revolution of the earth': round, round, around Mr. Sun!"

I notice just the slightest movement of her head—*it* is going around, a small circle, indeed, yet one that tells a great deal about its mover, who

has stopped to take in about a third of a glass of water: "That Mr. Sun— he's keeping everything going here! I recall that Miss Brooks I just mentioned to you telling us that there were people in the past, in Persia, I think, near there, who worshipped the sun. We all laughed, and I went home and told my parents—I'd go tell them everything that happened in school!—and they didn't think us kids were being as 'smart' and as 'sophisticated' as I guess we thought we were. 'The sun is everything,' my dad said. Oh, Mom took issue with him, a little—not *everything*! But she saw what he was trying to tell me—that without the sun, the whole planet would die, and that would be the end of it all. So, when I can catch sight of that light, creeping in here, I talk to it, I say, 'Hello there!' I say, 'Fancy meeting you again—one more time.' I say, 'I hope this isn't the last time.' I say, 'I've missed you, I really have.' I say, 'Welcome, and please make yourself at home, as long as you want—just stay here.' I say, 'I know you've got other folks to visit, and I don't want to get possessive, and try to hoard all your treasure, and not share it with others—but it's *so* nice to have you here, and I'd like you to know that!' I say, 'I'll bet you've had quite an adventure, this time around; I'll bet you've seen, well, the whole world.' I say, 'Hello, stranger, have we been waiting for *you*!' I say, 'There you are, again, and thanks to you, here we all are again!' I say, 'Come visit with me a bit, and then you just go, and be wherever you want—the more places the better.' I say, 'If only I could turn over the chairs and the bed, and the tables, so you can shine all over, all over!'

"Now, after a while, I can feel the sun getting ready to leave. Things will cool down! Things get darker! I'll start gabbing again. I'll talk to that fading light; it gets dimmer, saying good-bye, and I feel my heart sinking. But I try to be cheerful, and express my gratitude: 'Thank you, *ever* so much,' I say. 'So long, and I hope and pray I'll be here, and see you tomorrow,' I say. 'You've been kind, to visit us, and I sure wish you a safe and sound trip,' I say. 'What joy you've brought us, and we all are so

grateful,' I say. 'Here's to your trip,' I say; and I'll remember my mom and dad drinking champagne when they wanted to celebrate someone's vacation—that they were getting ready to take, [for example] my brother and his new wife, setting out on the train for the West Coast."

She sighs now, no common occurrence. Her brother has been dead twenty years, I know, and I think mention of his death has caused the sigh, and a certain subtle but noticeable slump to her body. But no, she has another explanation: "I hate to say good-bye to someone I love—and the sun is the biggest friend we all have! When the sun is shining, the shadows [which comprise what ophthalmalogists call her 'visual field'] begin to sparkle for me! I laugh and keep staring, and even if I'm 'blind,' I see! I talk away, as I told you. I say, 'Look!' I'm talking to the shadows, to the light on the shadows: they become illuminated—that's how they appear to me. When I tell the [visiting] nurse that, she wonders about my thinking, I know. I can't see the look on her face, but I sure can hear the catch in her voice, when she says, 'Really?'; then, I say, 'Yes,' and I mean it!"

She is a bit put out by her account of an apparent inability on her part to persuade a person she likes (on whom she much depends) of (literally) a particular viewpoint. She is worried, anyway, at times, that she may be losing her mind's ordinary capacity to think accurately and appropriately. She forgets more and more details, sees so little of the world, is hard of hearing, doesn't keep up with the daily news, tires easily, and as she puts it, lives every day "hovering." She doesn't think anyone is in any doubt as to what it is she approaches, but in case there is such doubt, she'll say it with a clear, strong insistence: "I'm hovering near my death; I'll go quickly, I think. I have a weak heart, and I wasn't meant to live this long. I've lived way beyond what I ever dreamed was possible for me—I've lived to be the oldest person in my family, on both sides. I just hope I go with my mind still working right!"

This concern (that she keep her wits about her, that she be able to

speak with some intelligence and good judgment) is sometimes set aside —in favor of other matters that count a lot. She will have had an especially enjoyable time, watching her room fill up with light, or lose its light, so she doesn't care what others might have to say about her sight; she knows its gifts. She is, really, entranced: "I look and I look, and it's much better than watching television or going to a movie! I say to myself, *this* is life—the morning glow, and the evening shadows returning full force. In between, at noon, I'll sit and enjoy those shadows, but early in the day and at the end of the day—I tell you, they grow smaller and they shine, or they grow larger and they'll touch, they'll blend into each other. So, I talk up a storm with them, and I don't want you to think I'm losing my grip on things, and I'm 'seeing things.' But you know, I *am* seeing things, and sometimes I say to myself, 'Here you are, nearly a hundred, just five years from there, and mostly, that's what you do, you see things, you talk to the light!' "

As for the diminishing light of evening, she is closely attentive to that phenomenon as well, though as she describes those waning hours of the day, her language shifts in tone, in imagery: "I can't say I look forward to the night. But you know when it's actually happening, it's really something to hear!" She stops, and seems to be waiting for me to respond. I have heard the word "hear," am puzzled by its usage, but don't know what to say. I want *her* to "say," to continue on her spoken way! I'm not sure, actually, whether she has stopped for her own reasons of exhaustion (always a threat), or confusion (her mind does, as she has put it, "slip" every now and then), or in order to receive a message of encouragement from nearby. I am at a loss to know which tack to take, and suddenly realize that I don't have to make any choice—that, actually, I haven't correctly regarded the human situation before me. She lets me know the score: "I don't mean to be rude, but when you don't have all that 'input' coming at you, you make up for it by paying as much attention as you can to what you 'have' (what little you can see and hear). In my case, I

can hear much better than I can see, so I concentrate on seeing what I can, and enjoying it in my own way. But sometimes I spice things up! You know what I mean? [I say nothing—she doesn't really stop and wait for me to speak.] Sometimes, I'll just listen *so* hard, and I *do* hear things, even if *you* wouldn't!"

She stops—and I feel put on the spot. What am I to think—that she has an auditory hallucination of sorts now and then, or that she some-what "hysterically" conjures up an audiovisual drama for herself in that still and darkening room? She could be (I also think) merely playing around, amusing herself and me with some hyped conversation: an elderly woman's daydreams given the special emphasis that an absence of other events makes possible, understandable. I decide to be quite relaxed (especially so with respect to my inclinations as a doctor). I tell her, turning almost ostentatiously philosophical, that we all see our very own world, and that language is a personal challenge to each of us—how to share what we have experienced with others. I am (too) pleased with what I've said, and even more delighted that it seems to register well with her: a smile, a nod, a gentle sigh, which I interpret as evidence of relief and satisfaction rather than tiredness, frustration, irritability. But she proves to be an astute, demanding conversationalist and wants no part of what she has quickly figured out to be my condescension. Years ago, she reminds me, there was no such problem as the one that I am tactfully addressing with my fuzzy, evasive generalizations about human particularity and privacy—the vicissitudes of human relatedness. Years ago, she spoke, others spoke, and, as she poignantly put it, "we were all in the same room," and lest I fail again to get it, "we shared the same ground, common ground." Now, she continues, there is the big difference that old age makes. I ask to hear about that, of course—I'm there, actually, to hear precisely that: the nature, the quality of her present-day life. She doesn't quite address my request for specifics the way I'd hoped—maybe, I begin to realize, she is trying to do me the favor of sharing her

imagination with me, rather than some of the details of habit that seem so very much on my mind.

This for starters: "I will tell you, I can hear the evening approaching; I can hear the darkness coming." I dare not ask for *those* details! I hope this is preliminary melodrama, soon to be relinquished for the facts, man, the facts. She, in fact, has the facts very much in mind—and continues: "When the sun starts its going down, I can tell by the way that chair over there [she points at it with her chin, rather than one of her hands] appears—it gets a shade darker. I don't really see it as a chair, anyway. I know it's a chair, so I can make it seem more chairlike to my eyes. Do you see what I'm saying? [I nod, then realize she may not have seen me do so. I say yes, and then she tells me she saw 'my shadow' moving, and knew I was assenting.] The darker the chair, the later it is—until the chair disappears into the heavy darkness, the *thick* darkness! I have the switch [at her side] that I can use—a press of the thing, and presto! The darkness lifts, and then there is that light—and the shadow that you call a chair! But I never am in a big hurry to call electricity to my aid. You know, I'm old enough to remember a world without electricity *every-where*! We had it, but not the way people do now: buttons to command it, plugs to pour it into a dozen gadgets, and they are *indispensable*, I hear people say, and I have to smile to myself—that is called 'progress,' the growing number of appliances that you *can't live without*! I sit here and think to myself, 'I've lived without all that, and it's been a pretty good time I've had!'

"I'm wandering; I know you want to know how I spend my evenings. [I protest; I tell her no, I want to hear whatever she wants to tell me, but she knows I'm half-lying, even as she knows that she herself is responsi-ble for my disinclination: she has kept threatening to tell me about how things go for her at the end of the day, and naturally, the orderly chron-icler sees a chance for a methodical account, chronologically arranged, to

be, at last, fully realized.] The truth is, I like to enjoy those evenings—not get rid of them!"

She stops to let me figure her out, and I'm slow to do so: I don't see, even now, helped by her so very much, the humor of her remarks, not to mention their telling documentary candor. She has already, actually, told me what she favors, a slow onset of the evening's dusk—letting it bring under its control the material objects of her room, so that she sits surrounded by a cloud of invisibility, tables and chairs immersed, paradoxically, in the evening's special kind of light. Yes, light: "I know you think I'm getting senile (I'm entitled to!), but when the evening settles in, I think of my room here as lit up by darkness! I love to sit and look at it—the 'heavy' darkness of the chair and the couch, and the lighter darkness of that table and the lamp beside it. They are all shadows to me—I keep repeating myself to you!—but that's good, not bad (the way the eye doctor thinks)! I can use my imagination; I can turn them into anything I want! When there's a full moon, of course, we have more light here, and when there's no moon, we're all blacked out—even the shadows are gone (for me at least)!

"Mostly, I sit and remember; but I listen, too. I listen to my bones—they are grinding, the way they do in old folks. I listen to my plates [teeth] clicking. I listen to the [venetian] blinds rattling, the wind, a gentle whiff of it, helping them make music for the windows, and for me. I listen to my clothes, as I move a little, *very* little. I listen to the doors open and shut down the [apartment house] hall. I listen to the rain, to thunder—but first, the lightning, cutting through the darkness here, and I count right away, until the noise strikes, and then I know we're a safe distance away, or it's close, fairly close. I listen to my life—I can hear my daughter crying the way she did when she was a baby, and the way she did just before she had a baby! I can hear my son-in-law, raising his voice, preparing his speech before some judge or some jury: he was an

honest lawyer, and I know there are lots of people who will tell you that those two words don't belong together! I can hear my granddaughter on the phone, asking me if I'm 'all right.' 'Are you all right, ma'am?' I love hearing myself called 'ma'am.' You see, she grew up in the South! They know how to be polite there! Here, it's all business, or all plain Jack Frost, and I don't only mean the weather! I can hear my great-granddaughter crying, or shouting, 'Hello, Grandmama.' I'll ask her what she calls her grandmother, and she says, 'Granny!' I have lived long enough to see my daughter, my only child become a granny—and lose her husband. I hear all those voices in the evening. Later, I see the people, in my dreams—when you dream, you *see*, even if your eyes have gone on the blink! But early on [in the evening] I'm just sitting and listening to the darkness come over me, and remind me (I'll have to admit it) of what's ahead.

"I had a heart attack, you know, twenty years ago. They thought I was a goner. They called everyone up to tell them I wasn't going to make it, they didn't think. I recall getting to the hospital, and then I must have gone unconscious, something like that. I was 'checking out'; they'd done all they could, they told Susie [her daughter]; but I 'came to'—and I remember that *so* well! It was like being 'born again.' I'm not getting 'religious' here! I mean, I just sort of woke up, but I knew it wasn't from some ordinary night of sleep! I could feel all these needles in me, and I was tied to this machine—but I can still recall my eyes opening, and seeing the ceiling. I thought to myself, 'It's the ceiling and not the sky, and not the top of a casket, so you must be alive, even if it's to be such a short time before you go for good'—and here I am, all these years later."

She lowers her head, as if to thank the good Lord for all the "extra time," as she has called it, given her. She fusses with the sleeves of her dress. She picks up a pencil and a piece of paper, and looks at the doodling she has made—then reminds me that she can't really see what she's done, only "imagine" it. She makes a summary of her visual life—"shadows and more shadows"—but then says, once more, that she has

great fun dreaming by night and by day ("I have daydreams all the time, and I don't need any glasses to have them"). She edges her hand toward the alarm button she is always to have near her, then playfully caresses it: "I want to throw the thing away; I don't want them resuscitating me this time around. I don't have to make my hundredth birthday!"

What would she like to see happen, were she to live that long, only a few years down the line? She has already given some thought to that increasingly likely eventuality. She hesitates about talking out loud about the matter—she is superstitious: the less said, the more likely and the better! Still, gently prodded, she isn't averse to a speculative foray—she has taken many of them: "I've put myself into that birthday time, when I've got three digits to my name! I've heard Mr. Willard Scott taking my name in vain on that morning television set. He's called me 'a nice old young one,' and I've thought to myself, 'He sure doesn't know the half of it!' I've had my family near here, and then they've given me a big piece of cake, and it was damn good, real good! (How have I lived this long, with my sweet tooth? They tell you these days to avoid desserts, and stay thin; but I love desserts, they're all I've ever really liked to eat, and I've always been a little tubby, not fat, but a little tubby, my polite way of being easy on myself!) Well, I'm wandering, as always, but toward the end of that day [yet to come], I'd just be sitting here alone and doing what I like best to do, thinking about all the things that have happened to me, and waiting for the sun to leave, to give way to the night. That's what 'old age' means to me; and it's a long wait, if you get to be my age! I only hope and pray the good Lord takes me when I'm still half a human being—when I can think and remember, and when I can appreciate this world around me, the first light of the morning, and the first shadows, the early dark of the evening."

2. *The Fall*

Her name, Laura, has been a source of great pleasure, even pride, for as long as she can remember. She once asked her mother why she gave her that name, only to be told that the idea was her father's: he happened to like the sound of that name, and besides, he had a favorite aunt who bore it. Her dad was especially glad she had been given that name when, in 1919, that aunt died, during the great flu epidemic. The aunt lived in the upper (peninsula) part of Michigan and was only fifty-five when she succumbed. Her namesake was then ten, and recalls clearly her father's sorrow. She also recalls a heightened awareness of her name—almost as if she had become a repository for her great-aunt's spirit. Now, so many decades later, she can still summon for herself the charged, melancholy drama of that time: "My dad was extremely upset. She [the aunt] had been his mother for a time, because my grandmother had tuberculosis, and had to go to a sanitorium, and she died there. Dad's Aunt Laura took him in, and he became one of her children. Since she had three girls, she really took to him—he was the son she and her husband had wanted! Dad told me once that he remembered lying in bed, as a boy, wondering what would happen to him if his Aunt Laura got sick, the way his mother did."

There was more—a family story that she knew well and was glad to recite. Even then, approaching eighty, she savored the sound of her name, the distinction it brought to her childhood, to the rest of her life as well. The movie *Laura*, for instance, and the song of that title composed for it—she saw the film "several times," and has a record that she loves to play for that song. She was in her thirties when Gene Tierney played that part—and whenever she plays the music now, she is instantly "back there," in the years that immediately followed the Second World War. For her, without a doubt, that was the best time of her life—and she went further: the best time for her beloved country. "I've always been patriotic, I guess you could say. A lot of folks—I'm not criticizing them—they take the country for granted. I can see why—if you've been born here, and your parents before you [the case with her and her various friends], you get used to everything being here for you, the freedom and the standard of living we have. If you go abroad, you realize how lucky we are—and back then, of course [the thirties and forties] we were spared all the destruction that came to those other countries."

She pursues the subject further, more pointedly—talks about her husband's tour of duty in the Pacific during the Second World War. There she was, thirty-two when the disaster at Pearl Harbor took place, and the mother of two small boys. Her husband was an electrical engineer, a year older. He quickly enlisted in the navy, worried though he was about his family. As she talks about that time, she wonders whether I can quite understand the swell of idealism that surged across the nation, the desire of "everyone," so she insists, to do "everything possible" for their country, once it had been attacked by the Japanese. Each time I've heard her speak on that score, I've had my doubts: surely there were draft dodgers, war profiteers, people relatively indifferent to the national emergency—but I feel like some dour, stingy misanthrope unwilling to be as generous as she is to the memory, admittedly, of a great national effort. She perks up mightily, telling of that effort (the bandages rolled for the Red

Cross, the war bonds purchased, the rationing of certain foodstuffs eagerly embraced) and I smile and want to go buy a flag and wave it (and say nothing of what I learned about Harry Truman's important work as a United States senator during that war: the investigations he launched into the various schemes to defraud the government on military contracts).

After the war her husband, safely home, and she and their children lived a "happy, happy life." She connects that time to another postwar film, *The Best Years of Our Lives*—that says it, for her. She cried through that film, saw it again, cried again. The same with *Laura*—"such a sad movie"; but the song, so haunting, lives for her, apart from the film. It is *her* song. Do I know the one Frank Sinatra sang "so beautifully," "The Song Is You"? Her husband, Tim, would say that to her about "Laura" —*that* "song is you!"

I much enjoy being carried back in time by her—perhaps enough so that I have to distance myself a bit, turn standoffish, ironic, bemused, skeptical, lest (sin of sins!) I turn, with her, openly and unashamedly sentimental. That last word—she has not the slightest embarrassment at claiming it, demonstrating its kind of emotion. There is another song, for instance, "I'm Getting Sentimental over You." Do I know it? No—well, how sad: she doesn't have a recording of it; but she can still hear Frank Sinatra singing it. As I am told such tales, offered such reminiscences, I feel the tug of the past, not hers, but my own, one that doesn't go quite so far back. I realize, too, how heavily she counts on the past to get her through the present. The issue, she makes clear, she insists, is not one of old age and its tendency to discredit what is, in favor of what was, for the obvious reason that one can be far less able to enjoy contemporary life as an elderly person than one could during one's youth. For Laura the "golden years," as she calls them, have to do not only with her particular life's young middle age, but with her country's fate. For her, something "very wrong" happened in the 1960s, and she is convinced that, were she a teenager then, rather than in her fifties, she still would

have been first surprised, then dismayed and saddened, and then very troubled, indeed.

I hear her out; I understand her line of argument fully; I don't agree with all she says—especially not with her view of the civil rights movement ("It went too far"), and the struggle many pursued against our policies in Southeast Asia ("An awful thing to do, oppose your own country when it is in the middle of a war"). Indeed, as I disagree with what I hear from her, I have to wage my own struggle—and do so, by converting as best I can my annoyance, my irritation, my outright disagreement, my anger into a determined effort at comprehension, at analysis, at listening and learning, no matter my personal views: an "objectivity" more celebrated than actually achieved, one suspects, in the annals of social science research. So doing, at times, I ignore as best I can the substance of her remarks, toss them aside as "ideological," even as irrelevant: what matters is their "role" in her aging life's "psychology." I never, of course, spell that out to her, but I begin to realize, slowly, that she has her own way of being "psychological," of figuring out *my* mental economy, as it were, even as I am pursuing my career as the one who does precisely that when I am "interviewing" others, such as her. I suppose it is "intuition" with which I credit her—with the condescension of the clinician.

One day, she tries valiantly to get us both beyond the above impasse of sorts. She tells me that it is hard for her not only with people my age, a generation "below" hers, but even with some of her friends very much "along in years." She tells me, for instance, of an eighty-five-year-old lady whom she encountered at a church meeting. They are both in need of help walking, because of illness. She has had a stroke, and has limited use of her left side. The woman she has mentioned has severe arthritis and coronary insufficiency. Nevertheless, with the help of their respective sons, they both came to a Presbyterian Easter service, and they both stopped afterward, in the basement of the church, for coffee and cake. "It was a huge trial," she lets me know, to get herself down those church

steps, and then up again. At home, she uses a walker. With her son, she can't "pretend" to be able to walk in a fairly normal fashion. She loves those moments, actually—summons the past in connection with them, too: the symmetry of her as a mother helping her young son to walk and him, now, helping her to do so. But she doesn't want to indulge in *that*—"nostalgia for its own sake," she calls it trenchantly. What she *does* want to say has to do, again, with cultural and social and political shifts in the United States—and their significance for someone who is old enough to have experienced them, and as she has reminded me repeatedly, "lucky enough" still to remember them (or is the word, she adds, "unlucky"?).

As she was making that point in her own storytelling way, rambling one moment, quite pointed and concise the next, I was beginning, at last—well, to meet her halfway, through a kind of abstract embrace of the larger issue in question: the relationship between a person's longtime experiences and beliefs, and his or her response to the world as it now is. But she was able to develop this issue much better than I have just done, by concretely comparing her views and how they affect her daily life with the views of Theresa, her newly met lady friend—what she had to say, what those statements tell of her attitudes not only toward politics, but toward her own daily life. In the beginning, unfortunately, I resisted this breakthrough turn in our conversations, regarded it as a distraction. The point was to learn from *her*—to earn her trust, so that she would go beyond (beneath) talk of movies and politics and get us both nearer the obvious reason for our meetings: an exploration of how she managed her limited, elderly life. Yet, in time, at Laura's deft, knowing insistence, I began to understand not only what her friendship with Theresa meant for her, obviously, but for us as well as we conversed. An important tip-off, one day: "Theresa reminds me of the way I used to think, and I'm convinced that she still does [think that way]." I show some interest, of course, because she has mentioned her own past point of view —though she wants to talk, first, about Theresa, and I submit reluc-

tantly (rather than derail her train of thought through questions and more questions, always an option for my kind, no matter our frequent protestations that we welcome any and all of those "free associations").

Yet, this time I realize, at last, that Theresa has opened up for Laura a part of her life long since firmly set aside—done so much to Laura's surprise: "She is so frail, to look at her. I see myself in a few years! The doctor once said to me that the difference between the early eighties and the late eighties is huge—and it's not just skin-deep! Your bones 'go,' even if you're not seriously ill. You slow down even more, and you have to rely on others more and more. That's how it is for Theresa—[and] of course she's got her arthritis and her heart trouble. But I'll tell you, she's an amazing person! She's so upbeat! She's lost her husband, like I have, and she's lost a daughter to cancer. Her son lives nearby and is of help, but he's closer to his wife's family. She has one granddaughter, and there are two great-grandchildren, I think, but she doesn't see much of them. But here she is, going to church every Sunday, and singing those hymns, and smiling. It's what you notice about her: the big smile on her face.

"I began to wonder where her 'good cheer' comes from—that's what we used to say of someone like her: she's a person of good cheer! I used to be optimistic like her—back in my younger days. But not now—the world is too troubled, and I guess I pay too much attention to all those troubles. Theresa—I've asked her about her 'good cheer.' I've said, 'Doesn't all the bad news you hear about bother you?' She said, 'Laura, there's always been bad news. You have to remember that.' I said, 'Yes, but it's getting worse.' She said, 'That's because you're forgetting how bad it used to be, and concentrating on how bad it is right now!' She reminded me of a lot I *have* forgotten, and by the time she was through, I told her I was getting depressed, remembering all those things. But she said, 'Laura, that's the point—if you put all of that behind you, a lot of your troubles come from having done so!' Maybe she's right, I thought. Maybe, when you get old, you lose some of your perspective. You don't

only forget people's names, and dates, and chores you're meant to do, but you forget what it was once like in the country; and since you're now old, and you're not in the middle of things, all you do is hear about the bad side, from radio and from television, and if your eyes hold out, from the papers. You're not seeing a lot of the good things that are happening, because you're cut off, more and more, from them. Theresa told me, 'Watch out, Laura—you'll get more and more scared of this world, the further off you are from it!' "

Even as she had been given pause thereby, I now am thinking about all that she has just told me—her sense of the decline of America, a steep and apparently irreversible one, but also her counterargument (a cautionary reminder to herself, actually) that warns of the consequences many elderly people have to endure: as they get cut off, become at a remove from life's various events and rhythms, they receive a rather biased, if not distorted view of things. No wonder, then, a growing gloom—which highlights, by contrast, the past even more: its virtues such a contrast with today's all-too-apparent vices. Laura is enough aware of the above, obviously, to more than hint at it, courtesy of her friend Theresa, whom she does, after all, quote on the issue with evident respect, even gratitude: "I thank Theresa in my prayers—she has a positive outlook all the time, I think, and I don't, so I need to listen to her, even if I don't always agree with her on specifics."

She is shrewdly introspective enough to realize that Theresa presents a challenge to her: how come her hopefulness, seemingly immune to the downward chain of events she herself has described? Laura is now tempted to go in two directions: summon that old staple, "temperament," or move in the direction of twentieth-century psychoanalytic thinking, by making reference to concealment. Perhaps, that is, Theresa also has her down times, and tells no one of them, maybe even including herself. As she weighs those alternatives, she is circumspect and savvy enough to be even-handed, to sift and sort, to come out intelligently unsure of her conclu-

sion. Some old people she knows have "always been upbeat," and she believes (or rather, concludes) are "that way by nature"; but others "put on a good face," whereas by themselves, "it's different, really different."

I hear a plunge downward, so to speak, in the way the word "really" is spoken—almost as if it is meant to convey, single-handedly, the truth of what can sometimes happen to the person who has just used it. She seems to have heard herself, I begin to realize—for she begins to spell out what can happen "backstage," she charmingly puts it, while "in front of the audience" all appears to be going quite well: "I save up my strength to go out and meet the world. I don't just mean my physical strength! I think of myself as needing to put on the best face I can; then, I'll be back in my apartment, and I'll be sitting on the couch, and suddenly something will set me off. It's not always the same thing, no. [I had wondered—on my face, not with words.] It can be a thought that comes to me, but mostly, it's my eyes: they bring something to my attention! The walker—more than anything, the walker: I'll just be sitting, and the sight of it makes me realize what's happened to me, and I'm sure there's more to come! I'll remember how I used to walk, and run, and play tennis, and then golf—and now, for me to get across the living room is a big event; it's an achievement. Maybe if I was Theresa, I'd be patting myself on the back every time [for maneuvering successfully with the walker], but I'm not her, and I don't. I'll put it this way: I don't fall down much, not real hard so far, thanks to the walker. But I *do* 'fall down,' way, way down (do you see what I mean?) when I use it—even when I catch sight of it sometimes."

She closes her eyes at that moment, opens them quickly—takes explicit notice of what she has done, and why: "I guess I really mean what I say!" She backtracks, observes the walker with candid realism—speaks of its obvious functional significance. She then laughs, even as she is staring at the aluminum fixture: "Would you believe it—I had a dream last night, and it was there!" She talks about the dream—she was trying

to get out of her house because of a fire, and she tried to crawl, but realized she wasn't going fast or far enough, so she crawled to the walker, and with its help, proceeded safely outside. When she woke up, she realized that she probably could crawl as quickly as she could walk with the help of a walker—or could she? She pictured herself crawling the way she did as a child—then reminded herself that she no longer is one, "that's for sure." Some second thoughts, though: "Everyone says that being old is like being a child again, and for a long while I didn't like to hear that comparison, and I thought it was untrue, actually. I still do— when you're old, if your mind is holding out, you're not a child: you have a ton of memories, so you've got plenty to think about, unlike youngsters, boys and girls, who are always jumping from one activity to another, and don't spend a lot of time remembering (why should they?). My doctor said we're like children because we are 'dependent on others.' I didn't like hearing that! It's true, for a lot of us, I know. But I don't think of myself as 'dependent on others'—even if I am. Children don't know how to think of themselves any other way, so I think it's very different, to be old and need others, but to have a mind of your own, and plenty that's happened to you, and it keeps coming back to you, especially at night, when you toss and turn and can't sleep, and the next thing you know, in your thoughts, you're not old anymore, you're young, or you're middle-aged, and you're talking with people you haven't seen in years (they may be dead!), or you're doing things you haven't done in years. Children usually sleep right through the night, and they don't have this storehouse of past experience that will wash all over them!"

She has made a substantial point or two, and now falls back in her chair, only to lean forward, so that she can pick up a nearby glass of water, which she empties in several long gulps. She now lets her eyes return to the infamous walker, which receives a prolonged stare. "If looks could kill," she tells me, and sees no reason to complete an enunciation of the cliché. But her mind is letting itself follow its associative direc-

tion—so, she is now talking about death, not by murderous glance, but through the attrition of the years: "Children don't notice what time does to you—they haven't really *discovered* time! I think you begin to realize what time is when you're in your twenties, and the honeymoon with it is over, and the world is beginning to say to you, 'All right, come and join up, find work, get married, and prepare for the end, slowly.' I may be getting a bit dramatic, but I really do recall suddenly realizing, one day when I was twenty, maybe, that I had to stop and think about things, and plan and figure out—not skip and jump, and oh, have a lark, even if there were bad days, too. I'm not saying that you are happy, most of the time, as a child, and then it all stops. I'm just remembering how conscious of time I suddenly became by the time I was twenty or so—well, actually, maybe there is a build-up [of such consciousness] a few years before that."

She stops to ponder what she has said, and more broadly, the issues she has put to herself, and to her listener. She summarizes her points—then wonders out loud why she is so determined to criticize such a common comparison, that of childhood and old age as in certain respects similar. She repeats her points a third time—then laughs: "You see, children don't keep going over and over the same subject a million times! We *are* different [from them]." We both laugh, and she settles back in her chair, after asking me to fill up her glass of water. She resumes her concentration on the walker, lets her mind, once again, contrast the dependence she has on it, with the brief spell she knew as a mother who was helping her son walk with some confidence: "I guess I was his walker for a while—I'd hold his hands, and he'd take one step, then another. What a difference, though—a brief second or two, versus every day until the last day of my life! I used to enjoy that time—I sure don't enjoy this time. But I'm feeling sorry for myself, and that's wrong!"

She tells me, once more, how hard it was for her to be resigned to needing that walker "indefinitely"—and with that word, a smile ac-

knowledges the use of a euphemism. Only a few months ago she stopped renting "the thing," told her son to buy it outright. He seemed relieved, and she was, thereupon, quite angry at him—as if he *wanted* her to use the walker. She soon enough had realized what she was doing: "I was being 'crazy' for a minute or two!" She is anxious for me to understand that she never *said* any of the above to her son. I was quick to observe that we all have to deal with a host of worries, thoughts, attitudes, and convictions that we know, even as they cross our minds, or certainly, moments or longer afterward, don't deserve the shared life of utterance. Her response to that not especially original comment proved to be longer than I would have anticipated: "If you want to know what I think 'old age' *really* is—well, I'll tell you, it's something more than your body going downhill, downhill all the time, and you never do really know when the speed will accelerate, but you sure do know where you're headed! The body is one thing—but the mind, what happens to your thinking, that's the real story of what growing old is all about (I've begun to realize), and I'm not talking about becoming 'senile,' you know."

She stops herself, suddenly, and I'm getting ready to say something (tell her yes, I see what she's getting at) when she resumes her commentary: "The other day I was sitting here, looking at that walker, and feeling sorry for myself. Then, I got angry at myself for feeling sorry for myself. Then, I just sat and tried to find reasons to be happy. I said, at least you're alive, that's the biggest reason. You've had a pretty good life, that's another reason. You've got a good family, there's a reason. The doctor you see, he's a good man, and he really tries to help you out, and he's kind, very kind, there's a reason. But then, I realized that the worst of it—this life I'm leading now—is that I have to sit here and count up all those reasons! I've never been one to sit and think and think; I've been one to get up early and do things, and go through the day, and then be glad to 'hit the hay' when it's evening! Now, I'm all the time thinking about things, and worrying: will I be able to do *this*, come next year, and will

I be able to do *that*, come next year—and will I even be *here*, next year? I try to stop myself—I try to lose myself in the television programs, and in trying to sew and knit, and in listening to music, and I plan my trips to the kitchen and the bathroom, and I talk to folks on the phone (though I don't hear too well when I'm on the phone, I've got to admit, and the hearing aid doesn't help much). But that leaves me plenty of time to think, too much time! It's a terrible thing to say, but there will be moments when I want to turn that thinking off, and I just can't, and I have these ridiculous thoughts: some doctor could come and do something to my brain with a needle, and afterwards, I wouldn't be thinking so much."

Another moment of silence, while I wonder whether to ask her about the nature of all that thinking. I'm about to do so, when I'm told by her that she can see that I'm interested in what "crosses" her mind, and she wishes she could tell me "all that does," but she forgets, forgets, forgets, and *that* is part of the sad problem, too—not because, again, she thinks she's "senile," but because "it's all such a waste." Now, I'm getting ready to reassure her, to tell her (in the contemporary way of my kind) that she is being much too hard on herself, when she, once more, seems quite readily aware of what to expect of me, never mind herself: "I know, I'm the one who's responsible for my troubles—I should just relax and ride it all out, these years. Sometimes, I do—I just smile and say: 'Laura, this is your final test, and try to get a good score, try to get an A, or an A minus!' The trouble is, I'll convince myself for ten minutes, for an hour, even, and then I'm back to remembering, going over and over what I did, and what I should have done, and wishing I was younger, or sometimes, I'll just say it, wishing all this was over."

She is stopped in her tracks by those last few words—looks at me to make sure I have gathered their import. I am having my own "thoughts" to confront—is she "depressed," more so than she is ready to let on, and if that is the case, what ought I to say, never mind do? The names of certain antidepressant medications are popping into my head, when she in-

terrupts that psychopharmacological reverie with an expression of self-remonstrance that is, at the same time, I begin to realize, an effort on her part to clarify matters, put them in some larger context, both for her own sake and mine: "I'm not meaning to worry you! I'm not meaning to say that I'm seriously interested in leaving this world. Maybe if I thought it was a sure thing that I was headed for a better life with the Lord— maybe then, I'd be trying to hurry myself along (you see what I'm thinking?). But the minister tells us, if you try to do that—you'll ruin everything! It's up to the Lord, when you'll die. You can't take His business into your own hands!

"Anyway, I'm not about to do myself in! I think I'm just—oh, frankly, I'm just old and, mostly, alone, and I think I'll be trying to get used to being like this all the rest of my 'allotted days' here. You don't *get* used to it, you only keep trying to, and that's what it is, old age: the realization that there's nothing to do, but to hold on, hold on (you know: hold on for dear life), and that's your full-time job. If you're the kind of person who used to keep going, who was an active one, then it can be pretty hard sometimes, to live like this. If you were always one to look out the window and dream—this is quite a bonanza you've got!"

I'm still not sure she has tackled for herself (never mind me) what it is about the enforced passivity, with its ruminating consequences, that has her quite so upset (or maybe, better put, so upset with herself). I waver between a clinical skepticism of what I've been hearing—dig deeper, learn more!—and a sense that I'm being told a kind of fundamental truth: this essentially solid, hopeful person, who has lived a fairly fulfilling life, is now, with good reason, impatient with how her days go, and sad at their diminishing number, and anxious as to how their cut-off, as it were, will take place. I am just there—the thought in my head about the thought in Laura's of such a finale—when she resumes: "I will be opening that jar of vitamin pills, when I stop myself to ask, 'What for?' I know, vitamins are good for you! But really! At my age, I don't think

it makes any difference—you've beaten all the odds, and you're still around, and you won't stay here much longer, because you've taken a vitamin pill every morning, or you keep your cholesterol down! I eat what I like—lots of butter and eggs. I like my ice cream. But I do take that [vitamin] pill, along with all the others! I'll smile, sometimes, when I swallow it. I look at the jar, and wonder if I'll live long enough to finish it up, take every pill in it. A couple of weeks ago, I got myself into a real fix because of those [vitamin] pills. I dropped the jar! They fell all over the floor. I started kneeling to pick them up. I fell, it was a gentle fall —I knocked the walker over. There I was, on the floor, surrounded by those red pills, looking at the jar, with a few pills still in it, and the walker turned upside down! Then, I got this tightness of the chest—I've sure had *that* before! I thought to myself, 'That's how they'll find me,' and I thought, 'I hope they'll laugh, "Poor Laura, she died trying to recover her vitamins!"' I decided not to fight it—not to try to get up, so I could get myself *another* pill [her nitroglycerin one, for the angina attack she experienced]. If I died with my vitamin pills around me, that would be fine! To get up, feeling weak, in order to get *another* pill, and then fall down again—I wasn't up for that!"

Soon the chest pain disappeared on its own, and soon she was standing, after having crawled about, collected the pills, and got hold of the walker, set it straight. Soon, she was contemplating that brief episode, not only in the minutes that followed it, but later, as she sat and looked back in time and, too, looked ahead. Soon, that experience had become yet another foreboding one, a hint of what her future portended. "I know I'll 'go' from a bad fall, I just know it," she said—the culminating comment of a narrative that enabled the summary I have just given. I quickly, decisively responded—reminded her of her own quizzical moments, when she is frank to wonder about her demise, how it, finally, will occur. Surely that is the likely case for most of us, I argue: we can't really know the details of the exit that awaits us; its *elusive* certainty, maybe, is the

last mystery available to us on this side, at least, of our destiny's scheme of things. She smiles, remembers her various past remarks—yet seems as grim as she's ever been, her eyes closed, her head lowered, her hands tightly clasped: "I know there's that bad fall awaiting me, and I know it'll take me, somehow it will! A lot of the time, when I'm getting ready to use that walker, I talk with it, *to* it. I'll say: 'What have you got in store for me today?' I'll say, 'Is this [day] *it*?' I'll say, 'All right, go and let me down—I'll fall hard, and break my hips, and then I'll get pneumonia and die, that's how my sister died, and that's how I'll die; it'll be the fall that'll do it.'"

She stops talking, looks up, opens her eyes. She glances at the floor, then at the walker, then back at the floor. She looks out the window, tells me the obvious, that it's cloudy, that rain will probably soon come. She becomes briefly reflective: "I guess we all fall down, one way or the other." I nod. She nods back and, then, a laugh, but no explanation of its cause, whereupon I ask to be let in on the secret, and she tells me she is sure I'll think she's "loony" when I hear what came to her mind—but she tells me: "If this was ancient Egypt, they might put that walker with me, when I die, in some room they'd have for us! You know, I used to read those *National Geographic* stories about the pyramids—they were always discovering new burial places, and you'd read about all the things, the possessions those folks took with them. I guess they were getting themselves prepared for the next life! I'd hate to think I'll be going into a new life, and I'll need this walker *then*, *too*! But, maybe—who can ever know! In Egypt, back in those days, someone would probably come to me and say, 'Laura, we're going to send you off with that walker, just in case!' I'd probably say thanks a million for thinking of me! Why, the other day, after I heard one of those ministers on television talking about Judgment Day, and all that happens then, I thought: maybe the good Lord has His own supply of walkers up there, so when we show up before Him, to be told where we're headed ('up or down,' my dad used to say!), He can give

us a walker, if He sees we need one. Jesus was a tremendous healer, remember! He wouldn't want to see us taking a fall, while He's figuring us out!"

She has enjoyed herself, telling that story, and has enough distance from her situation, in all its jeopardy and vulnerability, to smile at herself, to tell me that "the only fun I now have is making fun of myself," and thereupon to let me in on "a secret"—that she has a name for the walker, Clara. I am told without having to ask, that Clara was a woman who used to come and clean house when Laura was a young wife and mother. Clara was exceptionally efficient, able, tidy; and her fastidious ways both put her employer to shame and inspired her: "She gave me a lot of help—she made all the difference in those early years of my married life. I think of her a lot. Once I told her, 'You're my biggest ally,' and she smiled. She never did talk much, though." A few moments later, Laura and her walker are moving across the room, and as I try to attend and make sense of her words, a few here, a few there, I realize that they aren't being addressed to me, but rather to this second Clara, also untalkative and also willing to bear the brunt of someone's angry or grateful need.

3. *Eyeing One Hundred*

For a long time, during what he calls his "middle years" (as if he were a historian who specialized in chronicling his own life), George felt himself adrift. He had been a "tradesman," had done both plumbing and steam-fitting; and was, additionally, a good carpenter, a "passable" electrician. As I hear him tell of all that capability, exerted over the decades with competence and persistence, I am in awe, and say so—only to hear substantial exclamations of past ineptitude. He merely "did" his work—got no big pleasure out of it. He was glad to be able to "earn a buck," even during the depths of the Great Depression, but there were plenty of times when his hard work went unrewarded— "crooks, thieves, liars left me holding my hands out, while they reneged." That last word, I have learned, tells much about him: a proud artisan who is also an autodidact. He left school after the sixth grade, became an apprentice to a builder, who himself was a "jack-of-all-trades," and followed suit—while also reading whenever he could, even the dictionary or an encyclopedia. He would go to the library on Saturdays as a young man and swear to himself he'd leave "richer"—meaning, in firm, knowing possession of at least five new words, and maybe, some knowledge about a moment in history. Those were his "flush days," he calls them, a time

when he was discovering how to build a world for future homeowners, and discovering, too, a whole world of facts, words, ideas, all on his own.

In time he would marry a woman much like him, Lucy, a hardworking nurse who, as he put it, knew how to be thrifty. She tithed herself, saved money, learned how to invest it, became "better off than either of us ever thought was possible." How come? She put money in stocks (for a long while he'd never really known what they actually are), did so during the Second World War and after it, and of course, those stocks "really took off around 1950 or thereabouts," so he remembers. They became the parents of two daughters, devoted themselves to their rearing, while each of them kept working long and hard, so that "the girls" would have "a leg up"—and they did: they went to good colleges. Neither, however, pursued a career, much to their parents' disappointment. They both married young, became mothers soon thereafter, and thirty years later, were themselves grandparents. All of this (and much more) George delights in relaying to a listener, and especially delights when that listener comes with a tape recorder and a notepad: his *history* is being *recorded*, and he loves it, even as those two words, for him, smack of significance: "The worst thing that can happen, is that you 'go into the night' unnoticed! I don't mean you should be an attention-getter! I mean—I guess, this: there should be a record of us, before we leave. I've left some letters, and I've shown them to no one—but when I die, they'll be a kind of history of the family, starting with my granddad (I knew him well) and going through to my great-grandson. You know what that span is? It's from 1835 to now [1990]—you're talking about over a hundred and fifty years of America. You're talking about me knowing someone whose granddaddy was around when the country was being born! How about that!"

He can go on and on, a wonderfully eager and voluble man, quite anxious to make his mark on someone across the table from him as well as on the paper he has used to receive his words, his messages, for what he hopes will be many generations of interested readers. At times, in his

presence, I get distracted from my primary interest—to learn how he is doing *now*. Instead, he carries the both of us into the near and distant past, to the point that I leave quite awakened and informed by what I've heard about the First World War, say, or the 1920s, or the onset of what George nicely has called "the world collapse" of the financial markets in the early 1930s, but with no further sense of how he manages presently to get on with life, my appointed task. Once, he rather charmingly and surprisingly said to me what I had several times said to myself when away from him, only to fall under the spell of his "loquacity" (his kind of word) a day or two later, upon a return visit: "I have decided that I'm not helping you, with my verbosity. One of the English prime ministers, I think it was Disraeli, described an enemy of his as being 'intoxicated with his exuberance of verbosity,' and I think you've got another drunk of that sort sitting right here before you!"

I am, of course, quite taken with that delightful apology, but unable to resist, at least then and for an hour thereafter, another slug of the whiskey of words he tenders—until, finally, I start preparing to leave, and he takes notice, slows down, looks at me closely, then at the window opposite him, behind me. It has begun to snow, and he points that out to me. I turn to look. I don't quickly turn around; indeed, I rise, walk to the window, look outside, take the measure of the snow, its accumulation, its lightness, enabling the wind to swirl it about madly. George can bear to observe this only so long, and then the first plaintive remark I've ever heard him make: "I wish I could leap up, as you did, and catch sight of that snow falling on the grass." I hasten to offer to push him in his wheelchair close to the window, but no, he will stay put. In fact, it is his remark that has prompted me to take notice of that wheelchair! I've known all along that he sits in one; have seen it right before my eyes on every visit. Yet, each time we talk—well, that talk causes me to forget, virtually, how the talker is living, how he manages his day-to-day life, my stated purpose in making those home visits to him, a ninety-nine-year-

old man who is very much, as he has put it often, "down but not by any stretch out." I think of him, actually, as not "down," either—old, yes, but thoroughly on his own. True, a homemaker comes to visit him once a week, and a visiting nurse, who reminds him of his wife, who is "gone thirty years." But his mind is clear, and he is spry, when he wants to be, with the wheelchair. He moves it about deftly, and he is able, with no one's help, to get in and out of it, though with substantial and evident expenditure of a limited amount of energy, hence the calculation that tells him to stay where he is most of the day—reserve his strength for times of greatest need, the morning and the evening.

Eventually, I did get to hear him talk about the immediately fore-going—I believe he began to worry about me, the failure of a mission, hence his decision to turn our joint attention to what he called "the quo-tidian." (He was proud, but not smug using that word, and when I heard it, I was obviously very pleased: an exact recognition on his part of what I was hoping to accomplish on those "house calls.") He started us off, one afternoon, with a description of the mechanics of the wheelchair and his reason for being in it: "weak legs," and too, a neurologically induced imbalance that threatens him with the disaster of a fall, a broken hip. When he is feeling strong, in the morning, for instance, he can contend successfully with both of those problems—manage to get out of the chair and walk a few steps to the kitchen stove, to the refrigerator, or to the bathroom, without feeling dizzy, losing his grip, stumbling wildly. He is precise about the steps he has to take, so to speak, in order to take a few steps: "I have to *concentrate*; I have to think to myself exactly what I want to do, where I want to go, how I'm going to get there. I map out the trip! I bring the [wheel-] chair as close to my destination as possible, and then I sit and think and get myself ready to stand—that's the first thing, to get up so you don't fall right down upon the chair or the floor nearby! I always bring the chair near a counter, and they've installed these metal bars all over the place, so I can 'park' the chair (I make sure

it's locked, and it won't go running away from me!) and then grab a hold on one of those bars—and if I'm lucky, I'm home. I'll say that every time, out loud! There's no one to listen, and I can't hear very well myself, but I hear myself, inside my head; I hear my voice speaking."

He stops, as if to listen to himself talking. Years ago, when young, he'd go to political rallies—he loved to hear good political oratory. He wasn't so much interested in the content as the style, the language, the theatrics. He is not an unwilling performer himself—he calls the wheelchair his "prop," and he asks me repeatedly whether I have ever seen a Lionel Barrymore film in which the old trouper was confined to a chair. I say no, each time, and a week or so later, we have at the matter once more. After a while he remembers as we are talking about the movie that we've gone through a similar script a while back, and he apologizes for the "loose cogs up there."

Mostly, though, he is quite clearheaded, and not forgetful. He loves to talk while sitting; but when standing, holding on to a metal bar or to a counter, he waxes euphoric, recalls his earlier life, tells me of his favorite movies or political leaders. He imitates Franklin Delano Roosevelt, whom he calls, as did everyone of his generation, FDR. He imitates the Boston mayor and one-time Massachusetts governor James Michael Curley. He recalls VE-Day, VJ-Day, the victorious conclusions of our war with Hitler, our struggle with the Japanese military. He lets me know how much he once loved to smoke Lucky Strikes—informs me that there was an advertising campaign that was carried on through radio: "LSMFT." Did I know of it? (No.) Could I figure out what the five letters meant—oh, I get as far as Lucky Strikes for the first two letters, and then draw a blank. He urges me on. I fail to respond to his prompting. He is disappointed in me, and I notice: I get a hard look—a teacher spotting a pupil who may not have a very high IQ. I am told the answer: Lucky Strikes Mean Fine Tobacco—the rage of American smokers, so he claims. I enjoy being called "young man" by him, enjoy his reminder

that I'm almost forty years his junior, but I try to keep our conversation on the here-and-now, not the past, the distant past of half a century and more back. He resists, gets feisty with me, tells me that I'm another one of those doctors who are always trying to "practice medicine," rather than "enjoy their patients." At such moments, I realize how much he yearns for an old-fashioned argument—he was a great one for that: he'd stop at a neighborhood bar, every late afternoon on his way home from work, have exactly one beer, "light up a Lucky," get into one or another talking brawl, come home satisfied. Now he doesn't smoke, doesn't drink —but lets me know that he spends a lot of his time thinking back to those ordinary daily "high points" in his life. I am moved to a lust for a drag of a Chesterfield (my own one-time brand), or a belt or two of Wild Turkey as I hear him declaiming on the feel of smoke at the back of his throat, down his "windpipe," into his lungs, or the soothing, relaxing consequences of a Bud on his muscles, tired and taut from a long day of it on the job.

Once, as we talked about his life at ninety-nine, he told me his survival was a miracle; and he also reminded me that he had "defied the odds," that no doctor ever would have given him "a ghost of a chance" to get as far as seventy or eighty, never mind ninety and beyond. His mother and dad died early (albeit from infections, I reminded him, so they might well, these days, have lived into old age). More to the point of his assertion, he had been told at fifty that he had "mild to moderate high blood pressure," and been given a number, "a bit over 140," to prove it. He had a coronary seizure at seventy-two and was told then to stop smoking, but kept it up until "eighty-five or so." Why did he stop then, I wonder out loud. Not for reasons of health, he insists—rather, he almost lost his life in a fire he inadvertently set by leaving a cigarette only partially perched on an ashtray at the edge of his bed. He'd had a "beer or two" at that time—and was feeling "low": the anniversary of his wife's death (of cancer). He lost a lot of his possessions, including a

much-treasured family album and a scrapbook he kept—newspaper clippings that went back to the 1920s. Even now, I am told, he will sit and remember or be in bed and remember those clippings—they meant the world to him: Roosevelt winning, grinning; Curley coming home from prison; the atom bombs dropped; and hey, Hoover beating Al Smith, whom I hear described this way: "He was a hell of a guy—down-to-earth, for the working man. All he ever did wrong was be born a Catholic! It took over thirty years for him to be avenged by John Kennedy—but if you ask me, Smith was more my type of politician: a straight shooter, and no fat cat father running the show for him. I always felt sorry for President Kennedy—to have that bossy, bigoted, philandering, deal-making father to deal with!"

It is a sunny but quite cold day in early February, and I decide to "log in" an hour or so with him—his expression: "So, you've decided to log in some time here!" He is in the wheelchair, an empty coffee cup on a table nearby. An issue of *Time* is beside the cup, and I notice a coffee stain on the magazine. He notices me doing that, glancing around the room, stopping with my eyes here and there. He speaks: "I see you're taking in the room." I am embarrassed, but wrongly so, he lets me know. He has nothing to hide, he reminds me. Still, I feel like a prying intruder, and again apologize. "Ridiculous," he insists—besides, *that* is what being old is all about: "When you get to be my age, and if you want to hang around even longer, you'd better get yourself adjusted to visitors. Where would I be without that nurse, who comes and gives me pills for my heart and lungs [he has congestive heart disease], and takes my blood pressure and gives me pills for that, too, and they say I have some diabetes (at my age, you've got a good chance of having every disease known to man!), and so she tests my urine—she gives me a complete once-over, that's what! Then that homemaker comes, and she's arranging this, and rearranging that; I have to memorize where everything is, before she comes, so I can put everything back to where it belongs, after she leaves!

A novelist, I think, or some kind of writer, once talked about these folks with 'a rage for order.' I remember the line: I memorized it—and I tried to use it every once in a while. My wife would get a little too tidy for me, and I'd try to be nice, saying it: 'Honey, you've got a rage for order today.' She'd laugh right in my face and say, 'Well, well, well, the English nobility has arrived, putting on fancy airs!' That took care of me. Anyway, that Negro lady [the homemaker] has a high-octane-fuel rage for order! She fusses and straightens everything out until I think (God forgive me) a match lit and thrown would end her misery and mine, both!"

He stops his monologue and seems unhappy with himself: he shouldn't, even in jest, talk of setting a fire, given his past. He now begins a tirade directed at his own "wise guy" side—he should be grateful to that black woman, not sit there "knocking her, knocking her." He's always been a bit of a "slob," after all, so "thank the Lord" for those who are neat and willing to help others be neat. What *is* the matter with him?—he asks himself that often, these days. Do I want to know what it means to be old, and yet with one's wits about you, and able to manage, if with assistance, on your own? Well, he can tell me—and he does: "When you're old, you're on the verge of falling apart. First one thing [in the body] goes wrong, then the next, and pretty soon you're taking pills yourself, and someone is coming to give you special pills, and to check up on your blood and your urine and your pulse and your breathing, and you wonder what would happen to you, if there weren't all these medications. Some people lived up to my age (didn't they?) before the doctors came up with all their stuff! Anyway, the nurse holds me together, I guess, and that nice Negro lady holds me together, and I shouldn't be complaining about anyone, especially those two women!

"I sit here and I think—that's what I do! I think: it's Monday, so the nurse is coming. I think: it's Tuesday, so no one will be here—I'm on my own. I think: it's Wednesday, and Joyce [the homemaker] will be here, and she's *the* best person in the world, so far as I'm concerned.

Then it's Thursday, and I get these students, two of them come and they bring me cookies and they read to me, and they ask if there's anything they can come and do for me. The other day, I was thinking of them—I felt bad about my own young life, that I never even thought of the elderly and what I could do to help an old man like me. It says something about those students, that they keep remembering me!"

He stops and seems lost in his own thoughts. He looks at me for a long time, then asks whether I've given some thought to how I'll live when I'm "very old" and "can't get around." I tell him that I guess I haven't—that I suppose I've always assumed that I'd never live that long. He smiles: famous last words! He, too, had such a notion, he reminds me—that he wouldn't hit seventy, never mind ninety. Now he's on the verge of—well, here is where he teeters: "I've got a few months to go, and I'm holding my breath! Mind you, I have trouble breathing, so when I hold my breath, I'm *really* setting myself up for lots of trouble! They tell me I'll be on television—that guy Willard Scott on the *Today* show will have a picture of me, and he'll tell the whole United States what's happened. You become a 'centenarian,' that's what they call you! I can spell it. I can say it. I'll become it—and then, I guess you're the same person you were when you were ninety-nine years and 364 days; now, you're ninety-nine years and 366 days, meaning a hundred years and one day! If the big man in the sky still wants me to hang around here longer, I could start the climb of another decade, I suppose. A hundred and one, a hundred and two—hey, there's just so long anyone can hang on! I hear tell the oldest person who ever lived was over a hundred and fifteen, and the oldest person now [1990] in America is over a hundred and ten, but you know, it's all talk and hearsay. I haven't got an encyclopedia here, and my eyes don't work well for reading—that's why I love it when those students come and read to me from magazines and the newspaper. I can watch television and see the world, but not the fine print! The kids tell me how lucky I am, that I can watch television. But I don't like it much.

I was brought up on the radio—that way, you could use your imagination. You could visualize what you've heard—it was all up to you. Sometimes, I'll be 'watching' TV, but if truth be told, I've closed my eyes! I'm turning it into a radio! I have to sit *very* close, because I can't hear too well. I have a hearing aid in each of my ears, and they work 'a mite.' That's what my dad used to say: 'a mite' means a little! When the students sit near and read, I feel the best I'll ever feel: it's the high-water mark of the week for me—human voices speaking to me, telling me what's happening in the world!"

He stops for air and water. He asks a favor, some apple juice from the refrigerator. He goes into a rather extended and detailed account of what happened to that refrigerator a few weeks ago—a leak in the ice cube–making section of it. He remembers the man who came to fix the leak; he had been a plumber, and now he worked on appliances of various kinds. They had enjoyed what he felicitously calls a "nice visit." After the man left, though, there was this development: "I got really sad. I was actually crying! At first, I didn't know why. At my age, you know, there's always senility to scare you—it could come any day, any way (I once heard!), so I thought I was getting emotional for no reason, and that meant I was beginning to lose it. I'm alone here, I thought, my wife long gone, my two kids gone, the one grandson [of the four married grandchildren] across the country, and he doesn't care about me, nor even his own kids, I hear. [He is divorced, sees little of his former family, and has not remarried.] I took to thinking: what a *blessing*, if I was just to die quick and fast, here in this chair! A blessing to the world, not just me!"

He stops, almost as if he himself doesn't quite get the drift of his own comments, as they rather freely flow forth. He talks about *that*, his tendency to "wander a bit," as he speaks. He tells me that, actually, he was always such a talker: too vigorous, perhaps; apt to let his mind move from subject to subject with no great effort at organizational control. He interrupts, ironically, his speech on his disorganized manner of speech,

to let me know that he had forgotten "to finish his week." I am at a loss as to his meaning. He gets impatient with my apparent forgetfulness! Wasn't he, a while back, telling me how he spends each day of the week, and didn't he stop at Thursday, maybe Friday? Yes, I say—and he can tell that I'm not desperate to hear about the last two or three days. Still, he wants to finish his train of thought—hence, this: "It's all the same, days coming, and then leaving, and then returning; nights arriving, and taking over everything, and then losing their hold and being sent away by young Mr. Sun, but then he becomes a tired and old Mr. Sun, and he has to say *Kamarad*, the way the Germans did, in those trenches in France, on Armistice Day in 1918! When you have lived through all the days and all the nights I have, you sure know the routine pretty well. That's 365 times nearly 100: 36,500 days and nights. My Lord, think of all the grains of sand that have gone dropping down from the top part of the hourglass to the bottom!"

He stops to do such thinking, and seems quite absorbed in that effort. He is quiet for a long time, now, and when he is ready to talk, seems at a loss for words, to the point that his mouth moves ever so lightly (a warm-up for action), but he says nothing. I get ready to speak, then he makes that effort unnecessary: "I was just thinking, my voice has been going for almost a century, and it must be as tired as the rest of me is! You ask what I think about, sitting here. Well, it's this: there were the old days, when my body worked, and nowadays, every single part of me is moaning and groaning, and saying how long, Lord, how long, but the whole of me, I guess you could say, is still plugging along; and so, you know, I'll get reflective every once in a while, I'll ask myself—I'll ask myself *why*?

"My answer [he'd hesitated, and I felt compelled to do the obvious, repeat the one-worded question he had just posed for himself]: I don't truly have one! When you're young, when you're old, even, but you can use your body half-way normally, and your head is still working right—

well, you don't need to ask questions like that. You just keep going, like you always have. I want to tell you something. I believe people just assume they're going to be alive, until they die. That sounds silly, what I just said, but let me explain: when you're alive and kicking, even if you're eighty, you just meet and greet the day. My dad would tell me that when I was a boy: 'Son, meet and greet every day like it's your big chance!' But when you get ill, you stop and think. I recall having rheumatic heart disease, they called it, when I was a kid. I'm pretty sure that the doctors long ago licked it, with their penicillin. But in those days, it was a bad one; it could be a killer. I was in bed for weeks, and I could tell, looking at my mother's eyes, when she'd come into my bedroom, bringing me a tray of food, I could just read those eyes: this boy could up and leave us, he could die of this disease!

"That was the first time in my life that I *ever* thought of death. I mean, I *knew* about it, that you die some day: we had a dog that died when I was five, I think, and I still have his name there, stored up in my old head, where I can call it and it comes to me: Blacky! (You see—for me to do that, means I'm not yet senile, I guess!) Anyway, when I was sick there, just lying in bed, and to get up and go to the bathroom was a real big deal, and taking all those aspirin to fight the fever (that's all they had then, the doctors), it was death that was on my mind. I was not yet ten (a tenth of this life I've lived!) and there I was, thinking that this body I had might just stop: that was the word that kept coming to me, that I'd *stop*. I never went much further, though I think that was pretty far to go: the idea that you won't be continuing any more! Once, though, I did—when my mother was sitting on the bed, taking my temperature with the family thermometer we had. She looked real tired, and she was worried sick over me, I knew it. When she took the thermometer out of my mouth, and I can see her doing it now: reading it, looking at me, as though to compare the number she saw with how I looked, then shaking the thing down, to be ready for the next time—well, I guess I must have

had a high one, maybe 103 degrees or 104, it went way up like that in the afternoons. It was then that I asked her: 'Mom, could I die of this?' I could see her hesitate just a second, before answering me—and you know, with all the millions and millions of seconds I've lived through, in this gift of a long life, I can remember that one second better than almost all the other ones, maybe because it's the second that told me: you're here now, but one of these days you'll be departing, and you should know that, because that's the big truth of things!

"Mom told me, *sure*, I'd make it, and not to worry—but I'd read her thinking, and I think she knew I had: it was all in my eyes, and in her eyes. You know, a lot is said without words in this life: when you look at someone and someone looks at you, a lot can be communicated! When she left, I just lay there in bed, thinking away. I talked to myself: I said, you could just go to sleep, and never wake up. That's what death is! *You* could be gone, though your body would be left behind. People would come and take the body and bury it somewhere, and they'd all be sad, but you wouldn't be, because you'd be gone. There'd be no *you* to be sad! I can remember myself thinking that, having that thought in my mind, and I wasn't scared, I truly wasn't. Maybe I was, but I sure didn't know I was—so, I wasn't!"

He stops for water and rest. His eyes are teary. He pulls a Kleenex out of a nearby box and uses it. He explains to me that thinking of his mother—*that* was what had got him "all choked up." He looks past me to a picture he'd had with him his whole life, one his mother put in his room when he was a little boy, that of a lone Indian sitting on a horse, the horse's head, the rider's head both turned down. He stares long and hard at that picture, tells me he forgets to look at it sometimes, only to catch himself up, and give it the attention it deserves: the only physical link between him and his childhood. He is in a spell of remembrance now, and shares some of it in talk, but mostly wants to sit and think and let those vocal chords rest. When he feels stronger, he goes back to what

he has said earlier, presented just above: it clearly represents his rock-bottom notion of what death is, and clearly, also, is a testimony of sorts that has great meaning for him at this late time of his life, as he soon makes clear: "You know, for me 'life' is being here, in this chair, in this room, and thinking about leaving! I guess it's every day, now, that I do it, think about leaving, just like I did back then, ninety years ago. If someone wanted to know what's on my mind (when anything is on it!), I'd answer, 'Thinking about leaving.' Oh, sure, lots of the day, it's given over to 'routines': getting up, getting into the chair, getting out of it, taking food, going to the bathroom, listening to the television, talking with the nurse and the homemaker (and you), going to bed, all that. But when I do go [to bed], especially, and when I wake up—both those times, more than any other—I'll be thinking to myself: you're here now, but it's near the end of your being here, and maybe this is it, the big day: when you stop being here, and that will be that!"

He pats his right knee with his right hand, as vigorously as he can. So doing, pain registers in that hand, and on his face. He reaches for some water with his left hand, sips from the glass, puts it down, gently covers the hand that hurts with the other hand. Now, pain becomes very much the subject on his mind. He fidgets in his chair. He seems uncomfortable all over, not just with respect to his hand. He shakes his head. He looks across the room to the television set, which is not turned on—indeed, I have never seen it at work during my visits. He stares rather long at the screen, maybe ten seconds, then directs his gaze at his ailing hand. Soon we are talking about that hand, about the television set, about his life—and that of a younger brother, whom he has rarely mentioned, but who now appears prominently in a long spell of introspection: "This is the way I live—if that is the word for what goes on! I have to remember to be careful about every little thing I do! To slap my knee—it becomes a dangerous move! I hate feeling sorry for myself, but I've been accumulating more and more reasons [to do so]. It's living with trouble, lots of

trouble, that's what old age is all about. As soon as I wake up, I think of pain, because it's there, in some part of my body. I have pains in my joints and my back. I have pain in my prostrate, and when I urinate, it's—god-awful! I have pain when I breathe, and I've broken ribs, from just moving around, so I have pain in my chest, even when I hold my breath for a second or two. I get stomach cramps all the time, and it hurts me to swallow. It's a damn miracle I'm here talking—or is it a curse? I apologize, I do."

He has stopped talking, but he clearly wants to continue, and does so with no necessary encouragement from me (in fact, I am made uncomfortable by what I have heard, and worry about the agitation that comes with the topic under discussion). "That television," he declares with some mix of scorn and preoccupation, "it's just waiting for me." I'm not sure what he has in mind, and he is alert enough to see my perplexity—and so, the explanation: "Sometimes, I feel it's so sad, sitting here and waiting to see myself on television at 7:15 one morning [the *Today* show], and trying to get through another day of hurting—so sad, I pray the heart will get really tired, and just plain give out. I think to myself, a lot. I ask myself *why*—what does it mean, that I'm still here? Is there a reason? I get so upset thinking like that—I try to stop. I can't always, though. I mean, I know the answer—there's no reason: it's the luck of the draw. That's what I tell everyone who comes here and helps me, and they want to know the 'secret' of it—why I lasted this long. Hell, there's no secret; it's just how it turned out.

"Look at my kid brother—he's been gone thirty-five years, actually. You know, he was born in 1900, that was a special year. I remember my mom saying: 'Tim will live to be one hundred, and he'll greet the year 2000, *think* of it! She explained to us that the year 2000 will be more special than the year 1900, because it'll be two thousand years, even, since Jesus Christ was born. A big birthday! We all thought Tim was special—he welcomed in a new century. He was born on February 1, and

my mother always said she wished he'd been born on January 1, then he'd be the baby of the century down to the *day*! My dad kept telling her the new century didn't start until 1901—but she got really irritated with him, and said it's *nineteen* hundred, no more 'eighteen years' left, so it was a new century so far as she was concerned! Of course, every time Tim had a birthday, it coincided with the year it was in this new century, and so we all thought he was special, real special. I remember when he turned fifty, in 1950—we spoke on the phone (he was living in Texas, then, Houston), and he said to me, 'Fifty down, fifty to go.' I remember what I said: 'Tim, I know you'll make it—you'll be there to say happy birthday to the year 2000, and we'll all be long gone by then,' meaning me and our sister and my wife and my brother-in-law and everyone else. (Tim's wife was sick, even back then, and we knew she'd be gone in a few years: cancer.) He really did believe he'd live to be a hundred—oh, he'd laugh and say no, no, no, but I could tell, he thought he had a big chance: it was as if the good Lord had picked him out for some special purpose, something to do that would really mean something!

"When he called up to tell me the news, that he'd had this tightening in his chest, and it was getting harder and harder to swallow, and he'd vomited up a load, and he'd gone to the doctor, and it was bad trouble, cancer of the esophagus, and there's nothing they can do, because the chemotherapy doesn't help much—you know, I hate to admit it, but the first thing that came to me (I never mentioned it to Tim) was that he wasn't going to live to be a hundred after all, not even seventy, it looked like, the three score and ten you hear those ministers talking about. When Tim died (he only lasted six months from the diagnosis to the end of his life)—oh, my Lord, it was painful, painful, and he just wasted away to nothing, nothing. Well, there I am, remembering it again, what our mother told us."

He is shaking his head, and he is clasping his hands together, tight as he can manage. I see his legs cross one another—I realize how upset he

is, no matter the decades that have passed since his brother's passing. He continues, shaking his head, all the while looking down at his knees—until, finally, something crosses his mind, even as he uncrosses his legs, disengages one hand from the other, so that he can raise his right hand a bit (he has obvious, limited motion of his arm) and point with his forefinger toward the television set: "You see, there's where I guess I'll soon be, my picture on the screen. The nurse said the other day, 'No way anyone can stop you!' I said, you tell that to the good Lord, and you tell that to my heart—it's barely working, even with all the pills I take, and my lungs, and the whole body, what a touch-and-go life this is, the last time of it here! She told me I was sounding 'depressed,' and that's no good for me. I laughed—and then my ribs hurt, and my lungs, and my mouth and my neck. All I have to do is try to act like someone who is really alive, and my body will react and say, 'Hey there, you're not really alive at all, you're just a semi-mummy, like the kind you see in a museum, from way back in Egypt, maybe, only you're one from the U.S. of A., and you're in a wheelchair, not sitting on some bench they made in Cairo a couple of thousand years ago!' Well, that nurse (she's very nice to me, all the time, she is) told me I might need to take another pill, if I didn't watch out, to 'settle my nerves!' 'Honey,' I told her, 'I don't have any nerves left—I'm just this skeleton, with some skin over it, and I'm gone, but I talk, and that's about it!' She went and prepared me some Cream of Wheat; she knows that's my favorite of everything I eat, and she said she wasn't supposed to do that (there's a lady who comes here and cooks food for me, besides the homemaker). So, I laughed, and I said, 'Now I know how to get me some nice warm cereal for lunch on Mondays.'"

He is feeling better, now—Tim's life has come and gone in our conversation, I think to myself, a dark cloud to someone who keeps emphasizing how hazardous the weather is, the roads are, of his "so-called life," that phrase, "so-called," occasionally used as an incisive and ironic (or

sardonic) statement. Still, there is sun out, as he would notice a half hour later: it shone brightly on him, and he introduced it as a welcome presence, an antidote to his melancholy mood, which commonly yields to a certain hopefulness—a state of mind that, however, almost seems to embarrass him by its appearance: "I wish I could go out and enjoy that sunshine, but look at me, I'm a prisoner, and I don't have visiting privileges with the outside world, not in the winter, anyway. I'll admit, I perk up when I at least can *see* the sun, even if it doesn't warm me up. That sun never does give up, does it! I'll be sitting here, and its a rainy day; I just look at the rain pouring down, and I think: this is the kind of a day for me to die—just right for that! Then, the sun will come out, the next day, and I want to clap, and say: you keep going, so I guess the rest of us can keep going, too! Of course, the sun will last for billions of years, I guess. It'll die, too—everything does. Get to my age, and you think like that!"

He is smiling at himself—amused, it seems, by his dark humor as it finds expression. Suddenly, he is ready to leave himself, as it were, think of others, all the people who don't weigh down the weather, the sun, the world of nature, with their own particular anxieties or apprehensions. He apologizes profusely for what he calls his "death talk"; he says he has a hard time getting rid of such thoughts—even as he is sure that there are "folks" who are his age, "out there," who are more "optimistic" than he is. He then becomes philosophical and psychological, both, speculates on why some people go through old age with equanimity and even pleasure, no matter, even, the ailments that besiege them, whereas others (such as himself) are always "looking on the downside of things." As he sees it, one's earlier "disposition" (a nice word, I think, as he uses it) prevails "right to the end." For him, philosophy follows psychology, which in turn follows biology. Put differently, a constitutional inclination lasts "right to the end."

In that regard, he gets surprisingly specific, though not in a lugubri-

ous way—indeed, he is bemused, his voice sprightly, as he contemplates his last moments, and those of others he has known: "I'll be seeing the Devil, I'm sure, when I die, if I'm conscious! Maybe, I'll be seeing some masked robber, who comes with a burlap bag, and stuffs you in it, and hauls you away—your soul, if you have one; I mean if there is one! My brother, Tim, he probably was humming a tune when he died. He was an amateur musician; he played the piano—I'll bet he had music in his ears, even if he was in bad pain, and all wasted at the end, the day he went. My wife, she was like Tim. She loved to whistle. Back then, women weren't supposed to whistle, polite women. That's how I was brought up to think! Well, she did, anyway, and I loved it, hearing her whistle the songs, like that "Three o'Clock in the Morning"—I'll bet you never heard of that song. [I shake my head.] That's a hard song to sing, never mind whistle! She died in the middle of the night, almost at three o'clock, it was two-fifteen to be exact. I remember thinking: she almost made it to the time of her favorite song! She was asleep, and her heart gave out, so I guess she wasn't thinking of anything! I've thought to myself a lot: would you like to leave awake and knowing what's happening, or be asleep or in some coma, so you won't know anything? There will be one day, I'm for being awake, and the next, I'm for being 'gone' already [asleep]. Well, you can see what it's like for *me*, to be almost a hundred! I'm eyeing it [that birthday], and I hope I make it, since I've come this far, already, but I'll let you in on a secret: every time I picture the day I turn that age, I get a sinking feeling right square in my stomach. I think—that will be the end, the real end, for me, because then I'll have nothing to be waiting for: the big goal, I'll have got there. So, I dread being a hundred, plus one day, that first day afterwards, and the few that will follow it. I'm not one of these people who will live to a hundred and five, I can tell you that!"

I try to figure out whether those last words, that last sentence, is spoken in playful jest, with some irony, or in dead seriousness. I scan his

face. I listen to his further remarks, about the kind of cake his caretakers have promised him: no clue. I decide that, in fact, he has already given me my answer: his quick-changing moods, his capacity to be amused and amusing, his capacity, too, for a kind of wry self-observation; but also, his times of quite serious sadness—as if the burden of a century has just about knocked him out, though he is still in that proverbial ring, stumbling and barely conscious and ready, quite ready to fall, but not yet, strangely enough, not yet.

4. *The Dancer*

At eighty-three she had been called an alcoholic, much to the surprise of her only daughter, who was then fifty-five and a pediatrician, with a husband who was also a pediatrician, and whose only son had become a pediatrician. The daughter, Sally, told me that her mother, Anne, had never liked alcohol much all through her long life. She had served wine only occasionally, had shunned hard liquor. Most of her energies had been given over to taking care of her home, her husband, and when their only daughter grew up, the Episcopal church to which she belonged: she lavished attention on it, insisted upon bringing flowers to it, weekly, exerted herself (an act of humility) in the Sunday school classrooms to straighten things out. She arranged the chairs for the children, scrubbed the blackboards clean, tidied up the toy closets so that the boys and girls would have access to particular games, rather than a jumble of all of them, hard to penetrate or figure out. Yet, two years after her husband, Carl, died of what she called an "overwhelming stroke," which took him in "maybe five minutes," though he'd "never really been sick before in his entire life"—it was then that various individuals urged her to go see a "counselor," or at least, to level with the beloved Episcopal rector of her church who, after all, had no small acquaintance with "people who drink too much for their own good," the

way Sally put it when speaking of her mother's "problem" during the early months of its public emergence.

Of course, all who had worried about Anne after her husband's death knew to say, later, that she must have started "sneak drinking" at that time, and must have done so "for months." When I talked with Anne herself, she had stopped drinking "completely," and as she put it, gathering herself up with some conviction, "irrevocably." Yet, a year earlier, as she was the first to admit, her "prognosis" had been "very poor." When she reviewed the last few years of her life (as she put it, "the first four of the eighties") she was still ready to call herself "surprised" by all that had happened. They were, she added, "busy years"—a contrast to the "quiet ones" that preceded them, her sixties and seventies, say. Here is what she intends by drawing that distinction: "For the longest time I was a 'housewife.' When I hear that word mentioned, I say: I know what it means, every letter of it! I hope I don't sound bitter. Maybe, I'm bitter because it's over—I can't be a housewife; maybe I really was happy then, and now that it's over, I'm living a 'second-best' life, and I'm trying to make the best of it, *think* the best of it. I do remember, back then, thinking I was a 'bird in a gilded cage,' I do. Maybe I was a *happy* bird, but I was so *protected*. When my husband died, the roof fell in—I wasn't just devastated; I felt I'd lost *my* life. He was gone, and (I don't know how to say it!) I was gone, too! That's what I kept thinking, even during the funeral. I said, Carl, you're leaving us, and I'm going with you, I'm sure of it: this is *our* funeral. You know, it *was*—the end of a life we'd both built. I was left here, my body was, but my mind was so tied to him, and to the world we'd built together, that I didn't know what to do, but sleep and eat and go through the motions of being alive, but not really being: that's it, *not being*, not being an individual.

"I know they say I'm an 'alcoholic,' and 'once an alcoholic, always one'—but to me, alcohol was a way for an old, old lady to kill time. That's what I'd think, when I sat there drinking: you're left here, and

there's nothing for you to do but kill time with this stuff. You're *not* here—that's what I really felt: I was gone, and this body was here, and it was best to knock it out each day. I know—that all means I was 'depressed.' The minister came to see me, and told me I had a 'reactive depression.' I asked him what *that* means, and he said I was still grieving, after Carl's death. I said, 'No, you don't understand: I'm not here anymore, either! I'm not "grieving," I'm gone!' Well, he sure looked at me very carefully, then! I could see him worrying if poor, nice old Anne was taking leave of her mind, and so ought go to that 'retirement home' the Episcopal church runs for 'the elderly who are having a hard time managing on their own'—I know the words by heart, so I guess I don't have Alzheimer's! But it sure was 'hard'—to get my thoughts across. Here was this minister who I'd known for twenty years, and he really didn't understand what I was trying to tell him. He was thinking of me as though I was a *patient*, someone who wasn't getting over her 'period of mourning' as fast as she should! He kept using those words, until I finally spoke up, thanks to a little wine in me—you know, alcohol isn't *all* bad! I said, look—look at *me*, not this 'period of mourning' I'm supposed to be over with by now. Carl and I were one person—just as two people are supposed to be, to become, when they've got a good, strong marriage. When he left, I wasn't just left, I was taken away, too: more than the rug got pulled out, you know! I was getting angry, and he saw that, and I did begin to realize that I was a problem for *him*, just as I was for my daughter, even if I didn't think of myself as a problem for anyone—because I thought of myself as someone who was gone, not *here*, making trouble for people!"

She is quite aroused, quite anxious, still, to be understood. She is speaking in an existentialist tradition, and resents the imposition of a psychiatric nomenclature (and not so subtly, a moral judgment) upon her recent life. Still, she acknowledges a present distance from that immediate past, and she also is delighted with her day-to-day life, which has

given her "a real boost." I don't quibble with her psychologically; I don't try to confront her with her own implicit acknowledgment that maybe she was, indeed, going through a down spell. She told me she'd been "a ghost" for a while, but now she was "back"—and whether she'd returned from a world beyond our knowing, or had snapped out of a clinical depression, a bout of melancholy, she was now unarguably very much among the living, and by her account, it was an individual she never met (never could meet, because he died years ago) to whom she owes her present vigorous existence: "I used to love those Fred Astaire–Ginger Rogers movies—they got us all through the terrible thirties, when so many people really needed a lift! I never thought the day would come that Fred Astaire would return to help me personally! No, he's gone, I know that—don't think I'm senile! [She had seen a quizzical look cross my face, unwittingly.] I never thought I'd be dancing to his music and learning to be a Ginger Rogers!"

She stops to laugh, to assure me that she's being "a little funny," that she's (again) not some "old lady who is going soft upstairs." She becomes quite factual, lets me know how she became involved—at a dance studio, with a "Fred Astaire program," to the point that she has become a rather experienced "ballroom dancer," she calls herself. She tells me, also, about the kind of dancing she does: the fox-trot especially, the waltz, the samba, and variations on all of them. She hopes that I won't think she is "making a fool" of herself—a worry, I am told, that crossed the mind of her daughter and son-in-law, and her grandson. They are all doctors and they feared that she would "overexert" herself, or worse, "fall and break a hip." She already has "one artificial hip" and will probably need another one soon—but not, they hope, as a consequence of an injury!

Recently, her family has become "reassured." Recently, they have begun to see that dancing has not become an "obsession," but an expression —her effort, she tells me with some wry irony, to do the best she can with "this body" her husband left behind when he departed, her spirit

(her mind and heart) in apparent tow. Put differently, her dancing life is for her a resolution of a dilemma she faced during that "period of mourning." She explains: "Look, my daughter thinks I've 'recovered,' that's the word she uses—from drinking and depression, the two *d*s! Well, I'm glad I'm helping her to feel better!" The slightest pause there, and a knowing look directed at me, punctuated by a wink: talk about irony in this ordinary life! She resumes at a fast clip, tells me she is proud of herself for the way she stopped drinking, rather than for the fact that she did so. I listen to her with a veiled smugness, sure in my own mind that she is unaware of the anger that informs her defiance of the medical authority with which her family has confronted her—stop drinking, with the help of this or that "therapeutic program," or you will soon enough die. She said no to all that—and just when things seemed at their lowest ebb, she found her way to this present life: "I was driving my car—maybe for the last time, I thought. My license was expiring, and besides, my daughter was getting ready to take the car away from me, because I might drive it while 'under.' That's the word I was using for myself: I'm 'under'—and I meant it: 'under' a great cloud of sadness! I went for a drive that day, toward the ocean; I wanted to sit and stare at the waves coming in, even though it was a cold and cloudy November day [in New England]. I always liked to do that, sometimes alone, mostly with my husband. At the ocean, I stop to think about things! This time, I was playing some music—I love this station that has swing and jazz all day, the old torch songs: the music I grew up on! I sat there in the car. I remembered those 'ballroom days,' when my husband and I forgot our cares and worries—put on our dancing shoes and 'stepped out,' that was what we'd say, when we were telling people we'd been fox-trotting the night before: we'd 'stepped out.' Then I saw this ice cream parlor—I sure remembered it from years ago—and I stopped for a cone, and had my favorite, strawberry, and I was feeling good: nice memories were coming to me! Next, I was passing a building and saw the sign: Fred Astaire

Studio—and I just stopped and stared. On a whim I decided I should go inside and look, but I was scared—I was ashamed: an old lady like me! I was ashamed that I was even interested in something like that! I stayed in the car. I took off. I didn't even go to the movies, like I'd planned. I went right home and took one of my wine bottles out of hiding!

"A few days later, I was still remembering that drive, the songs I heard on the radio ('Poor Butterfly,' one of my all-time favorites, and 'Marie,' another one), and suddenly I had this urge to go to the kitchen and get the phone book and start *reading* it! I swear, I had no idea what I was looking for! I can remember flipping through the pages, the white ones, but no one's name came to my mind. I remember thinking that my reading glasses are failing me—I need stronger ones; and then I thought, no, I won't be around long enough to justify getting a new pair. Then, I was in the yellow-page section, sort of drifting through—and there it was: 'Dancing Instruction,' and this big ad, for a 'Fred Astaire program.' I still remember what the ad said—the words 'confidence and competence,' I think it was, but the phrase that really got to me was 'The tradition lives.' I thought—well, they wouldn't mind an old lady like me, because I'm part of that 'tradition.' They described the dancing they taught— 'ballroom' and 'social' and 'nightclub,' those were the three that caught my eye. They advertised the country-and-western kind, too—and I laughed: what would Fred Astaire think? Probably he'd smile—but I just couldn't for the life of me picture him and Ginger Rogers doing country-and-western dancing! I never would have made that call, though, if they didn't say [in the advertisement] 'No partner necessary.' You know, that phrase just stuck with me—it kept ringing in my ears! I know you'll make too much of that—my son-in-law did! But I tell you, I wasn't feeling lonely, and looking for someone! You don't replace a husband you've lived with a half century by going dancing! Do you know what entered my mind? I thought, I'll go get lessons, maybe, and, that way, I'll feel *closer* to my Carl, not on the hunt for someone to replace him with! I

thought of him smiling somewhere. (I just can't picture what happens to you when you die, whether that's the end, period, or you go someplace —but where, and what are you like, in what form are you? It's all too much for me to think about, or certainly, talk about!) In my mind, while I'm here, Carl is here, too—my thinking about him makes him here! I can hear his voice—I could hear him that day, saying, 'Go ahead, darling, call them; you can go in the afternoon, because they're open, it says, from one o'clock on, and I know you won't want to go in the evening, because you get sleepy.' It was then, hearing him, that I called. But I hung up when they answered!"

She struggled for days over the matter. She kept the phone book open, on her kitchen table, kept coming over to look at the advertisement, until she knew it by heart (a considerable achievement, she points out, for "someone over eighty"). Finally, she picked up the phone, again, started dialing the number, but hung up that time even before she'd punched all the necessary digits. Several times afterward she did dial the full number, only to hang up when someone answered. She was sure, thereafter, that she was known to those who answered the phone at the studio—even as she realized, simultaneously, that such was not the case at all. One afternoon, after watching one of her television soaps, *Against the Storm*, she found herself sitting in a living-room chair, staring at the floor, a bottle of wine very much on her mind. She could visualize the bottle, taste the stuff. She could smell the wine as she pictured herself pouring one glass full, another. She could feel the immediate, fast-growing warmth in her body, the pleasantly dizzy feeling that came over her. She could see a package of cigarettes on the table, could imagine herself taking one out, putting it in her mouth, lighting up, taking in the smoke, and thereafter, the joy of it, the charge of the nicotine hitting her head. Booze and tobacco: a great high leap—but then, the collapse; and then, the desire to take more of the same, lest she go lower and lower.

Her father had once told her that nothing is free, and that wisdom

haunted her, a woman in her early eighties, a widow, as she sat there struggling, in her own fashion, "against the storm" of her various worries, desires. She had yet to get a firm grasp on her financial situation: she had enough money, more than enough, to live a comfortable life indefinitely, but her husband had been the one to keep tabs on their bank accounts, stocks, insurance policies. She drew a blank on the subject when her daughter or her investment counselor tried to talk with her. She had also failed to take responsibility for the house she and her husband had occupied for over forty years. Again, he had been the one to keep after things, to hire people to work on the inside or the outside, to keep track of what was wrong and needed immediately to be done, what was going wrong, but could be ignored for a while, and what ought be done preventatively, to keep trouble away. Now, she shunned such a relationship to a building, to the grounds outside it, the rooms inside it. She had sometimes imagined herself, in her worst moments, as a quite senile old lady, semi-paralyzed, sitting amidst considerable deterioration and decay, helpless and confused, but enjoying herself with butts and booze, a source of great frustration, irritation to others, "a terrible kind of thinking," she called it, but one that had some apparent appeal to her, because she admitted that she sometimes smiled as she constructed the fantasy!

But on that particular afternoon, she stood up to the seductions of cheap wine, of Chesterfields or Camels. She said no to a melodrama, a scene of chaos, with alarmed kin and neighbors as helpless witnesses (and accusers). Suddenly, she was on her feet, and soon thereafter, having paced about for a minute or so, she was on the phone. This time she did not hang up after a ring or two; did not hang up upon hearing a voice on the other end. This time she politely gave her name, made her inquiry, agreed to come in for an "interview," an "evaluation." This time she enabled herself to have a new burst of fantasies—herself dancing with Fred Astaire, for instance. Months later, by then a "regular" at the

Astaire Studio, and at dances it sponsored, she could still remember that afternoon—how delighted she was, how ashamed, also: "I sat there dreaming, I guess you'd call it. I was awake, but I was lost to another world: I'd taken Ginger Rogers's place! I never told anyone, not for the longest time, until I'd gotten used to being a student, again—a student of the Fred Astaire School of Dancing! There, I could be starstruck about this man who is already dead! But that afternoon, after I'd thought of myself as being his dancing partner, I had a small supper and went to bed. I felt as if I was losing my mind, and the best way to 'treat' it, was to go to sleep!"

It was not easy for her to show up for that first appointment, or to show up for the classes that followed. For the longest time, for several months, she wavered back and forth continually, one moment calling herself "silly," a "foolish old woman," an "empty head," the next moment delighting in the music she heard, in the instructors, who were very respectful and polite and considerate to her, and most of all, in the dancing itself, which gave her, she felt, both a "workout" and a sense of achievement, her body newly agile and capable and responsive. Any time that latter point of view surfaced, she was quick to make clear that she was not being fatuous, or as she often put it, that she was not "going through a second, and *very* late adolescence!" She wasn't, either, pushing herself into dancing modes that would be, she firmly believed, "unbecoming" to her. She kept, mainly, to the fox-trot, her favorite—became quite proficient at it. She loved the waltz, but it was exhausting for her, its movements too fast, its demand on her bodily coordination too extreme. Similarly with the polka, and the Charleston—she loved watching others do the latter, and she daydreamed that she was an experienced Charleston dancer who made that effort with Fred Astaire, and with her favorite instructor, Harold, who was about forty-five, and got along well with people twenty years his junior or senior, and even, she laughingly observed, with people "a hundred years older than him," such as herself!

Dancing had become her passion. She danced at the studio, of course, and at the social functions it sponsored, but more than anywhere else, she danced at home, alone. In the kitchen, especially, with its imitation tile floor, she glided here and there, mostly in a circle around the table where she ate. She took to singing out loud, supplying her own music to her solo performances—all the while, in her mind, conjuring up a partner: the ever-available Fred Astaire, of course, her husband Carl, and some men she knew in the past, all husbands of her (four closest) friends, and all now "gone," the word that she used when speaking of someone's departure by virtue of death. She danced elsewhere by herself—in her bedroom, after dressing, and in the living room, while listening to the old 78 RPM records which, of course, supplied ideal music for her efforts: Tommy Dorsey and Benny Goodman and Glenn Miller especially, her favorites back then, and in the early 1990s, a half a century later, still her favorites. She had never forgotten, in fact, the day news came of Miller's death, in an airplane crash, during the Second World War. Now she thought of him, even was so bold as to have him as a partner, as she danced to (in her mind) a slow version of "Moonlight Serenade," a song that could bring tears to her eyes—happy tears, though.

Dancing had turned into an enactment of her capacity, late in life, to remember its best moments, to hold on to them, as she once put it, "until the very end." True, she would sometimes trouble herself with far less joyful thoughts—ones that had her not dancing, but bed-bound by virtue of a stroke. She tried to banish such gloomy times with music, with a few reassuring "steps" that signified a body limber (within the confines of her age) and quite skilled in keeping time, in moving rhythmically, smoothly, gracefully. Mostly, it worked—her "upbeat thoughts," as she called them, the victor over her "downbeat ones." Every once in a while, though, to use her descriptive sequence, the words to the music caught hold of her, the often melancholy lyrics, to the point that she got captured by them; she didn't dance—she only felt sad, then sadder, then

"really sad." Now, the wine bottle and the pack of cigarettes returned to haunt her, to unnerve her, to turn her into a quite scared person who, in desperation, fled to her bed, no matter the time of day. During such moments, she refused to answer the phone; she stayed under the covers; she announced to herself that she was "practicing" for the time when she'd be an invalid, a destiny she was absolutely sure awaited her soon enough, anyway. Such retreats to the bedroom lasted for the better part of a day, never longer. She had a "cold," she would tell people—and accurately: "I get chills, then—a feeling I'm about to die! No, it's not my temperature [I had asked], it's this realization that I'm only a few steps from the grave." A second's interruption of her narrative momentum, and then this blend of dread and humor: "I guess that will be my last dance—and I can get frightened beyond belief of it, one day, and the next, I'm calm, even curious about it all: the dance to the grave! Here I am, old enough to fall down one day and never wake up, because I've had a coronary, or a stroke—and I'm humming those love songs, and moving my body, one, two, three, one, two, three, one, two, three, four, one, two, three, four. Can you figure it out? I ask myself that, and I answer myself: it's not for any of us to figure it all out! Anyone who claims to have found the right answer about life—what it means and how you should act while you're here, I'd like to meet that person!"

Such times of metaphysical anxiety ground her—slow her down, give her just enough second thoughts and apprehensions to prevent her from becoming (again and again she worries about it) "silly," that hard-hitting swearword in her vocabulary. She has met elderly people whom she considers "silly," meaning, they "act like schoolchildren, when really, they are the grandparents of them, even the great-grandparents." Moreover, she recognizes quite astutely and consciously, music can be like liquor: it can lift you up high, drop you down low; it can go to your head, carry you away, sever the bonds between you and the ongoing reality of this life. She knows; she has been tempted; she has to be wary: "I'll be danc-

ing, and I'll be listening to some wonderful song, 'Taking a Chance on Love,' or 'The Song Is You,' or 'I Can Weather the Storm,' and I forget so much—I forget *too* much! I think I'm a 'spring chicken,' and I think I'll keep going until I'm two hundred! It all becomes unreal, I'm afraid. So, my dancing isn't 'the answer,' either!"

Her dancing gave her *that* answer—helped her not only rescue herself from a couple of serious, life-threatening addictions, but helped her to think about important personal matters as her time here neared its end. The all-too-easy interpretation of the role dancing played in her life was always offered (to her, or by others, speaking of her) with reference to loneliness: the Fred Astaire Studio came to the rescue of a "clinically depressed octogenarian," what her doctor had written on her chart when she came to see him for severe headaches and constant gastrointestinal pain, both secondary (of course) to "a rising intake of ethanol." Her daughter told her she was ready to contribute financially to the Fred Astaire system—it deserves psychiatric recognition! Perhaps she could establish a fund for poor people like her mother who needed what dancing did for her, but lacked the means to follow (literally) in her footsteps! But she herself had no use for such a way of seeing things. She felt *lonelier* as well as happier while dancing, especially to the music of certain songs. An impressive capacity for ambiguity informed some of her introspective consideration of what she refused to call a hobby or an "interest." Not that she had an alternative, descriptive suggestion. "I don't like hearing people talk about the dancing I do as if I was in some 'vocational rehabilitation program,' or I was doing 'occupational therapy'! I'm overreacting, I know, but there's something very serious about all this (for me) and yet I have a hard time putting it all in words, so why shouldn't others not know what to make of me and my 'new hobby' (they call it, with admiration). I will admit, I get quite upset with them, when they talk like that! I can't explain to them that this is no 'hobby'; this is hard work—on my body and on my mind! I tire so quickly—I do a dance, and then

I have to rest. Maybe two or three dances, and that's *it*, for the whole day! But, I've *done* something—don't you see!"

She stops to look right into my face, to wonder in connection with me, perhaps, what she has wondered out loud rhetorically—whether any of us quite "see" what she is getting at, as she goes about her last years on those dance floors. After our eyes have met, and I have tried to figure what I do "see," or better, whether I am seeing the vision she has found for herself (not to be confused, that last objective, with interpreting her "behavior" in accordance with my own tenets, or, if they are worthy of the word, my own vision)—after such an interior rumble and tumble, I nod without saying anything, and she is quick to nod back gratefully: if you get it, I'm glad!

She is sitting at an odd angle, I notice, both her knees pointed left-ward, her feet wrapped under them, and almost tucked into the space underneath the wide-armed chair, whose comforts her own arms, wrapped around her midriff, are forever stoically resisting. I decide to switch to a broader line of inquiry: I ask her how the dancing affects her other activities—whether they are reduced, now, given all she puts into her pursuit of Mr. Astaire. She has, after all, just told me that this is no easy job, that of being a late-in-life dancing activist. She tells me quite directly what she has already more than suggested; that there is a price to pay, a saying that pops into my head, apparently out of nowhere, as I remember my mother's voice while I hear this lady talk—she who is about my mother's age when she first took sick for the last time: "I have a million, zillion ideas of what I'd like to do when I first wake up. I don't know how you people define old age, but if it means you've lost your imagination, then please count me out! I think I have more ideas and plans now than I've ever had—last things to do before I take my last breath! The trouble is—doing them all, even getting *near* to doing them all: that's the big challenge. When I wake up I start thinking of the day ahead. I let my mind go all over the place for a while, but then I say

whoah! I reign in those horses! I say: I'm doddering, that's what I am—so, give me a break! I'm talking to myself—to my swollen head, with its big dreams! Pretty soon, I'm down to a few things I've *got* to do (shopping, filling up the car with gas) and then there's my dancing! Don't think, though, that I just get it all accomplished, easy as pie!"

Abruptly, she stops talking. She straightens out her knees, and at the same time pulls her feet out so they are directly under those knees, squirms a bit, registers with her face some clear discomfort. I want to say something, don't know whether I should (I am well aware of how irritated she can get with anyone whom she judges to be patronizing); so, I sit there with what I hope is a kindly, attentive look on my face. Finally, she begins to talk, the tone subdued, in keeping with the story told: "I've been told that I'm very lucky, that my hips are holding out! People my age say, 'The hips will make you or break you!' They say, 'If your hips goes, you'll go with them!' They say that for women, especially, it's dangerous to fall, because our bones aren't as strong as men's. Everyone over eighty should be 'thinking from the hip'—my cousin wrote to me. She's my age. I wrote back and said, 'I'm well over eighty and I never, ever think of my hips!' I was shooting from the hip! Today, though, I *am* 'thinking from the hip': yesterday I tried a *little* of that Charleston dance (I love it so much!), and something told me I had to stop almost before I started. First it was my knees, they didn't cooperate; then my ankles—and then my brain kicked in: it said, for the sake of the Lord Almighty, give yourself a break and keep to the fox-trot! But, for a while, I kept with that Charleston—and now I'm just plain stiff all over!

"Finally, I admitted I just wasn't up to it, and you know, the instructor, he was *so* relieved! I think they don't know what to do with me—they love having me there, and they've been telling all their customers to send over any elderly people they know, because if *I* can do it, so can they. The head [of the studio] even asked me if I want to work for them! Can you believe it—I'd be their 'representative' with the old folks, if any

of them ever do show up! I'd talk with them and make them feel at home: show them what I've done, and encourage them to aim high! I almost said yes, and then I thought: wait a minute! I'm doing this to challenge myself; and I'm doing it because I love, love, love the music, and love moving in company with the music, doing my own kind of music, body music, I guess you could call it. If I start working for them, I'd be waking up and that's all I'd be thinking: I've *got* to go to the studio, because I'm getting a salary; and I've *got* to talk with these people, and dance with them, because it's my job—no sir, I said, no sir. I did agree at first—I'm a sucker for flattery; I agreed when the manager asked me. But I called him the next morning and said I'd thought it all over, and I'd just as soon remain one of his good customers!"

She is still squirming a bit, and she is visibly more tired than she was even ten or fifteen minutes ago. I want to volunteer to go get some water for her, or a cold drink from her icebox, which is filled with them, I know, from many past visits. But she is struggling not only with her body, but with her head—she wants to sit there and continue our conversation. Soon enough, she resumes; she informs me that she has "wandered off the track," that she hasn't let me know why she is, then and there, so "uncomfortable." I perk up: the doctor as well as the interested guest in me; and she notices—the potential patient, maybe, with a keen eye for these people whose job it is to try to be of assistance to others. She kids with me, asks me if I know my "orthopedic surgery." Hardly at all, I admit. She knows that to be the case, of course—and then, with great amusement, she tells me that precisely because I *don't* know "the subspecialty," she'll trust me enough to tell me this: her leg muscles, "up and down," "from my toes to my thigh," are hurting her, and she is worried that she will have to take a break, maybe a long break, from doing any dancing, never mind attempting a five-minute return to the Charleston.

As she talks, her body goes into a noticeable slump. She seems older

than old—and I begin to worry. I start asking her questions—living up to the joke she has made about my medical background. The more I hear, about spasms and "tugs" on her muscles, her limbs, including her upper extremities, the more concerned I become. I remember enough of my medical school lessons to think not only of an immediate reaction to a dance, but of diseases that can prompt her symptoms, diseases that may well have been giving her some trouble *before* the Charleston incident, which is her marker, but may have only exacerbated what doctors call "a pre-existing condition." I think especially of Parkinson's disease—I have been seeing plenty of it, in various stages, as I do interviews with elderly men and women. She observes me observing, notes my reluctance to speak, wonders out loud what is crossing my mind. I tell her the truth, that I'm trying to think about what might be causing her the difficulties she is experiencing. She thereupon lets her guard down further, tells me she is definitely feeling weaker than she's felt "in some time," *and* that some of what she is now experiencing "could have begun" before that dancing studio episode. I note her way of putting things, conclude that she is telling me not what "could have" been the case, but what she has concluded *is* the case. I tell her—just what she expects me to convey: that a visit to a doctor is not a bad idea. She agrees.

A long silence, and then, a startling confidence granted me: "You know, if I *have* to be sick, I hope it's not something caused by my dancing. People have warned me that I could fall while dancing, and that would be terrible, but I've known from the start I wouldn't! If I'm getting sick now because I'm destined to get sick now, that's life! If I hurt myself while trying to do the Charleston, that would be a disappointment! I'll tell you why—it's been such a thrill for someone like me, an old lady nearing the end, to dance my way through these past months, and remember the years back, through those songs. I've enjoyed myself so very much. I'd hate to have all that pleasure turned against me: some doctor telling me and my family that I've been a bad, bad girl, and I've

got to act my age—I've heard plenty of talk like that during these last few years of my life, for one reason or another! I'd much rather be told, 'Look, you've got this illness, and it's going to require that you stop one thing, stop something else,' than be told to 'act my age.' I *am* acting my age—I'm trying to recall the good songs of my life, and remember all the good times I had; and I'm trying to end it all *gracefully*. That's what Fred Astaire and Ginger Rogers were all about—being *graceful*; and that's what the studio people tell you dancing does for you: it helps you to feel graceful, and to be graceful, in the way you act, on that [dance] floor."

A big sigh, a look of exasperation, and then a strong effort to raise herself up, which succeeds. Once standing, she seems stronger, no longer so vulnerable and frail. She looks at the floor, takes a single fox-trot step, laughs at the sight of the rug, hardly something on which one dances, proceeds toward the kitchen/dining-room area of her apartment. She will, indeed, go see a doctor, she tells me, and she is now ready to wager that she will be told that something *is* wrong with her, but not, she adds, as a consequence of the dancing she does: that is what is *right* with her! I nod, in my mind intending an ambiguous (or all-too-cautious, maybe cowardly) gesture: yes, she should go to a doctor, and yes, I understand what she is saying. I know, then and there, that she would like for the nod to have signified a larger agreement—an approval of the moral passion (so she meant it to be) that informed her comment. But I hadn't quite, then, comprehended fully the overall purport of those many discussions we'd been having about ballroom dancing: that activity as a final vocation of sorts for her, a manner of recall, of introspection, in the tradition of the music, and of self-presentation, of grace rendered—in the tradition of the dance.

Three weeks after that meeting, we would have another one—and now she would be able to tell me that she was, yes, happy: she does have Parkinson's disease, I would hear, though it is not yet serious. She soon

will be taking medication for it—*and* the doctors *suggest* exercise. They approve of her dancing as—well, just that: something that will help keep her limber, keep her from getting "rigid," a not rare consequence of the illness. She has "won," I am told—and after I stop funneling her words into my various psychiatric and psychoanalytic categories (such ironic talk of "winning," when connected to news of a major illness is surely a sign of "denial," of an underlying "depression," and on and on), I am ready to notice about her a certain calm, a certain self-satisfaction that avoids smugness. She has been battling an incipient illness, after having battled successfully an addiction, all the while dealing with a widow's realization that what was is not ever again to be—though, I stop and think, as a dancer she has managed to turn what was into what very much still is: those many learned steps, in their sum, very much a big step for her. On another visit, she told me about the opportunities and perils of a version of the samba she had tried, and told me, too, that she wished sometimes she *could* take that proffered job, help enlist other elderly people in an Astaire Studio program—but she had concluded that maybe one such enlistment, her own, was enough for her to have achieved, especially given the difficulty she had in managing that particular recruitment. In any event, now ailing, she'd keep giving her "all" to learning a few more steps, a few more dances, since "in a little while," she observed with a smile, she'd be "graduating from the Astaire school—and who knows if there will be any dancing where I'm headed!"

5. *Slow Time*

"Seventy-five and sick," he tells me—then lest I not take him seriously, he adds, tersely, gravely, "very." He has "hypertension," he lets me know, using that medical word; he has "coronary heart disease," again a medical phrase; he has diabetes, and it is the worst of the three ailments, because it interferes with his lifelong eating habits, takes away eating as the last joy of life, turns him into an all-too-self-conscious consumer of protein and complex carbohydrates and counted calories. In no time, after this enunciation of a body's impairment, vulnerability, he talks with ease and knowledge about his response as a patient to a situation that he knows is precarious, at best. The doctors, he tells me, want him to be in a nursing home, where he can be kept under closer medical surveillance than he alone can manage, or "so they think." That last phrase is utterly his—a sardonic qualifier that tells of his skepticism: "I've heard so many doctors tell me so many things—I just listen and wait for the next one to give me advice. Wait long enough, and they'll contradict each other."

A year ago, actually, he permitted his "boy" (he occasionally calls him —there are two children, a daughter who lives in California and a son who lives in the same Massachusetts town) to take him to a nursing home; and he lasted there three weeks. He would "rather die"—he kept

saying that; and he stopped eating, thereby creating havoc with his diabetic condition, which requires close supervision, since he takes insulin. Finally, the son took him to his home, and a week thereafter, back to his apartment, which had not been disturbed: "I got my son to hold off—not to let go of this place; it was the only way I agreed to sign in [at the nursing home], and boy, was I glad to be back here!"

I sit with him in that apartment, he on a couch, I on a chair opposite it. The living room has a dining area at the end, and beyond that a spacious kitchen. At the other end there is a bedroom, and beyond it, a bathroom. He has lived there three years. Before that he lived in a single-family home in a comfortable (but not wealthy) suburb of Boston. His wife died when he was sixty and she was that age, too—of breast cancer, a long, painful, frightening ordeal for both of them, one he still remembers and wants to mention: "I learned about sickness from Molly: she taught me about doctors and their promises that don't work out; she taught me about pills, and schedules for pills, and side reactions to pills; she taught me about *waiting*, sitting or lying and wondering what will happen next. That's what it means to be sick! You know what's wrong. The doctors have explained it to you, because you want to know. Then you leave [their offices] and you're home, and you've got this life of yours, and it's in danger, and you try to keep going, but you know that something is wrong, and no telling when you're going to know about it. So you hold your breath, and you talk to yourself, and try to keep yourself going, through the day—but, I'll tell you, it keeps coming back to your mind. No way to get free of that, the knowing, the thinking, the expecting the worst while hoping for a little breather. That's what I call my life now, a breather."

He notes me slumping a bit, a look of alarm as well as concern. I am fumbling with words, mouthing pieties meant to express my regret. He receives them silently, then turns on himself, tells me he oughtn't "drag" me through the details of his considerable travail. Anyway, his wife suf-

fered much more than he ever will—do I understand the very special burden cancer places on its victims? I think I know what he is aiming for me to understand, but I'm not completely sure, and anyway, that's what I'm there to do, listen to him, turn his questions into occasions for an answer on his part to what he has posed for me to consider. He gives me a painstakingly slow, considered lecture on cancer, its relentlessly hovering presence, its slow march on a victim's life, taking one bodily outpost after another, until in the end there is nothing left to do but surrender. The military imagery abounds—the fight, the immune defenses, the weakening of the patient, the rampage of the metastatic phase, wherein organ after organ is invaded, attacked, weakened. "I give up," his wife said one morning—and the next day she became unconscious, and a week later she died.

His diseases, in contrast, aren't as "linear." He was a civil engineer, and that word comes naturally to him. A scientist, he has paid close attention to his fellow scientists, the doctors who took care of his wife, and now take care of him. Cancer goes for the jugular, directly, and you know it's never going to let up on you—so he describes it. (I listen, keep my reservations about his unequivocal assertions to myself.) But high blood pressure and heart disease and diabetes—they are less "predictable." They are serious; they are life-threatening, but—oh, he's not quite sure how to say what he knows to be the difference. Finally, he comes up with this: "Cancer means business; these diseases I've got are going to get me in the end, but they're not in the rush a cancer would be, if I had it."

I decide to share some medical information with him—let him know about exceedingly "lazy" cancers that take ten, twenty years to do their deadly work, and I remind him (callously, insensitively, I realized, only in retrospect, after I'd departed his apartment) that heart attacks and strokes can befall any of us, at any time: a swift end, indeed. He smiles, says yes, of course—but insists that I simply don't understand what he has been trying to tell me; and when he does so, yet again, I realize that

he was quite right: "In the mind, that's where it's not the same." That summarizing remark clears up *my* mind, helps it fathom a patient's view of the inexorable, the implacable, as against the insidious, a matter of private imagery that has some (if limited) connection to observable, clinical reality. He is, I know at last, struggling with the vague and uncertain course of his own body's decline, a contrast with the steady, predictable deterioration he witnessed while attending his wife. Moreover, the doctor gave her medicine, all right, but to little apparent effect, whereas when he takes pills to deal with his angina, with his congestive heart disease, with his high blood pressure, he gets results, feels them, even as the insulin with which he injects himself enables him to keep eating, and again, be somewhat free of the symptoms of diabetes (lethargy, dryness of the mouth, frequent urination).

Only when we get finished with the above comparative analysis, are we able to talk about the other part of the life he lives from day to day—the way he spends his time when he is not taking medications or thinking about his past symptoms, his present or future ones. For weeks, for a couple of months, he maintained that his entire life was devoted to dealing with sickness—"That's what I am, a full-time patient." I felt stubborn, unrelenting for a long time, as I tried to encourage him to talk about other subjects: there aren't any, he would quickly let me know. But one afternoon a subject came up—the start of the baseball season—and though I broached it expecting to get nowhere, he lit up, told me he'd been a Red Sox fan all his life, and started sharing memories with me about the old days at Fenway Park: his dad taking him to games, his own trips there with his children, the pitchers and hitters and outfield players he remembered. He went further, told me that even now he would "treat" himself to one of those memories, let his mind wander back, stay connected to a particular scene. "You know, that's what I do, every day," he remarked, and then the description: "I'll talk to myself—out loud. If one of you psychiatrists was here, listening, you'd fill out a legal form

and have me sent away for observation. I know how you guys work—someone is behaving a little strange, so you check him off as nuts! Well, being old and being sick is being nuts, in a way. You're at the edge of life; you're hurting; you never do know if you'll see another day, so you never do relax and just live, the way other folks do! Anyway, what I do—I talk to myself. I say, 'It's Tuesday today, and you've got this long desert to hike through, hours and hours of time. So, better make the best of it.' When I hear my voice, I feel I've got company. I'm alive; and that's something. The other day, I thought of Jimmy Foxx. Do you remember him? He belted out one home run after another for the Red Sox, back in the 1930s, 1940s, I'm pretty sure, over half a century ago. He was my dad's favorite, so he became mine. When he hit one over, Dad jumped and shouted, and I did, too—and now (you know what?), I tell myself it's Jimmy Foxx day, here in this apartment. I sit here and remember him and his record of hitting home runs, and my dad, and the hot dogs we ate, and my father with his coffee, and me with my orangeade, and the subway ride to the park and back home, and my mother, waiting to hear from us who won and what was exciting, and what we ate and drank, and if we saw anyone we knew. I think I'm the last person I know of all those people I knew back then—all my childhood friends. We aren't so long-lived, you can say: I'm only seventy-five! It's hard, reminding myself of all the people I've lost, the world has lost!"

He clasps his hands, stares at a picture of his parents that he keeps on a table near him. The silence continues, longer than is usual, and I begin to worry not only about a possible impasse in our conversation (what may have caused it, what to say that will resolve it?) but about a physiological rather than a psychological etiology: he seems rigid, impassive, a bit "lost," as he looks so fixedly at the old photograph, to the point that I wonder whether he's experiencing a neurological "spasm," a possible prelude, even, to a stroke. "Are you all right?"—and he replies, right away: "Oh, yes." Back to psychology—I muse about questions to pose. The

seconds accumulate and I look at my watch. I think ahead to other commitments awaiting me. Maybe this is not a good day for us to converse. Lest I judge myself wanting, I turn on him: his face registers tiredness. I throw in, for good luck, the occupational curveball of my ilk (we talk psychiatry, but deliver our own brand of moral criticism): he seems *depressed*. Finally, aware of my growing anxiety and irritability (and not insignificantly, a certain self-importance that is implied in the conviction that I'm wasting time now, "just" sitting here, and not learning something, doing something, carrying on an "interview"), I suggest that perhaps it's time for me to leave. But he is right *there*, so to speak—"on to" our situation: "You've only been here fifteen minutes—but if you have to go . . ."

Now, I feel accused, so I promptly fire back in my head, judge him to be "dependent," "clinging." His behavior lets me know he's lonely—and again, that great catch-all, he is "depressed." But I put those thoughts aside. I shake my head. I declare that I have "plenty of time." He picks up instantly on that last word: "I don't! I have very little time left—I know that. But it's very strange, being old and sick and alone here. I feel that I've never had more time on my hands—it's as if I'm rich in time: I have so much of it, I don't know what to do with it! My closest friend growing up, Jack Felton, had this expression: he'd come and see me or call me and he'd say, 'Let's go kill some time.' I've been thinking a lot about him lately, mainly because I can still hear him saying that, and now, it's what I say to myself, 'All right, here's another bank account [of time] to go through!' But it's *so* hard—I have to work to fill up the minutes, the hours. I read the paper. I read *Time*! I listen to the radio—I watch television. But mostly, I don't do any of that—I just sit and think and remember and wonder about—well, when I'll go, how I'll go. When I get too morbid, I stop and try to enjoy myself—I have some chocolate yogurt that is fat-free and sugar-free, though I'll tell you, it's not ice cream!

"There's a big cloud above me—it's that clock on the wall there, but it's also a clock in my head. I check in with both clocks every once in a while, and I feel I'm moving along OK through the hours. But there are moments when each minute seems like a long, long day, and the morning or the afternoon drags and drags, and I think I'll go crazy every now and then, trying to 'kill time,' and not doing a very good job!"

He bows his head, as if in self-arraignment. He asks, rhetorically, how it might be possible for him to "do better with all those seconds, ticking away." He speaks as if the days, the weeks are a burden, a wasteland— something to be endured, something through which one journeys, but altogether without hope. The clock haunts him, controls him, vexes him, defies him, at times provokes him to tears: "I feel as if I'm losing my common sense! I'm letting that 'thing' over there, with that hand moving around and around—I'm letting that hand put itself on my shoulder, and on my head: it grabs a hold of me, and I feel like I'm nothing but putty, putty in that hand!"

He stops to pay attention to what he has just heard himself say. He is struck by the power of his own words, and cringes a bit, rubs his neck with his right hand, looks at that hand, then continues with his dramatic account of his days and ways. "Good God, it's as though this hand [his right one, now held out] doesn't matter so much—it's all [a matter of] that one [pointing at the clock] going round and round. Once I had a dream; I woke up from it, and I was in a cold sweat. I thought I was having another coronary—the same cold sweat I had when my chest near exploded, and I thought I was about to die. I lost my pulse for a bit, the doctors told me afterwards: I had this terrible cold sweat, and then the pain that near killed me, and then I went 'out,' and it's a damn good thing I was in that diabetes clinic, having my insulin 'regulated.' They rushed me to this intensive care place, and they saved my life. I had this 'irregular heart rhythm,' they told me. You know what I thought caused it [the coronary seizure, the arrhythmia], it was the nurse sticking the

needle in me, to take my blood sugar, in the clinic! But the docs said it could have happened anywhere, anytime—I was lucky, if you can call that luck!

"I'm wandering off the track. I do that a lot! I get going on one subject, and then I cruise into another, and next thing you know, I'm all over the map! I was telling you about this dream I had—oh boy: in the dream I was sitting in a chair, but (the damnedest!) it was a baby's chair (you know what I mean?). The chair had this tabletop attached to it, like a high chair does for a little kid, so you can feed him, and to prevent him from falling out. So, there I was, and I was having my dish of ice cream, my favorite, that Rainforest Crunch, it's called, from Ben and Jerry's (the homemaker shops for me, and she says it's expensive, but I eat so little, I can afford it, and with my insulin, I can get away with it, if I really watch everything else I eat, and only take a tiny bit, a couple of tablespoons, that's all.) I was feeling pretty good, I guess—when all of a sudden the chair began to give way. The table part fell, and the ice cream was all over the floor, and I was looking to see what was happening, and I didn't know, but then I saw this big clock, attached to the wall across from me, and the long hand, that goes around, had stopped, and it was pointed at twelve, and you couldn't see the short hand, because it was behind the long one: it was midnight, and there wasn't any more time left, I realized—I'd never see another day.

"I looked out the window and it was dark, pitch-black, and that's when I realized I was about to die. I looked back at the clock, and it still wasn't moving, and it was then that I fell forward, and I was headed for the floor, I knew, and it was at that second I woke up, and I was sure I was about to die, and this was my last second of life—I knew I was coming to the end of it! The downfall of me! But instead, there I was, in bed, thinking I was about to have another heart attack, scared out of my mind, and I picked up the phone, and dialed the 911 number, and I'll tell you, they didn't answer and they didn't answer, and I thought I'd die this way,

not the way I did in the dream: calling 911, and hearing the ring and the ring and the ring, waiting for a voice, and not getting one to say anything to me. Finally I hung up and told myself: why not die, right here and now! I've got all these troubles, and I'm near the end, anyway, and all I do is sit in that chair and try to breathe and look at the clock, and then try to forget the clock, and that's hard to do, because I don't have anything that really takes me away from sitting here and thinking. I mean, I'll try to concentrate on the television, but breathing is hard, and I have all the trouble with my prostate [it is enlarged, prompting urinary pressure constantly], so I'm either going to the bathroom or coming back from it or thinking of when I'll have to go again, and everything I eat, I have to *think* about it, what will happen to me if I 'go overboard,' or if I don't balance one kind of food with the other: life isn't meant to be like this—you're thinking of *yourself* all the time. You can't get away from yourself, and so the clock just stares you in the face, and says, 'I'm watching you, and you just try to get rid of me!' "

He is shaking his head, and he is rubbing his neck again with his right hand. He is upset—with himself as well as at his condition. He apologizes to me for being so self-preoccupied, for being so "childish"—as his dream had also declared. He doesn't need any help, actually, in figuring out that dream. He tells me that he lay there in bed, afterward, talking out loud to himself, telling himself that he was reduced to a kind of childish dependency and vulnerability, and that the preoccupation with the clock in the dream (in his daily life!) was his way of emphasizing the essence of his contemporary life: "It's the slow dragging down of me toward the grave—let's face it! It's slow time—around and around the hand goes, and suddenly: boom!"

I must not get the wrong idea, though, he insists. It isn't as "gloomy" as his dream and some of his talk might obviously suggest. He can smile; he can laugh—even at his "low spells." They are that, temporary in nature. He can do other things with his mind, "beyond torturing it with

that clock." He can remember women he's been with and trips he's taken. His body doesn't respond to those women the way it used to (in their company or when they were part of his daydreaming life), but he can see them very clearly, as he sits there in that chair, no matter the glaucoma he has, and the diabetic retinopathy, two "illnesses" he regards as "the least of my problems." Context matters enormously, he points out, and I have the feeling he is lecturing himself, never mind me, on that score: "Hey, I can see well enough to move from here to there in this apartment. I can see 'picture-perfect,' even with all my eye problems—because I have my memory, and so I close my eyes and I see a girlfriend I had as a teenager. Was she something to look at! I can see my family, too—but I'll be truthful with you. When I get 'down,' I don't want to think of my family, especially my wife, because then I get even more 'down': I miss them, and I feel alone, alone. It's hard to remember my wife without crying.

"So, I turn to those girlfriends, and I remember the war—fighting in Italy: I was with General [Mark] Clark, one of his boys! I tell you, that was a dirty, dirty job, pushing our way up that damn Italian peninsula! I lost so many buddies. When I came home, I told my mom and dad: I'll never be afraid of death, never—not after facing all those bullets coming at me from every which way! No, never. Well, I guess I'm a little scared now—but not too much! I'll think of those bullets a lot—and I'll have these nutty thoughts: there's the heart attack bullet coming at me, and I'm dodging, and the lung disease, emphysema bullet coming at me, and I'm dodging, and the diabetes bullet, it's trying to get me, and the other bullets, *shrapnel*, maybe, they are, the eye troubles, and the prostate trouble (they say it could be cancer, but I shouldn't worry, because it won't be the thing to take my life!). All I do, is duck *these* bullets, the way I did a half century ago (more!) in Italy. Hell, one of them will get me, I know full well. But I've not done so bad, and when that clock *does* stop on me, I hope the alarm goes off—but not because I'm in trouble,

or to wake me up, but to *celebrate* (I mean it!), to tell folks that I've gone, and it wasn't a bad time that I had here, even though at the end it wasn't your best way to live!"

He smiles, a grin meant to indicate general satisfaction with a life as it has turned out. He volunteers what is on his mind: that military stretch, those days when he was sure he was going to die young, when he had made his peace with God, even thanked Him for the privilege of being an American, an American soldier. As he talks, his voice becomes stronger, deeper, livelier; his eyes hold their gaze at mine; he uses the palm of his right hand to punctuate some of his comments: "All my life, during a bad time, I've gone back to Italy, remembered what we went through. You know, I never have left this country, except for that one time. I wasn't one for travel. A good walk in the neighborhood did me fine! But I sure have traveled to Italy, constantly! I kept going back there, thinking of those roads, the mud and more mud. You never knew if some retreating Germans were going to ambush you, pick you off, one by one, or the Italians still sticking with Mussolini—they knew they had no choice: the people in the towns knew who they were and were just waiting to shoot them or string them up!

"We talked about dying all the time. I read once in the paper a few years ago that when you're in big danger, you don't admit it—so that you won't be scared. I wondered who these people are who come up with all those ideas! Maybe they do talk with folks who have been there, in danger [I had suggested so, in reply to his rhetorical question], but I'll tell you this, right now: we sure knew exactly what was likely going to happen to us, very likely—though I'll bet that if someone asked us questions later, after it was all over, we'd have said we just got through it, and didn't give it much mind!

"Those days, 'life was bigger than life,' that's what one of my buddies, Kevin kept saying—and one day, he took a bullet right through his chest, and oh Lord, I've never seen so much blood in all my life come

out of a person, and he lay there right beside me, and I saw the life go out of him. He said, 'Hey, please tell my mom and dad I love them,' and he never did say another word. The medic said it was hopeless; it was the aorta that got torn, the biggest artery there is in the body, right near the heart, feeding into it. I think of Kevin a lot. When I feel sorry for myself—my breathing and all—I think of him, stretched out on that mud, the rain pouring on him, and the blood shooting out, and his face getting paler and paler, and the sweat. I say, Kevin, I'll soon be with you, and Kevin, I'm ashamed, I truly am, that I should be pitying myself, after all I've been given, since that day you left us. Do you know [an intense gesture toward me: his right arm lifted high] that the bullet Kevin caught missed me by a foot or two at most; I was right next to him when he fell. I can hear his voice saying, 'Oh'—if I'm stone deaf, and I'm getting there, I'll hear that sound until there's no brain left in me to recall anything!"

He continues with great intensity of feeling. His eyes are wet. His voice cracks. He hunches over. He is using both palms—they move in small circles on the table before him. I get worried. I start thinking of him as excited, as overwrought, and finally, as in medical (never mind psychological) danger: his vulnerable cardiac and respiratory status. I try to divert us, tell him I'll need to go soon. He abruptly looks up, straightens up, says, "Me, too, I'll need to go soon myself." I'm embarrassed—worried, too, at being taken so literally, at his use of my usual comment. But a smile appears on his face, and he reminds me, yet again, that "time has been dragging" for him these recent years, and he's glad for that, of course—such a contrast with the quick, awful exit that fate forced upon Kevin. Still, soon his "turn" will come, and he hopes and prays that "things will pick up then"—a fast departure as a fit conclusion to the recent slowness of things in his declining years.

6. *Two Oldsters*

The two of them, Callie and Charles "came up" together. They were both born in Alabama, in Eufala, to tenant farming families; they both had grandparents who could sit and talk for hours about slaves and the Reconstruction era, not as abstract subjects but out of a lived experience: black folks who "had to watch their every step, their every breath, and then some," as Callie puts it. She is ninety and so is he when I first meet them in 1990, and we three smile at that coincidence: "We go with the years of the century," they say, practically in unison. That is one of their habits—their achievements, maybe: the desire, the capacity to speak simultaneously, as a pair with one voice. Of course, they have sung together in church for decades, and though they aren't now "much good at doing so," they are still honorary members of their Baptist church choir, and sometimes are brought forth, to sit and make their own musical efforts, even as a younger cohort, standing, projects the mighty sound of this or that piece of church music. They love to go to church, get there weekly; and sometimes, in a major personal effort, go during the week to sit alone and remember and talk, but most of all, pray. Their oldest son, seventy-two, comes to get them, drive them, but on the weekday occasions, tactfully leaves for an hour or so, then returns to fetch them. They call him Junior—though sometimes his mother wants to give him his full due: Charles Edward, Junior. Without him, both his parents

insist, they wouldn't "be around." He is the one who looks after them, shops for them, makes sure their clothes are cleaned, their apartment is cleaned, their medicines are there, on a counter near the "icebox," as all three of them call the refrigerator—with memories of a time when a big hunk of ice was delivered to the home several times a week.

Their son, Junior, is not without other responsibilities: his wife, Louisa, has had multiple sclerosis for years, and is confined to a wheelchair. He attends her, attends his mother and dad, who live across the street, and helps out, too, his daughter, Gloria, who struggles with the consequences of a major kidney disease, glomerularnephritis. But he is devoted to his parents, and they to him. They call him their "lifeline." They call him, unashamedly, their "good son"—a contrast with Ronald, who "turned out bad." They are reluctant to discuss the details of Ronald's life, other than to say that he "ended up being in the West Coast" (instead of New England, as was the case with them and Junior) and out there turned to booze and too many women and ultimately, drugs. They have not heard from or about him for five years and fear (assume) him dead. His children, by two women, have never really "looked" to them—"they are their mothers'." With Junior's son and daughter it is quite otherwise, Callie notes, with Charles nodding: "Our Gloria is sick, but we see her a lot, and we see her daughter, and she has a little one: we're great-great-grandparents! They're all near us, and they come by every day to say hello Granny and hello Grandpa, and is there anything we can do, they ask. Our Junior's son, Philip, has a son, Philip, and that means there's 'young Philip,' and now we have a 'tiny Philip'! Would you believe it? They're all near, too, so we're these old, old ones, and the little kids [the great-great-grandchildren and the great-grandchildren] come and stare at us as if we're a Civil War monument. They'll ask us if we talk much! They'll ask us if we eat! They really do think we've died and gone to heaven, and then decided to return for a while, but we're not really living the way they are. [Of] course they're right! We eat so little; we

need so little to eat. We're living off the past, that's what. We think of Alabama, and the trip north we took, on the bus, and we remember all the cooking I used to do, when I had a big coal stove, and I'd spend half my day doing things on it—the bread and the yams and the collards and the ham and the chicken, Lordee!

"Now it's orange juice and pills and toast and milk and tea and soup, only it's not the soup I used to make with everything in it. Our Junior comes with his chicken soup, and it's 'strained'—I say, but no, it's from a can. I think I was the last one in my family to enjoy a stove; the others, all of them, *use* it; I would call it 'Momma,' after my momma. She passed, before we left for the North, of pneumonia. By then, she'd taught me all her cooking tricks. I was only twenty [then], and she was thirty-seven, I believe. That stove of mine was called 'Momma's stove,' and my kids thought it was named after me, but I knew the real truth. Up here, we lost sight of our kin, and didn't ever really know them much, except for a phone call from time to time [when phones became fairly accessible]. Everything began with us (you see what I mean?). All the family that came, since we got here, they think of us as the first ones. We try to tell them about the ones who came before us, back south, but not a one of our family has ever gone back to Alabama, or any place in the South. I see their point, but they don't know the good times we could have, back there, even with all the trouble. I gave up reciting [the nostalgic memories she had] long, long ago."

In fact, she loves to talk of her early years down south, or the early years up north, when her husband found work, no matter the state of the economy. He was his own kind of entrepreneur, always ready to knock on doors, even to offer to work for nothing, until he could prove his worth, his indispensability. He hauled garbage. He scrubbed floors. He swept city streets. He pruned branches and shrubs, raked lawns. He put gas into cars. He ran errands. He sat up through the night guarding buildings. He loaded stock in grocery stores. He sawed wood. He hauled pack-

ages to the cars of customers. He washed dishes in restaurants. He did dry-cleaning, through the night, in a big city laundry. He shined shoes. Sometimes he was doing several of those jobs, one after the other, to the point that he'd average four to five hours of sleep, at most. He was paid little, and not rarely, during the Great Depression, he would not get paid for what he did: "I would be told, 'Sorry, we just don't have the money for you.' Wasn't anything to be done. [I had asked what recourse he had.] Times were different then—a colored man was at the mercy of anyone, even up here! Besides, white folks weren't working, or getting paid for what they did—the same as with us. I figured I'd rather go and work *for nothing*, than sit at home and cry and curse and turn sour! I'd go knock on a door, and ask if I can be of help. They'd say, no work, no jobs to do, and they'd be getting ready to shut the door, or maybe, slam it in my face. But I'd say, just let me help, and if you can't pay me, then that'll be my bad luck. Some would give me another look then! You see, I grew up in Alabama, where we'd work and a lot of the time not get paid! True, we could grow our food down there, but I'd go begging for 'old food' up here, and I found some land where they let me put in some vegetables during the [Second] World War, they called them Victory Gardens, then.

"We stayed alive. People would tell me, they were coming to depend on me, and they'd give me some quarters, or a [one-dollar] bill—that be lots, back then [the 1930s]. I never did go on 'relief.' I never did ask the city to give me one single penny. The church, they gave us some food once, and then a month later, I brought them some back for [to give to] someone else. We'd be in the dark, because they'd turned off the electricity: food came first—so we went to bed with the sun down. Well, *they* did: I was out looking [for work] or doing something, hoping I'd get my reward, that's how I looked at it, not a salary, you see, but someone saying, 'Charles, you've given us all you've got, and we're going to surprise you with a tip, with a little something for you.' I'd bow and say thank you a few times! Today, people would say, 'Uncle Tom'! Back then,

there wasn't but us poor folk, trying to stay above water, and the white man, he was in the same boat, lots and lots of them."

He stops and muses. Callie has been adding bits and pieces of forgotten incidents to complete the story. After she spoke, he would repeat her words as if they were his all along, never uttered by anyone else. But he also announced that "women know all the secrets, and would rather keep them, but men love to talk, even if they forget a lot of the details!" In that regard, Callie has her own manner of offering a self-critical confession: "I'm not the talker here; I'm the listener. But I will have to say, I know how to get Mr. Charlie going, and if he stops, how to start him up again! He's my Mr. Charlie, you know [she winks at the race-connected irony that she evokes with her 'Mister Charlie']. When we were first married, Charles would talk a spell, and then ask me what I had to add, and I'd always say I'd heard enough, and I wanted to go back to my cooking or my sewing or my cleaning. Now, today, our grandchildren, and their children, tell me it's different: today, women talk, and they don't wait to be asked. That's all right! Whenever I wanted to get something spoken, I'd sit and figure what I needed to ask—for Charles to go on and make one of his speeches. But I don't assume all marriages are the same. If the woman is a talker and the man is a listener, that would be fine. Now, if you have two talkers or two listeners, then you may have 'something'— especially two talkers: something to worry about."

She smiles. Her husband smiles. He starts getting talkative again; he wants to fine-tune his wife's enunciation of a polarity. True, he is the one who does a lot of speaking, and she is the one who is always leaning forward, attentively. But I ought to remember (as I listen) that the biggest privilege in the world is to sit back and be told things; and the hardest work in the *entire* world is to have to spout and spout, so that others will get a certain point that is being made. To that assertion Callie eagerly, visibly, silently assents—her head nodding up and down three or four times. But then, she reaches for her neck with the palm of her right hand,

massages it a bit. She has "an arthritis" there, and the slightest movement can be "like a light switch that got turned on," whereupon the arthritis rages. She needs her pain-killing pill. With great and elaborate movement she gets up, hobbles ever so slowly to the counter where the bottle of pills is in sight. She stops at one point, smiles, tells Charles to tell me where she is going: "To the Promised Land," he says—and he asks her to "leave two out for me." No sooner has she returned to her seat, than he is on his way. She has left him a full glass of water, with two Advil beside it. Whereas she took one pill, then another, he gulps both down at once— and his wife cannot resist psychological commentary: "My husband was always hungry to get everything done, real pronto; he was a mighty impatient man to live with, when he had all his 'full steam ahead' energy. He's a quieter one now, slower, but every once in a while I see the old days returning—he'll be doing two or three things at once, or he has no time to enjoy his food; he just gobbles it down. 'Charles,' I once told him 'you grab at life!' 'Oh yes,' he said, 'and you, Callie, you are the one who enjoys watching me do it!' Well, I guess that's just us two oldsters."

They are sitting side by side. He is holding her left hand with his right hand. They each look at those two hands, one tightly gripped by the other, and it is Callie who speaks this time, observes that "there's a lot of years of work that's gone into those hands." He nods, as she usually does. He says he can't remember half of what his hands have done—but he does know this: the best thing he ever did was tie the knot with her. She takes to that moment of poetry, returns the compliment. They both suddenly change their angle of vision, look to the future with some considerable wonderment. Will they live to see the two-thousandth birthday of "the Lord, Jesus Christ"? Probably not—because their chance of becoming two centenarians that year must surely be very slim. Will they, then, live to usher in the second half of the last decade of the twentieth century? Each defers to the other—he will, she will! I hear of their ailments, the heart attack Charles has had, the minor stroke Callie sustained, the arthritis both struggle with, her partial urinary incontinence, his growing

blindness (glaucoma). They decide that when one goes, the other will soon follow. They decide they want that to be the case—it would be intolerable, unthinkable otherwise. They look simultaneously at their hands entwined—and suddenly, as if one has spoken to the other, or the two have been told something by an invisible force of sorts, a presence, they unlock their hands from that knot, and together bow their heads. Charles speaks softly: "This can't last, we know." Callie shakes her head, as if to be defiant in response to those few words, but quickly nods, and then, to make sure her sentiments are known, offers her version of resignation: "We've had more than we expected, so we've got to be grateful; but you can't be happy saying good-bye—I mean, completely happy!"

Another day we are sitting and talking, yet again, about their life together, and Callie, rather than Charles, initiates a return to the old days, the hard ones, not self-indulgently, but as an aspect of her self-reflective faith: "I used to wonder if God really wanted the two of us to be around here bothering Him with all our troubles. It must be easier for Him to come and call us back, that's what I thought. My momma used to say, God puts you here, then when He decides to, He calls you back, and it's usually when He thinks you've had about all there is for you to carry, in the way of trouble. Well, it's not the way it happened to us two—we're sitting here today on easy street, humming our tunes, and even if we can't go struttin', not even stepping out, we can sit here and have our pick of ice cream and spaghetti sauce and some good vegetables, and isn't that nice! But back those years—we would go to church when we could, and I swear, I'd ask the Lord, I'd *beg* Him, 'Come pay us a look, and see if we're not near 'going time.'"

She stops, and Charles picks up on the same theme: "Lord Almighty, we must have been close to 'going time' in those years. I'd do my praying. I'd never tell her, just like she'd never tell me, but I was sending the same message up to Him; I was saying we're missing meals, and we have no lights to switch on, and they're threatening to come throw us out ('eviction,' they called it), and my pride—it was that! —told me no, don't

take a single cent from Uncle Sam and his WPA (I never did know what those initials meant!). I figured when the Lord had run out of all hope for me, He'd come get me; He'd say, like Callie says, that He's calling us back home, across the river to His place. So, we waited and we prayed; and meanwhile all those days kept going by, and now they've mounted up to this huge number, and people say, 'You're both ninety, and isn't that the biggest thing, to last that long,' and we say to them, the biggest thing was to go from one day to the next when we were half ninety, less than that, thirty-five, that was the biggest thing. Now, we're talking about cashing a Social Security check. Then, you were talking about finding a quarter one day, like I did, and thinking it was God sending you a message that it was the last one, and as soon as we spent it, He'd be here with his wagon, to carry us due north, and I mean all the way north, upstairs!"

She laughs at his rhetorical flourish, his excesses. She has mentioned that before, the way her husband gets "carried away" with his language. Mention of the Lord carrying them away, perhaps, gets her going, so she fuses the two phenomena with her own kind of "carrying away" exclamation: "I always did want to 'go' with my husband, [at] the same time, because I know when the Lord carries him off, there will be lots of singing and hallelujah shouting up there by Charles, oh, will there be, and I'd like to hear that, just like I've heard everything else he's said, down here, these many, many years. We came up together, so it would be great to go up together—of course, we might not stay together! We might be sent to different places—I'd better not think too much of where, and what it could be like!"

He is laughing, and he turns to her, lets her know in no uncertain terms that she hasn't the slightest chance of going anywhere but "straight to Heaven." As for him, that is another matter. "A man's a man," he asserts. What does that mean?—she wonders, as I do. She asks. He replies with extended vagueness—the gist being that out in the world, men have to fight, make deals and compromises, whereas women stay home and don't get tempted to bargain with the devil. She mocks that kind of con-

ventional split, lets me know how irritable she used to be, how often she let her children down, due to her own moments of self-absorption, of melancholy, of anxiety and fear turned into a brittle, grim withdrawal from life which surely her children, especially, must have felt. In her words: "My momma told me the devil has slippery shoes. One day, he comes to you, Charles, and the next to me, and it's the same devil, but he knows how to dress himself different. (That's what the devil is—he can do that kind of thing all the time.)"

She has more than made her point. He leans closer to her. He puts his arm around her. She looks down, and he looks down, and it is as if, together, they are praying to God for forgiveness. Neither says as much directly, but Charles does by indirection: "He'll add up our accounts, and what comes out will decide [the issue] for us, where we're going. I hope He holds us together. You want to know what's on my mind most these days? [I had so often asked, too often, maybe!] I'll answer you. I'm thinking: will Callie be taken from me, soon—not here, I'm not talking about one of us dying, her dying and me staying behind, or vice versa. I'm talking about lots longer than ninety years. Hey, ninety years is like a split second—in God's time! I'm talking about Judgment Day. That's when the wheat and the chaff get separated. Our minister says you can do something, even at the last minute, to change the ledger, so the odds are with you, not against you. But I'm not sure he knows the right score on that. I think it's your whole life that's being judged, and because the stakes are so high, and because you can't fool Him, you plain can't, then there's no good that will come of some last-minute try: to get a touch-down from way in the middle of the field through some fifty-yard pass, and to think He will miss what you've done, be blind to it—that's to be making a fool of yourself, and it might just be the last straw (do you see my meaning?) with the good Lord!"

Enough of all that, the two seem to think, to indicate by their decision to contemplate supper, which they prepare together, since her arthritis has become so severe, and since a hip operation a few years back took her

away from him, thereby forcing him to show the same inventive hustle in the kitchen he once demonstrated in so many other situations. His son wanted to be of help. His grandchildren, his minister and the minister's wife, wanted to be of help, but no one got to cook for him, because he made it such a matter of personal pride that he fend for himself. His son came and picked him up, took him to the supermarket, where he had a great time going up and down aisles gawking, dawdling, picking things up, putting them back, or placing them with a certain panache on the cart, which he loved for the great support it gave him as he pushed it. *Now* he knew the pleasure his wife had been enjoying all those years, though with a certain irritation (with hurt feelings, I began to realize, and with undisguised envy), he wondered why she had so persistently kept him away from this great occasion of joy, always on the excuse that it was a boring chore, a tedious necessity, a commonplace obligation— hence her wish to go it alone. He loved unpacking all those tempting treasures once they were brought home, but at last he had visited the temple whence they came.

In jest, he would tell her that he had, finally, discovered an earthly version of that "Promised Land" in a place called "Stop & Shop": "I stop and say praise the Lord, and I shop!" So, these days they cook together, and before that, shop together, and on this day, I watch the two of them pick up pans, open and close the refrigerator, pull things from it, from the cupboards, and I think of a ballet: two oldsters, all right, bending and stretching and bowing to one another, to fate and its gift of time, to the Lord above all else, as they prepare a meal, which they will not touch until they have told Him a big thank you, and which they will then eat with enough evident heartiness to make a visitor wonder whether they have agreed, each time they sit at the table to take food, that it might well constitute their last meal together, this side of His gracious presence.

7. *Crankiness*

One elderly person after another turns moody and won't let it go at that—the normal swings of an emotional life. Rather, I hear talk of "the gloom and doom" of old age, whereupon words such as "depression" or "melancholia" come to mind. But many of the elderly men and women with whom I've talked take issue with those who would regard such a psychology as an aspect of psychopathology. "The crankiness has visited me today," a man of eighty-seven declares as he sits in a comfortable chair in a comfortable apartment. He himself is reasonably comfortable, given his age, of course, and some of the medical problems he, in fact, bears with grace and with a detached resignation—arthritis and prostatic discomfort ("the usual," he calls them), along with the lingering consequences of a minor stroke (limited motion of his left arm). While receiving treatment for that last condition, he was noted to be reticent (described as "uncommunicative" in the hospital chart) and so was referred for "psychiatric consultation." For a good while, doctors considered giving him a "mood-elevating" medication, but he wanted no part of such, and the doctors themselves were hardly in agreement as to whether they ought to proceed on that course of treatment.

I suppose, ironically, their decision to bring the matter up with the patient may have helped him to be far less "uncommunicative" than had

been the case. He talked and talked; and now "they" called him agitated—but did listen (especially when he said he'd refuse their recommendation). He could be calm, actually, when speaking in retrospect about what he had gone through, and what he most certainly was still experiencing: "The doctors say I'm 'depressed,' but I tell them no, I'm realistic! I can hear the clock ticking, and I know it's all winding down, and soon I'll be on my way. They want me to take pills—so I'll smile, I guess, sitting here, my bones creaking and hurting, and having all this trouble passing water. I have to smile that they want (they expect) me to smile. *They* didn't strike me as the happiest folks I've ever met in my life! But I tried to talk with them—I tried to let them know that I'm doing 'as well as can be expected.' They picked up on that [phrase]. They sure did. I had to keep apologizing that I used it—because they said I could be feeling better, I *should* be. Well, who's to decide? I told them I'm an old codger, and they wanted to know what that means, and I said it means I've come to the end of my time here, and ahead there's plenty of trouble, if I hang around, and what I do is sit and read magazines with my failing eyes, or watch the tube, or eat and drink my tea, and mostly, I'm remembering the past, and worrying about the future. [He had just incurred what he termed "a new diagnosis," that of angina, secondary to coronary heart disease.]

"Am I supposed to be 'happy'? Am I supposed to laugh and smile, and be amused by life? Maybe so—but, you know, I was always a kind of cynical guy, you could say. I'd read stuff in the papers or the magazines a half a century ago, and I'd narrow my eyes and probably mutter something foul under my breath! My wife [who died twenty years ago] called me a 'crank' when I was twenty-five and thirty, and now that I'm nearing ninety, they're going to make a federal case out of it, those doctors. [He is a southerner, and uses that expression often!] *That's* what it means to be old [I'd asked and asked that question]—you're being given the once-over all the time by doctors and nurses and visiting people who help you:

the homemaker one; and the nurse, with her notebook to keep track of me; and by God, when they're through asking and poking, they sure as hell come up with something! I guess for them it's a matter of principle—of pride! I should be more 'understanding.' My wife always told me I was 'too impatient' with people. I was, I know; I was [that way] with her a lot. I wish I could have some of those days over again. I'd do better, I think. You never do really know, though, do you? *That's* what being old is all about—wondering how you'd do it over if you had a chance to, wondering what might have been, and wondering what your life's story tells you about yourself! Will taking a pill change that? Do I want to have it different now? Hell, I can go take a swig of whiskey, and I'll be in a nice, pleasant daze, but is that what I'm looking for—is that what the doctors want for me? (My prostate would sure say 'ouch'!)

"It seems to me that when you get old you can't *dodge* yourself the way you used to be able to, so you're with yourself more, and that means you're more *you*. Do you see what I mean? It's like this: there's a lot of time that just *is*—nothing to *do*, only *be*! It's *still*, you see, here: I listen to the quiet; and I mean the quiet inside of me, not just outside! Let's face it, this body of mine is shifting gears, going into low, 'slowing down fast' is how I put it, and so I can hear that big stillness of death getting ready to claim what's left of me—and I smile a little one day, knowing all that, and the next day I'm 'a mite annoyed,' as my dad would say, and the third day I'm regretting that it's come to this. But does that [state of affairs] come by being 'senile', or being in a 'depression'? One doctor keeps asking me to count back from this number or that; and they want to know who's president. (I tell them I try to forget!) And they want to know if I can tell them my phone number, and if I'm still 'handling my checkbook.' You'd think the smile on my face and the jokes I make would be enough 'evidence' that I'm no more in trouble than they are, but they're a serious bunch, and they've got Alzheimer's disease on their brains. I tell them that—and I get no laughs! Maybe *they* should try

some of those 'happiness' pills they want to give me—might make them smile more!"

He knows to stop, knows to anticipate in his own mind what that 'they' might have to say—remark upon his "defensiveness," his "hostility." He smiles at that, too—laughs, even: he is "getting out in the nick of time," because "psychology rules." Amused, interested, not all that in disagreement, I press for further discussion, but he is not a polemicist, and doesn't want to become the foil for another's potential polemic—so, a bemused, careful reticence takes over his exchanges. Mostly, he allows, he wants his reflective elderly self to be appreciated for its preoccupations, which he regards as legitimate, natural, desirable. Even if he hadn't always been a crank, for instance, oughtn't he now be permitted a modest go at being one? He soars to an argument, turns a lifelong inclination into an end-of-life demand: crankiness as the proper lens for an elderly person to use. I wonder whether he isn't being mock-serious, smiling somewhere behind the mask of earnest, argued conviction. A crank's self-justification, I think—until he tells me that by crankiness he means not his past moods but his present realism: "I feel bad most of the time—pain here, pain there. Soon I'll be gone, and I know it. The nurse who comes here says I should try to smile. 'Why?' I ask her. 'Because,' she says—and she tells me of others who are my age and with my troubles, but they are 'cheerful,' and so it goes to show you, she's suggesting to me without saying it outright, it's all in your mind. Well, it's *not* all in your mind—it's in your body; it's in your life that's passing away right before your eyes. I know, I know—I'm lucky to have lived this long, oh boy, *am* I! For *that* reason, I'll admit, I should be sitting here smiling away. But if that's what I was doing, I'd be some old jerk who's *boasting*, who's smiling all right, like a Cheshire cat! I'd rather be a halfway honest guy who levels with the world and with himself—that he's cantankerous and ill-tempered and surly all right, as well he should be. He's realistic, you see! In the *past* he was cranky, but now his crank-

iness has turned into his 'I'll put the cards on the table' attitude! Maybe I've lived this long, you could say, so that I would come to the point when *this* happened: when it is *right* that I should think like I do."

All his life, it seemed, he had been irritable, a character trait those who knew him had overlooked or accepted, had even come to find vaguely appealing. Now, gradually, he himself dwelled on that trait, a means, perhaps, of indirectly giving vent to the rage he felt at the pain, the inconvenience, the growing helplessness of his condition. Now, his crankiness, his life's signature, was his important crutch. Now, he could boast of it rather than feel peculiar because of it (possessed of a quality of mind that others looked at with disapproval or pity or the condescension, the smugness that can sometimes go with "understanding"). Now, he had come to be the witness of that time of his life when the crank had become the realist—and thereby, the appropriately sensible judge of all those who were unwilling to brave the grim candor he espoused.

8. *Upbeat until the End*

"I'm going there; I'll be crossing over soon; I've been here so long, I feel I should make way for someone else, but it's not my decision to make"—May Belle looks up, skyward, as if the Lord is listening and mulling the matter over. She is ninety-three, lives in Johnston Country, North Carolina, and in her younger days she helped her husband (dead thirty-seven years) pick tobacco. She "never much" went to school. She can "make out letters and numbers," though. She has gone to church all her life; committed to memory much of what she's heard and read from the Bible. She has seven children alive, four girls, three boys, and "lost five others," meaning had three miscarriages and had two youngsters die before her eyes, one at six of pneumonia and one at eight of "stomach trouble." She had no pediatrician for any of her children, no doctor for herself all her life. She delivered all her children at home, with the help of her mother and her aunt, neither of whom lived "beyond their three score and ten." She asks herself often: "Why me?" She goes further: "The Lord must have some questions about me that He's trying to answer. I don't know what they are, but I'm trying to acquit myself."

That verb comes to her mind and gets used often. She has heard her minister, the Reverend Johnnie Johnston, use "acquit" in his sermons: "We must acquit ourselves in the sight of the Lord." She has an exact, an

exquisite sense of what that word means—its judgmental and behavioral implications, as they connect with her advanced age: "Some folks need more time to prove themselves before the Almighty Lord, that's what I think. I sit here, you know [outside, on a cabin's porch, overlooking a field of crops planted for her family's use], and I say my prayers, and I wait to be taken, and I hope that my children will be near me, waving me on to the crossing ahead. I do believe that there's a river waiting, and I'll be able to get over it without some boat! When you've left this life, you don't have to worry about boats and airplanes and if you've got enough groceries! You've turned into 'spirit,' the way Jesus was when He crossed over the water, there, in Galilee. I think some of us, more than others, have to prove we're good enough to be in His company—I don't know why that is, no sir, I don't. [I had asked.] It's just the way it is—if you start questioning Him, you're in big trouble, I do believe."

She stops, looks downward, asks me if I've seen one of her granddaughters, Sissie. I say no—and hear this: "My granddaughter Sissie, is my best friend these days. I talk to her a lot. She looks after me, besides her daughter and her son. [She lives a mile away.] She is here all the time, making sure there's food for me, and I get up and stretch, and I go visit our crops." I'm not quite sure what she means by that last statement. I ask her to explain—and she smiles with a certain incredulity, meant tactfully to tell me that I'm the one who needs some questioning. She then helps me out: "Well, young man, you don't just sit here and expect those crops to do your bidding without a hello and a thank you! The Lord doesn't want a lot of praying for Himself; He wants it [praying] for His creation, that's what! So we go there, visit the carrots and the celery and the okra and the potatoes, and tell them they're looking fine, fine as can be, and please God, they'll soon be 'up and away'—in the house here: visitors, you know."

She is savoring the food in her mind, her jaws moving a bit. She tells me that as old as she is, she loves to eat. She especially favors sweet

potato pie. She's made "thousands and thousands" of them over the course of her long life, but for the last five or so years, since her hands "have taken to the shakes so," she's abstained. She waits for Sissie to come, and in that regard she's taught Sissie all she knows. There are sweet potato pies and sweet potato pies, I learn, and the issue is not the ingredients, as I presume to believe, to say, but that of art: how it all gets put together. I am assured that I could readily taste the difference—but it is hoped I won't have occasion to do so. "I'll be sure you always get some good pie," May Belle tells me with a smile.

She constantly wears that smile, to the point that I not only take notice, but become skeptical. Is it a disguise, a put-on for a white visitor? Is it an aspect of her own struggle to survive all the "pains" she mentions (with a smile), all the limitations of her life she also describes with evident good cheer? I decide to take up the matter—I tell her she has a good sense of humor and she certainly seems to be enjoying her old age. She accepts the compliment, but she wants to make clear, I begin to learn, what prompts her smile: "It's a gift, to be old—people say it is; but I don't believe them. They come up to me and say, 'Miss May Belle, you sure have been given the gift of life.' You hear that all the time! I always smile, and sometimes I laugh; I say gifts don't hurt, and drag you down, and make every step seem like you've been walking forever; and gifts don't bring you a sick stomach when you eat, and they don't make it so you can hardly catch your breath, and there's no teeth left to chew up what you try taking in. It's not sticking around; that's not what old age is about. Old age is being given a real close look by the Lord, before He decides what to do with you—that's what I think. I'm smiling for the Lord—is what I'm doing! I'm smiling to tell Him that I'm not going to let myself get down. I'm not going to be feeling sorry for myself, and complaining, complaining. I'm not going to be broadcasting all my miseries to anyone's ear I can catch. I'm not going to be playing tricks on people: you want the secret to hanging around here a long time—then

you come see May Belle, and she'll call up some story about how you can outfox every sickness there is, and turn one hundred down the line!

"My soul is waiting to be sprung! Oh, is it! I'm here awaiting the trip across the river, to the meeting place, where He'll be. I'm smiling, to let Him know what I know—that there are better times ahead! He may not admit me—now I tell you, that's what is at stake here: will He or won't He? You can't fool Him, but I have to believe, I *have* to, that He'll look and He'll listen: He can be persuaded! That's what our minister says; that's what the reverend keeps telling me, that 'He can be persuaded,' so when I get up, and every single bone in my old, tired body (it's sure falling apart!) is hurting bad, real bad, and it's a long day of trouble ahead—well, I can lie there, with my aches speaking loud to me, and smile, even so, and say, dear Lord, I'm here, waiting on You, and I'll stay upbeat all the way, until I meet You, upbeat until the end, because what's the end, is just the start. We know that, don't we!

"Of course, I have my doubts now and then; I'm not here to deny them. If I did, I'd be telling a lie, and why should I do that? It's too late for fibbing, my minister told me last week, when I said I'd be lying if I didn't admit I'm in pain a lot. So I admit the pain—but I try and smile, and I hope the Lord will give me the benefit of the doubt, even with my doubting Him sometimes! I mean [I had asked for clarification], I don't doubt *Him*; I mean that I wonder—I have to admit, I *do* wonder—why He hasn't made His decision on me! We're put here to be tested, and if we stay a long time, it's because the testing has to go on and go on, for some reason, and that's something none of us can know, the reason why we're not yet called up for the reckoning. But if we try to keep a good face for Him—well, we'll soon enough be up there finding out our answer, won't we!"

She has moved aside psychology in decisive favor of theology, even as I try to figure out whether she doesn't sometimes wave aside theology in favor of a few tears, a few sighs of sadness and irritability and anguish.

The harder I press her, though, on her physical condition, her state of mind, her daily worries, and her week-to-week expectations, the more earnestly and passionately her almost minute-by-minute spiritual intro-spection becomes acknowledged, declared. Finally, she begins to realize that the one questioning her may be, more generally, a questioner, a reli-gious skeptic—or so it surely seems, hence *his* jeopardy. With great tact, but with eyes that now are alive with awareness, she offers her prayers, her condolences: "I know it seems strange that I'm not sitting here in a puddle of tears. I know some folks my age, that's what has happened to them: they're 'going under.' I don't mean they're dying, right now; I mean they're still alive, but they're drowning in their own tears. I guess that's what would do me in, if I saw myself slipping into feeling sorry for myself, into counting up my miseries and telling everyone who comes along all about them."

She stops to look carefully at me—while reminding me that her vision is quite blurred. She humorously asks me if I'm "still there"—a nice way, I realize, for her politely to test the waters between us, see if I'm understanding her. Yes, I reply, I'm "still here." That is what she is try-ing to do, bring me from "there" to "here"—get me in closer touch with her assumptions (which are not to be confused with mine). She smiles, and continues: "I don't enjoy all my aches [lest I misunderstand!], and if I could wish them away, I would. I don't think the Lord has visited them on me, either. [I had suggested as much at one point—drawing upon her own remarks.] I know He's testing me, like He does everyone, but He doesn't sit up there deciding which of my hands will hurt this morning, and my elbows, and my knees and ankles! I've just stuck around a long time—is all! If I'd gotten sick and died when I was thirty-five—and I al-most did die then, of the worst pneumonia you can have—He'd have taken a good accounting of me way back then, and He would have known what to do with me. The longer you live, the longer it takes for Him to come to a judgment on you—that's just how it is: because you're alive,

you're being judged, and if it's a long life, it's a long judgment, and if it's a short life, it's a short judgment. 'His ways are not ours.' So I can't tell you anymore than that."

Her vision may be flawed, but her intuition is robust. She has sensed my unending frustration, sensed that I both comprehend what she is getting at and want to circumvent it in order to confront her: the cost to her, emotionally, of all the suffering she is experiencing, and yes, the cost to her of not acknowledging the frustration and exasperation and vexation she must at some "level" of the mind keep harboring (though not, clearly, feeling or expressing)—the price, that is, of her Christian forbearance. But she won't have any part of my psychoeconomic meta-psychology, with its accounting procedures meant to add up revenues and take into account expenditures and debts. She keeps telling me that anger is the Lord's, that pity is unseemly, that she (on the other hand) is no masochist who wraps herself in the self-justification of the Christian story—but that she has figured out something for herself, and it goes like this: "I have so many bad 'hurts and griefs'! My grandma warned me: 'You get old, you get lots of hurts and lots of griefs.' But besides that, she told me more; she told me that when she gets up, every morning, she remembers her 'burden,' but she thanks the Lord for letting her be the one who's carrying it."

I follow that line of reasoning—but am not convinced by it in quite the way intended for me. The word "masochism" keeps crossing my psychologically jaded mind—a way of being, I figure out, for her, as for her ancestors before her: a suffering of old age that is handed down by fate, then taken into consideration by the Lord (supposedly) for the sake of the overall evaluation of sorts that these folks seem convinced takes place for every single one of us. Not that this elderly "believer of the Word," as she characterized herself once, is pleased to be in constant distress. She has candidly told me that old age is a "between time"—meaning a tran-

sient spell of suffering sandwiched amidst the transient pleasures of youth and the eternal ones afforded by paradise, which one, admittedly, can't take for granted, but which is still something we can hope for, dream about, keep constantly in mind, sinners though we be.

I keep struggling, however, not with the notion of paradise, but with her psychology: how to do proper justice to it—how to describe what is to me an eerie contentment that lives strong, amidst her daily struggle with a deteriorating body? She is trying to help me, I begin to realize, rather than confront me as an antagonist. She is a teacher, it finally comes to me—almost blind, very hard of hearing, but with a generous heart that tries, in its beat, however labored, to respond to that of another (now, here, mine). So, another effort on her part: "I stop sometimes and talk to this body of mine—I say, 'Almost time to say goodbye!' The poor thing, it's had a long time to be here, and that's what happened: the wear, the tear, the tiring, and the hurting. It has fought the good fight, like the minister says, with all those germs, and the viruses, and the cancer [cells], and blood clots, Lord Almighty! It's about ready to quit on me—but you know what, I'm not going to be disappointed, upset. I'm ready to leave it; I won't push things, no sir. But one day, it'll happen: my body will just give out, and I'll be sprung—that's it, I'll be sent on my way to the Maker of it and of me."

I feel her full of more to say and am surprised that she has suddenly stopped. She seemed on a roll! I'm noticing the energy she has put into that statement; and determined to be a reductionist in one way, if not another, I now worry about her medical (as opposed to psychiatric) condition: how does she manage to mobilize such a concerted effort—the passion of a barely subdued sermon, albeit delivered to a congregation of one? She doesn't do as well, actually, as she *seems* to, I conclude, noticing her silence, her steady stare beyond me toward the window's light, which beckons her. She is in some kind of silent trouble, I decide, and so

doing, I am confirmed as the person I am: the one who looks beneath the surface of things, who brushes aside the apparent in a search for (always) an underlying reality.

I have missed the mark, again—so she would tell me if she were the kind of person inclined to having it all out, putting every single card on any table around. Instead, she lets me know this—with an earnestly so- licitous movement of her eyes, her face toward the shadow of me that she wants to address: "I think I know what's hard for a lot of people these days—it's remembering that the good Lord is the Maker, the Maker of everything, but you mustn't confuse what He's done, because the fish aren't the sheep, and the lions aren't the goats!"

Another pause, long enough for me to go back to my psychiatric vi- sion: she is giving me a biblical parable of sorts, her own, of course, and one not entirely "appropriate," a word that in hands like mine has strong normative significance. Put more boldly, her mind isn't adequate to our discussion. Such a thought, needless to say, is not without its own risks —the observer perching himself smugly at the top of a tree, looking down at various lower orders of creatures, as they slink along unwittingly (higher consciousness is reserved, naturally, for us higher folk).

Abruptly, words start flowing again from a modern-day biblical psalm- ist: "When God made us, He gave us our souls. That's who we are, the ones with souls—the others, the 'beasts of burden' don't have souls. [So much for my failure to comprehend her reference to the Lord as 'the Maker.'] That's me—not this body here! When I die, I'll be sad for the body, along with my family; but we'll know I've taken leave for another place, and so we won't fall to pieces. I'm falling to pieces in my body, right now, but I'm doing all right in my spirit, I hope. I pray for it to have strength—my spirit; *that's* what needs care, you know, and that's why our Lord came here and showed us He is a doctor, and He can heal. It's our souls He heals; you doctors tend to the rest, what comes and goes [the body]. That's how it is, I know—do you see?"

That last question of three words gets breathlessly tacked on to the preceding statement. She spoke those three words tentatively, as if she certainly wasn't going to take for granted any sight I may just possibly have. In fact, I *was* beginning to see, understand at least somewhat her sense of things, her detachment from her collapsing, aching, stricken body, her consequent ability to tolerate with apparent good humor its failures, its frustrations, its repeated flirtations (and more) with extinction. The various organs of that body were unquestionably in great difficulty, including the brain, which she several times called "weak," its memory impaired, its present-day awareness clouded. Still, there was something that hovered over all of that, the entire biochemical and physiological, and neurochemical and neurophysiological (and psychodynamic!) apparatuses included: a soul awaiting its voyage. The whole is greater than the sum of its parts, she so very much wanted me to know, she was trying so hard for me to understand, not quite in those words (which have a sort of conceptual acceptance among some of us twentieth-century materialists), but in words that soared, she hoped, in keeping with their task: to convey the uplift of vision that held her together spiritually, the aspect of her life that she had striven so long and hard to keep compellingly strong, with apparently great success.

9. *A New Life*

Sixty-five years of a rocky, troubled life together—yet, there they are, sitting side by side, remembering the disagreements, the intense, hard-fought arguments, the threats of divorce, but now smiling at the past, at one another, even at the future's prospects. He (Glenn): "It's a miracle, we're here—and another miracle we're here together! We had a tough life back in the old days—of the Depression. I was a carpenter, and I couldn't find work, or if I did, I wasn't paid after I did the job, because the people said they had no money. I'd come home in the worst shape possible; either I was depressed as hell, or I was fighting mad—and there my poor wife was, with *her* problems: the children, and how to keep them fed and clothed, when there was no money to pay the grocer, the butcher, the landlord! We squabbled. We shouted. I'd fly off the handle, and she'd be quiet like stone is, and I'd get madder and madder. She knew she could drive me nuts by keeping quiet! Alternative scenario: I'd be the one who was silent, and she'd start in: the whine, I'd say to myself, the whine about the bills that were outstanding, and the threats of everyone to cut us off—no food, no place to live, nothing to wear. I couldn't even look at her. I pretended not to hear her. She'd break out into a shout—music to my ears! Once I smiled when she was ranting and raving, and she picked up a glass, and she aimed it at me, and

suddenly turned around and threw it at the wall. Smash! The kids were, maybe, seven and nine, our two daughters, and the boy, he was three. They couldn't believe their mother threw that glass! They came running into the kitchen; they were listening to the radio and fooling around, I re-member—maybe [hearing] *Jack Armstrong, the All-American Boy*. (Even if the older ones were girls, they loved that program—and you know, they ended up marrying all-American boys!)"

There is so much more of that story to tell, but he has to stop. His mouth is dry. He has trouble swallowing. His dentures don't fit well. He has gotten "excited," so he worries that his high blood pressure will go higher, that he'll suffer another of those "small strokes" he's had, "never a big one," he keeps repeating, though he often adds two words, "some day," and usually trails off. "Some day" the "big one" will come and take him away (he has occasionally added as a clearly stated afterthought). It is now his wife's turn to pick up on the past, evoke its discontents, its desperations, its terrifying downhill direction. She (Hilda) doesn't easily get herself going, because she is struggling with Parkinson's disease; and she has a "delicate heart"—has had a coronary, gets anginal pain fairly often with exertion. Her arthritis can be "killing," though she tries to laugh at it, and calls it "the least of my worries." Well, asks her husband, what are your "really big worries"? Her response: "I only have one, you." They both smile, even laugh—though it hurts both of them to do so.

Finally, Hilda's turn at the stab in the dark that is spoken recollection: "I don't know how we ever got through those years. I'm talking about survival! I remember the worst time—I had nothing to give my children but some bread a neighbor gave me and a little milk, which I watered down, so it would fill them up, and some old wormy apples I begged the grocer to give to me, rather than throw away: I made applesauce out of them. I spent each day thinking I'd take my kids and go on the street and plead for pennies. He—he wouldn't go on 'relief.' That was the word back then, not welfare. He said he'd rather die. 'OK,' I said—'but what

about these three children?' He'd clam up. He'd walk out of the house. *Walk out*—he'd *storm out*! We had the lights turned off, and we had got an eviction notice, and I would sit with the children and try to play with them, and our neighbors (they weren't much better off) would bring me some peanut butter or crackers—and that meant less for them.

"None of us were sure we'd ever get through those days! I began to realize that our kids knew more about what was happening than I'd believed—they knew *everything*, I would come to understand! I was so sick, then—I had asthma, and terrible eczema. I never went to a [private] doctor. We had no doctor. I went to the free clinic in the hospital, a couple of times. Anyway, the doctors then didn't *cure* diseases, or even treat them: they told you what was wrong and they'd give you a 'salve' or tell you to take aspirin, or a hot bath, or they'd paint your throat with 'gentian violet'—I remember, for sore throats. When we got a little money for ourselves—toward the time of the Second World War, when things [in the economy] picked up, and there was some money around, a little, for folks like us—I went to see a doctor, in his office, and (you know what?) I realized that he was a very nice and honest man, and he meant well, but he couldn't do anything for me except sympathize, and I never was a big one for that, from anyone, and especially my husband."

She looks at him. He smiles, without returning the look. Suddenly he has a memory: her telling him that the doctor had "fluoroscoped" her in his office—looked at her chest with a machine he had. She did, after all, have asthma—and that way he could tell her that, nevertheless, her lungs looked "fine"! They smile at what his memory brings for both of them—the great distance medicine has traveled in the past century, over ninety percent of which they have been alive to experience. Since their son became a doctor, they know a lot on that score—and when they are not smiling at what they know (and recall), they are shuddering: all the close calls they and their children had. As they muse separately, silently, and (out loud) together, they drift from the hard facts of medicine and

surgery (their son became a general surgeon) to the less tangible specialty of psychiatry.

He: "No psychiatrists then—not for people like us. Maybe there still aren't [for working-class families]. I took an interest in that subject—I guess because of all the troubles we had at home. You know, the one thing I could do without paying a cent (the penny could buy something, then!) —I could go to the library, and sit there and be warm and read. I never told her [he nods toward her] that I went there when I had no work. I was ashamed. I thought she'd think I wasn't trying hard enough—and she never knew how awful, how *awful* it was! How could a woman, a mother staying at home with her kids, know, *really* know!"

She: "There you go again, dear! He says that from time to time, and I have to laugh! I knew everything—and more. I heard stories from the neighbors. I saw the look in their eyes. I saw *him*, when he came home— everything was written on his face. Words aren't necessary, sometimes. Facts—they come to you in the way someone carries himself. My husband came home a beaten man, and a robbed man, sometimes: he'd worked with all his energy, and he got no pay for it—and now he had to face us. No wonder we fought like cats and dogs! It was a terrible time— I wouldn't go back to it, for all the tea in China. I don't care if I had my health, then. Actually, I didn't—but I sure was healthier than I am now! 'Your health is everything,' people say—well, *baloney*! Your health won't buy the groceries, and if you're poor and the bill collectors are after you (why shouldn't they be! I understand their situation, *now*!)—well, your health will go, sooner or later, so even 'everything' turns to nothing when you're at the bottom of the ladder, and let me tell you, there were millions and millions like us, and I think, I believe if it hadn't have been for that war, we'd still be where we were. It's an awful thing to say, but the war saved us, all of us, this country. That's my opinion."

He: "You see, she *pretends* to be a quiet one, and she has all her shyness going for her—but boy, oh boy, she could start talking sometimes,

and I knew I was the one who had to hold my tongue, because if I didn't (and sometimes I didn't) we'd be at each other's throats—and we *were*!"

She: "My husband has always been one to exaggerate—with his psychology. He has spent too much time with that. It's been his biggest mistake of old age—but I forgive him."

He: "My wife is much more interested in automobiles than psychology! She was the first one in our street to have her own car—in 1952, as I remember, when you even flirted with the idea of voting for a Republican [Eisenhower]!"

She: "He'd made money, more than we ever dreamed. He worked and he worked—he always had a huge appetite for work. But now he was being paid, top dollar! Then, all that reading he'd done in the library, on 'psychology' and on 'economics,' came into bloom. Would you believe it—he said he was going to study the stock market, and he decided it was [a matter of] knowing the best companies, the strong ones, but you had to know yourself, too; you had to figure out where you wanted to go, and how you want to get there, and you can't panic, when other people do, that's the worst. My husband, the expert on crowd psychology! But he *was* [such an expert]—and he did so well: it became different for us. Oh, such a change, gradual but real, is the way I think of it!"

He: "It's funny, how after all these years, these *decades*, we both slide back to that other life, that's what it was. These days, a couple who had the fights we had—they'd be divorced in no time. Back in that time, we never even thought of separating. We were cursed—not by each other, only, but by the life we had to live, near the edge of everything, and I guess we knew in our bones that if it ever got better (America, I mean), we'd get better, the way we lived together."

She: "It's not that we still haven't agreed to disagree! We're no perfect little couple here, dear!"

He: "Of course, of course—would you believe in a 'perfect little couple,' if they showed up and described themselves that way? Bullshit!"

She: "I wish you'd use the word 'baloney' more and that other word, less. We're too old to swear!"

He: "I never want to be 'too old to swear'! I've tried to cut down. But you yourself will swear sometimes, my dearly beloved!"

She: "Listen to that talk—I want to swear right now: his 'sweet talk,' I've called it for over sixty years, nearing seventy!"

He: "You can see that we don't just sit here on this couch and smile at each other and agree on everything we hear from each other! We even remember some of our 'big fights' we call them, and go back to them! No, no [I had asked], we're not really rehashing them; we're not fighting; we're going back to the old days, and frankly, we're scratching ourselves in amazement, absolute amazement, that we got through all that, that our kids grew up to be wonderful people, and our grandchildren, and now great-grandchildren coming along: to live to see all that, to become 'comfortable' in life, so you'll never, ever be poor, and at the mercy of—well, at the mercy of others! To have lived this long, even with our illnesses: it's a wonderful, long time we've had, and right now, we both call this part of it our new life. Why? [I had asked.] I'll tell you why— because we know how lucky we are, we know how to appreciate what we have. I wonder if you can appreciate a comfortable life, really appreciate it, if you've never known anything else. I really do. We go out with our children, and we meet people like us—of our age. I mean, they're *not* like us—they worry all the time about little things. This is broke, or that doesn't work, or something has to be fixed, or they didn't buy the right car, after all! They talk about their health and their sicknesses all the time—you know the reason? I think it's because they've had it good all their lives (you do well yourself, and you end up meeting people like this!)—and the result is that now it comes as a big surprise, a *huge* surprise to them that something can go wrong, that you can't have everything all the time, and forever! For Hilda and me, this life we now have, it's not 'old age,' it's living long enough to realize that somehow we got

through the worst, the worst between ourselves and the worst from the point of view of our situation, of being at our wit's end as to whether we'd be able to survive as a family, and I mean by that, feed ourselves and not be out in the street, begging. That's why it's 'a new life' for us —we can't forget the old one, we don't ever want to. Why, years ago, I thought it might be nice for that to happen, but I was wrong. Old age— it's when you have plenty of time to get some perspective on your life, and that's what I believe we're doing, and maybe that's what our greatest luck has been, that we've had the time (plenty of it) to go back and look at all those old wounds, and wonder that we got through one day, and the next, and the next after that, and with all our bickering, lots of it, we stuck it out, and we came here, to this, to old age, together."

She: "He's always been so dramatic! I don't think we had any choice —or maybe I should say: we didn't think, we didn't know, we had any choice. My mother used to say: 'Where ignorance is bliss, 'tis a folly to be wise.' Well, we weren't really ignorant. It's just that—we lived in a different time, when people (people like us, at least) didn't go running off from each other; and when you were so determined just to survive—you didn't think of making things even worse by worrying over your 'psychological problems.' I hate to say this, but I told my daughter, when she told me that her daughter was seeing a psychiatrist—I told her (I felt bad after I said it), I said, 'If she had some *real* problems, she wouldn't have time to fret and stew and think up some for herself.' My daughter was very upset with me, but I guess I'm so old and fragile—our children and grandchildren hold their tongues with us all the time, almost."

He: "*Almost*! Our son will tell us off sometimes, in a nice way. He did tell you off about that [what she'd said to her daughter about her granddaughter]; he told you that each generation has its own troubles and struggles, and the worse thing about getting 'older' (he was so tactful; he said he was talking about *himself*!) is that you forget that, and you point the finger at others, of a different age, as if they're you, and it's just not

true, and it makes for 'a lot of strain,' 'a lot of needless quarreling.' I re-member his every word, and he's dead right!"

She: "Oh, my husband with the long view! Where was that [view] when you were young and exploded with the temper of Mount Vesuvius?"

He: "All right—I just said it: this is our *new* life; let's be glad we're still here to enjoy it."

She: "I'm not sure the word 'enjoy' is the right one—for you, never mind me! Good Lord, I can talk the way you do myself, but I only half believe it! My body is falling to pieces; it's got so nothing really works, except this head of mine, that has been spared Alzheimer's. I told Jim-mie [their son] the other day that senility can be a blessing. Now I real-ize it. We're suffering through these last years of life because we're not senile enough to be able to be in some trance—that's how you are, I guess, when you're senile!"

He: "Listen to her, looking for more trouble than she already has! One thing I know, she'll never be senile! She's too smart for that to happen! Me, I could lose my grip. I've always been the one to get worked up mentally, so I could go and blow a fuse, and that would be it!"

She: "He would be furious because I tried to keep calm, while he screamed. *That* got to him more than anything I could have said!"

He: "We were on the ropes. Someone had to let off steam. Remember the evening I thought of killing myself because of that hundred-dollar in-surance policy (a hundred dollars!) was about to lapse, because we hadn't paid the premium, and at that time one hundred dollars seemed like one million dollars, I mean it!"

She: "Yes, dear, I do. Oh, what a life we had then—not a 'life' really, at all. To this moment, I shake with [memories of] it—worse than with my Parkinson's. Sometimes I believe my Parkinson's is *that*, me shaking from all we had to go through, and it was by the skin of our teeth that we got through, and who would believe that we'd get here, to *this*, so far away from *that*!"

He: "You're right. It's so different now, I hardly know how to describe it to our grandchildren. Even our children don't really know what we went through—they were too young. They've had a good life—things really picked up for us by the time they were, maybe, ten or so."

She: "Now it's *you* who has forgotten that it's different for each generation. They've had *their* problems, our children have; and *their* children have a different country to live in, compared to what you and me and our children had to live in; and then there will be our great-grandchildren, the different life, the different century, that will be theirs. Well, the greatest thing about getting to this age, is [that] you *have* them, you *know* them, you *think* about them, all those offspring, and you wonder what the world will be like for *their* children and grandchildren and great-grandchildren!"

He: "You're talking now about two centuries of time, almost—from our time to the time of our great-grandchildren's great-grandchildren!"

She: "Maybe more [time] than that. My math was never very good. I guess I'm just trying to understand time, not 'talk about' it—understand it by giving it some flesh! We've lived long enough to be able to do that, to imagine what will happen in the future, the distant future, because we've seen right before us what can happen to our children and their children—generation after generation in this twentieth century. Now the century's about over. The second millennium is about over, just as the two of us are getting ready to be 'over'! That's a coincidence—I think of it sometimes. Then, I'll try to imagine what it might be like a thousand years from now, when the third millennium will be ending—but, in no time, I'm back to the here-and-now of this life. It's for others to dream and dream of the future; I mostly love planning the next meal, and doing my best to make it a good-tasting one for the two of us."

From the parables and psalms of the Hebrew Bible to the Greek tragedians, then to Shakespeare, and in our time, as well, old age figures as the universal shadow, inseparable from who and what we are. Psalms 90 and 144 remind us of what awaits us—ironically, if we are lucky enough to be spared an early death, to grow old. Sophocles is known by many today for his young Oedipus, but the aged Oedipus of *Oedipus at Colonus* tells in the most powerful language and imagery of our earthly destiny—time and its obvious gifts, but also burdens: we remain, but at a steepening price. Old Oedipus would, eventually, be followed by old King Lear—and the rage, the humiliation of those royal ones surely has had countless, anonymous echoes in the lives of ordinary people across the centuries. The reader who has attended the men and women who speak in the forgoing pages will surely recognize, in a conceptual moment, the earnest struggles of these elderly men and women to make do, each day, against the encroaching, enveloping night that is an aspect of old age. Still, they speak; and their words tell of defiance as well as stoic resignation, of humorous assertiveness as well as wry (or simmering) surrender—a bemused acceptance of the inevitable or a furious fatalism that finds expression in the sardonic. For readers who want to go further and link the words of these individuals, the sight

of them, to others, as they have been described and comprehended by historians, social scientists, and storytellers, there are plenty of books to recommend—and I would start with two extraordinarily knowing historical studies, each finely textured and tellingly narrated: *History of Old Age*, by Georges Minois (2d ed., 1989), and *The Journey of Life: A Cultural History of Aging in America*, by Thomas R. Cole (1992). I would add to this initial emphasis upon broad context the remarkable work of an anthropologist and documentary filmmaker, Barbara Myerhoff—*Remembered Lives: The Work of Ritual Storytelling and Growing Older* (1992), and too, her justly celebrated documentary film, *Number Our Days* (1975).

Then, there are the philosophers—in our time, Simone de Beauvoir with *The Coming of Age* (1972), and Jean Amery with *On Aging* (2nd ed., 1994); the psychologists, such as G. Stanley Hall with *Senescence: The Last Half of Life*, published early in this century (1922), and later, Carl Jung, whose *Modern Man in Search of a Soul* was published in 1933, and Erik H. Erikson—in all his writings, but *Insight and Responsibility* (1964) offers a good entry. *How Psychiatrists Look at Aging*, edited by George Pollock (1992) offers some quietly reflective essays by clinicians on the matter of old age, and Robert Butler, perhaps our foremost psychiatric gerontologist, is constantly thoughtful, helpful in *Why Survive* (1975) and in his shorter writings.

I turn to work by today's essayists, journalists: Tracy Kidder's *Old Friends* (1993), a talented writer's visit with the elderly who are confined to a nursing home; Timothy Diamond's *Making Gray Gold: Narratives of Nursing Home Care* (1992), a sociologist's similar "visit," lucidly evoked; Betty Friedan's *The Fountain of Age* (1993) and Studs Terkel's *Coming of Age* (1995)—two well-known and well-respected observers of our "American scene" apply their distinctive gifts to this matter: Friedan through the traditional illuminations and provocations of the essay, Terkel through his inimitable interviews, or "oral histories." A fellow Chicagoan of Terkel's, the distinguished lawyer and judge Richard Posner has given

us *Aging and Old Age* (1995)—a vigorously skeptical and erudite look at any number of social, economic, and political issues connected to aging.

No one can read medical journals without finding an article (or two, or three) that urges the reader to consider not only specific illness, but the larger question of "old age" as a part of life—a so-called developmental approach. A few worthy "moments": "Growing Old Gracefully," a series of book reviews in the *New England Journal of Medicine* (August 18, 1994); "New Hope for Home Care," an editorial, that responds to two research efforts aimed at helping elderly people live at home, both published in the same issue of the *New England Journal of Medicine* (November 21, 1995); "The Value of Geriatric Interventions," also an editorial responding to two articles that tell of geriatric advances in hospital medicine—in the *New England Journal of Medicine* (May 18, 1995); "The Dying Patient, the Physician, and the Fear of Death," a powerfully personal, affecting, introspective essay by Egilde P. Seravalli, in the *New England Journal of Medicine* (December 29, 1988); and with respect to "depression," never far from many older people, not to mention some of the rest of us, two good pieces of medical writing: "Diagnosis and Treatment of Depression in Late Life," written collectively by a National Institute of Health panel (*Journal of the American Medical Association*, August 26, 1992), and "Depression in the Elderly," by Dan Blazer, in the *New England Journal of Medicine* (January 19, 1989).

Some who work in medical schools and hospitals worry, however, that modern science (and social science) can prompt us to think of old age and dying as a "process," a series of "developmental" hurdles, to the point that technique (advice as to how to do this and that) becomes a reigning obsession—a philosophical outlook, really. I strongly recommend, in that regard, Larry R. Churchill's "The Human Experience of Dying: The Moral Primacy of Stories over Stages," in *Soundings* (Spring 1976). Such an article prompts a turn toward fiction, or the imaginative, lyrical essayist and social observer—Ronald Blythe, for instance, in *The*

Hero in Winter (1979), a marvelously wise book. Similarly full of wisdom are the short pieces of fiction gathered by Dorothy Sennett in *Full Measure: Modern Short Stories on Aging* (1988) and *Vital Signs: International Stories on Aging* (1991)—important and nourishing resources, indeed. I would also like to mention particular stories available in other collections: "The Country Funeral," in John McGahen's *Collected Stories* (1993); the title story of William Humphrey's *September Song* (1992); Alice Elliott Dark's "Home," in *DoubleTake* (no. 3); and of course, the title story of Tillie Olsen's *Tell Me a Riddle* (1960), which I use every year in my college class. There are poems, too—many stirring and subtle ones: William Carlos Williams's "To a Poor Old Woman," Susan Hahn's "Jowls," David Ignatow's entire volume, *Shadowing the Ground* (1991). I leave the reader, as I did in an earlier collaboration with photographers (one that told of young parenthood), by calling upon an artist, in this instance Rembrandt, his *Head of an Old Man*, his *Portrait of an Old Jew in an Armchair*— here is old age, all right, in its vulnerability, to be sure, but as well, its powerful presence, its authority, even majesty: to have survived, to have watched and heard and remembered so very much!

Photographs by Alex Harris and Thomas Roma

The work of the photographer is wordless—the silence of sight's explorations as they are rendered for us, the beholding "other." Yet, in the doing of that work there is, of course, much that happens: individuals are sought and met, conversations held, suggestions offered, requests made—language becomes an instrument of a visual approach to a particular world. Even the most taciturn of persons, intent on recording a scene on his or her own and with no interest in talk, has been prompted by a thought, an idea, a purpose, however vague or undefined or unexpressed: the stirring of mind (and maybe soul) that precedes an artist's decision, once more to engage with the tools of a craft (crayons, brushes, a camera) in the hopes of portraying something or someone for future viewers to see.

In this book, two photographers have called upon their own territory, as it were—found, in the neighborhood where they live or in nearby neighborhoods, elderly men and women who were willing to say yes to a narrative effort to portray in words and pictures how it can go for those who are "old and on their own." The result is a substantial amplification of a text by two experienced photographers who are knowing, skilled social observers, well able to engage with and explore a community and find in it those whose faces and whose manner of being have much to tell. For

Alex Harris this project meant connecting with a range of individuals in central North Carolina; for Tom Roma, further forays into his beloved Brooklyn. Nor were such initiatives meant to entail a brief encounter, a few clicks of a camera loaded and ready for action. These photographs were preceded by discussions, exchanges of opinion: lives remembered, shared by older people with two younger persons. Alex Harris met and photographed, among others, a banker and some tenant farmers, an electrician, a tailor, a writer, a couple of retired military men, a professor, a painter, a one-time boxer—women and men from Durham and Chapel Hill and Raleigh and points in between or nearby. Tom Roma enlisted a friend, Anita McCray, whom he describes as "a sort of mayor of her part of Brooklyn," and she referred him in turn to individual people. He also picked up the phone, and in time was sitting and hearing the stories of a diverse group of folks who, like him, call Brooklyn home.

As the reader, the viewer, will see, these are late-twentieth-century Americans who have lived their proverbial three score and ten (and then some) and who are now (in various places and ways) waiting out their fate, some still working, others making do against the odds of sickness, infirmities of one kind or another. They are racially and culturally and socially and economically and geographically diverse—in the words of the Book of Common Prayer, they are of "all sorts and conditions." Here we see them standing and sitting, doing their work or relaxing at home or driving a car. We see them alone or with another person or an animal. Here we see them in a sitting room, a living room, a kitchen, or on a porch taking in a view. Some seem very much turned inward, their eyes perhaps looking back to earlier days; others are "right there," thoroughly attuned to the one who is speaking with them, taking their picture. Some seem still attached to the things of this world, to plants and pictures and tools and furniture; some appear very much "on their own," to the point that they are scanning the past wistfully (or maybe, anticipating with

hope another life) and have no great regard for their whereabouts. Here are faces full of lively responsiveness and faces of distinct reserve—the former eager to have a say about, even a voice in the world around them, the latter ready to say a grateful or reluctant good-bye.

These eyes, these foreheads, these mouths, these bodies as they are used, placed, postured, summoned, confined suggest stories, offer hints about lives as they have been lived. But as with any photograph, the one who looks at us, courtesy of the camera, will be regarded differently by the various men and women who hold this book in their hands and bring to its stories and to its photographs their own memories and experiences, their own inclinations and aspirations. Since age insists upon its significance in these pictures—and unites a heterogeneous population—the way a person who turns these pages regards the elderly will strongly affect his or her response to these fellow citizens, who have witnessed so very much in this century. By the same token, in their day-to-day experiences many of these elderly folks have learned to take note of their impact on others—some of whom want to draw near, share time, listen, and speak, others of whom draw back in alarm, anxiety, fear.

The painter Rembrandt distinguished himself from many other artists of his time (or of other eras) by his desire to choose as his "subjects" certain ordinary people, some of them friends and neighbors—rather than yield all his time to those whose wealth claimed his attention. The results were his "old ones"—their weathered, wise faces a memorable part of a great legacy: on each face some light has settled, as if a ripened, knowing inwardness is now *there*, on record for all time. Today we can see so very much of others through the technology available to us—a click, click, click that knows few bounds. But in the end (all tricks and manipulations of technology notwithstanding), truth resides in the seen as well as in the one who seeks it; hence the glow of dignity, the evident composure and gentleness in many of these photographs. It is as if these Amer-

icans in their seventies, eighties, and nineties know what Rembrandt's elderly men and women seem to know: in the long, long run there is much nonsense to forget, and some terribly important matters of the heart to hold dear—life's gifts (of love, of friendship, of beauty) are a generous reward for those who have withstood for so long the strains, the blows, of time and chance and circumstance.

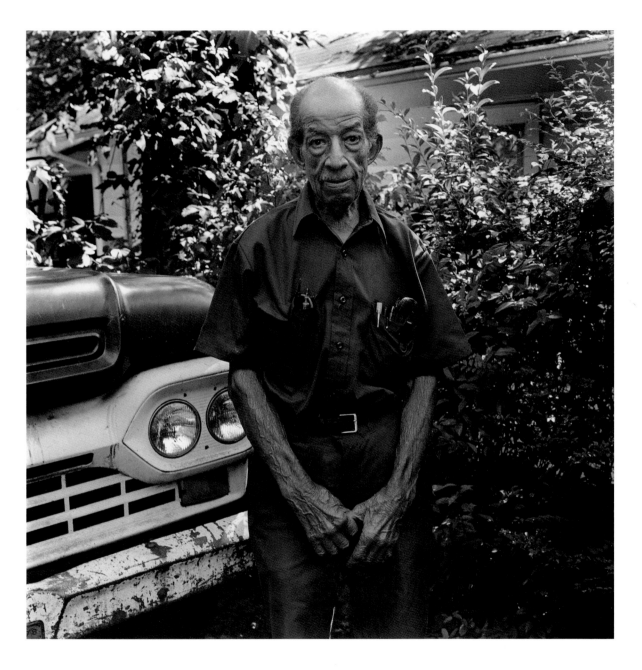

Edward Nell Toole, ninety-two, electrician, Durham, North Carolina, 1990. *Alex Harris*

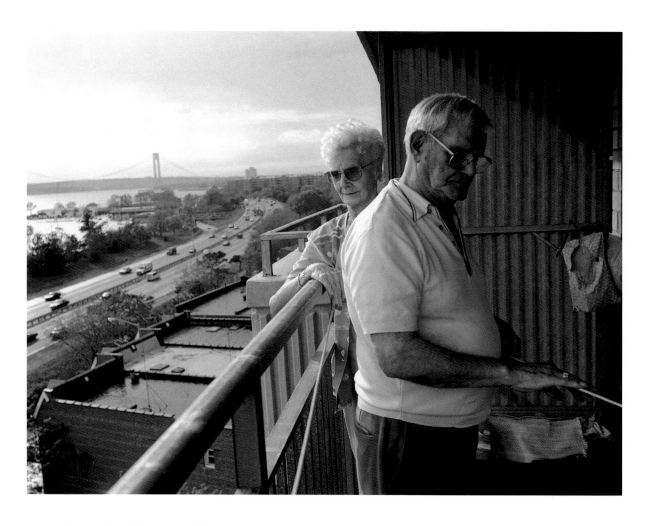

Angela Gandolfo, seventy-eight, dressmaker, and Salvatore Gandolfo, eighty, baker, tunnel worker, shoemaker, and Wall Street clerk, Brooklyn, New York, 1996. *Thomas Roma*

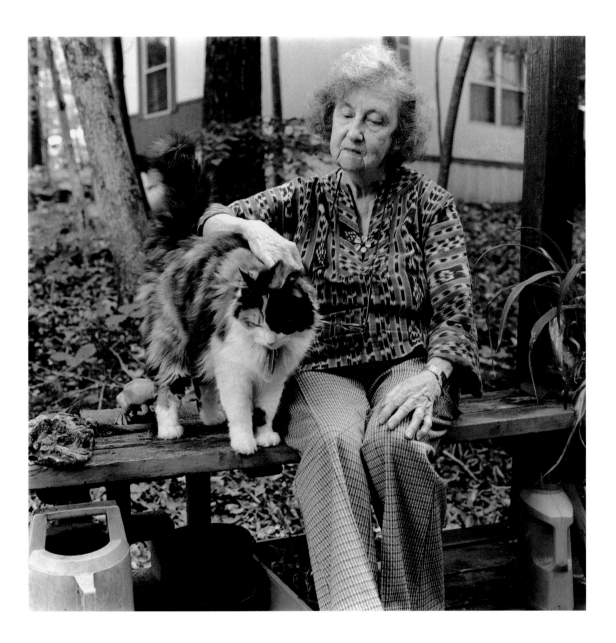

Villa Zala, eighty-six, writer, Chapel Hill, North Carolina, 1992. *Alex Harris*

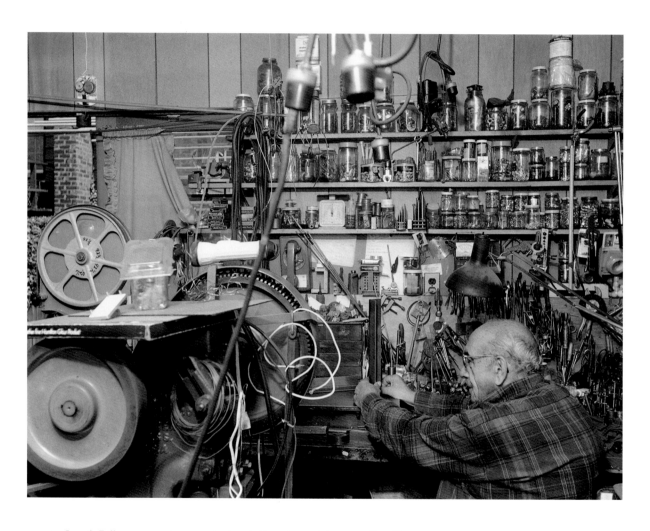

Joseph Pelicano, seventy-seven, tool-and-die maker and inventor, Brooklyn,
New York, 1994. *Thomas Roma*

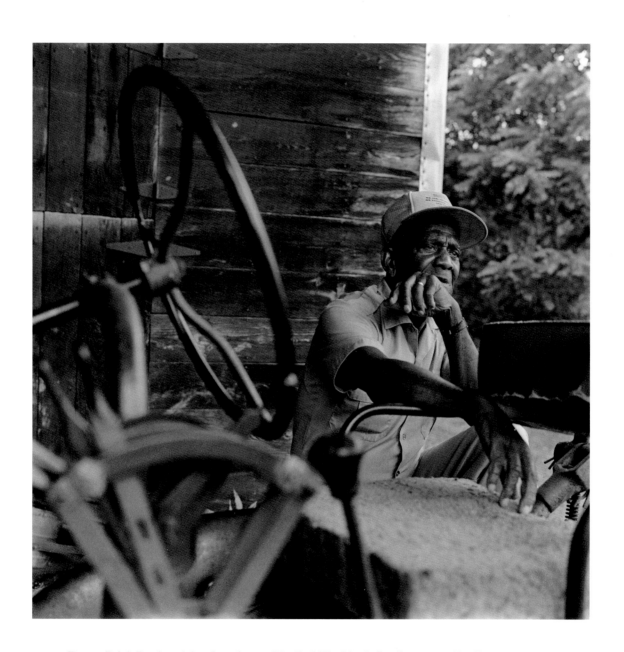

Doctor Ralph Beasley, eighty-four, farmer, Hurdle Mills, North Carolina, 1992. *Alex Harris*

Joyce Frank Steinhorn, seventy-five, realtor, Brooklyn, New York, 1994. *Thomas Roma*

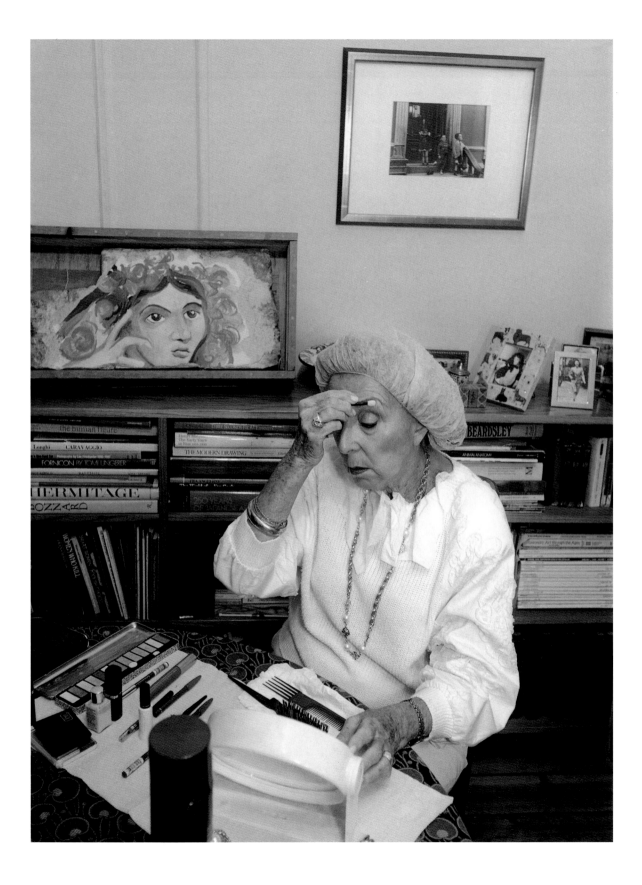

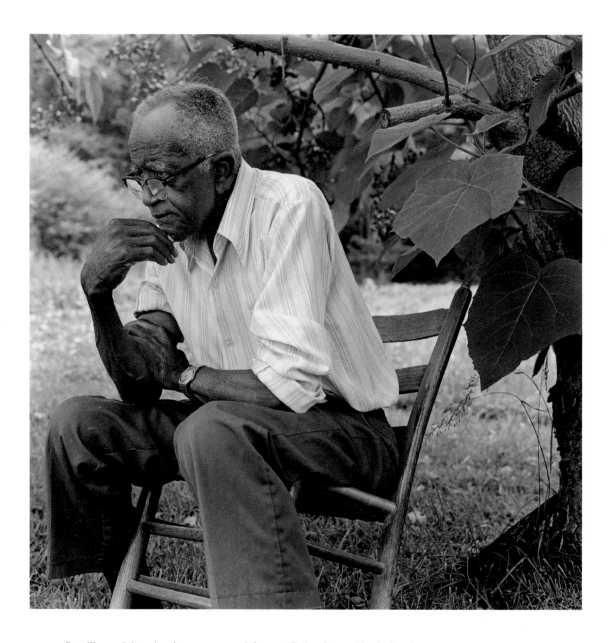

Roy Tapp, eighty-six, sharecropper and farmer, Cedar Grove, North Carolina, 1992.
Alex Harris

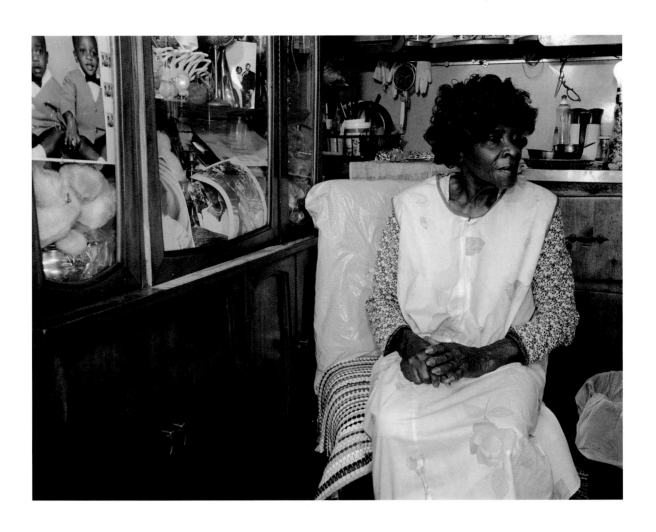

Grace Stevens, eighty, hotel worker and cook, Brooklyn, New York, 1995. *Thomas Roma*

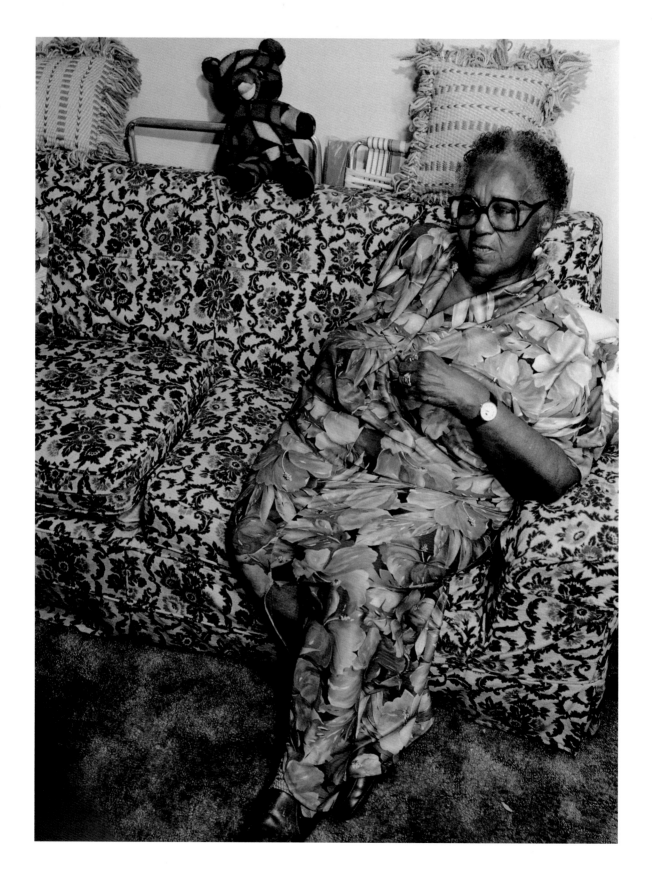

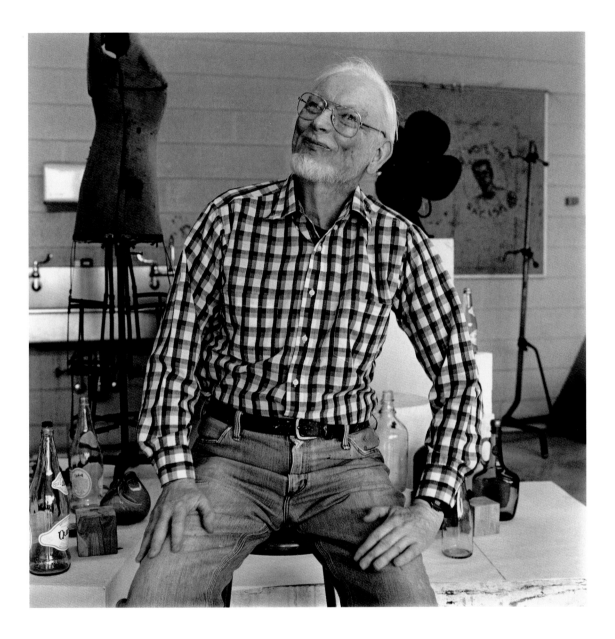

Above: Bayard Hedrick, seventy-six, government worker and artist, Chapel Hill,
North Carolina, 1992. *Alex Harris* Opposite: Ms. Joe Kersey-Walker, seventy-eight,
high school guidance counselor and co-chairman, Bedford-Stuyvesant Senior
Task Force, Brooklyn, New York, 1995. *Thomas Roma*

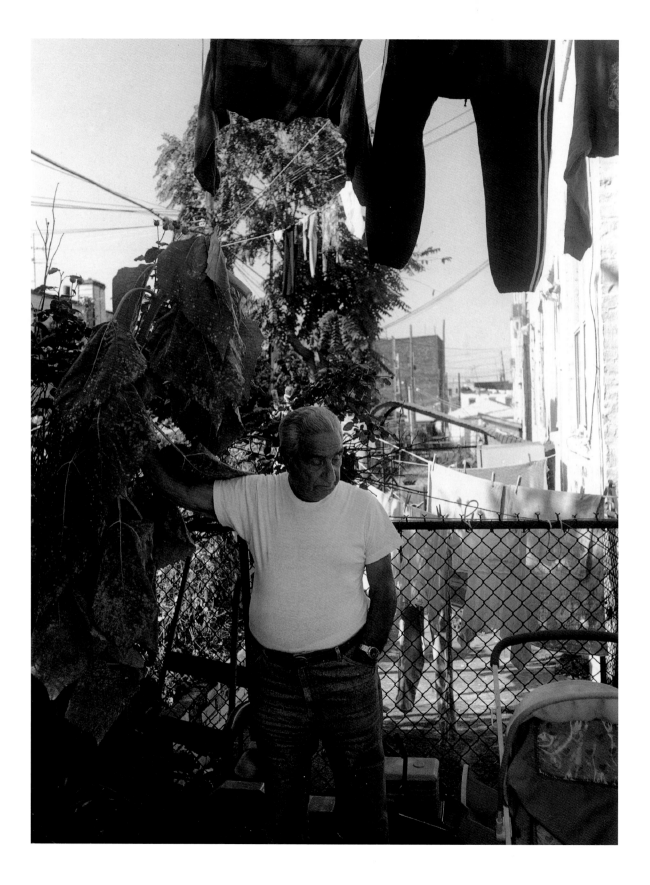

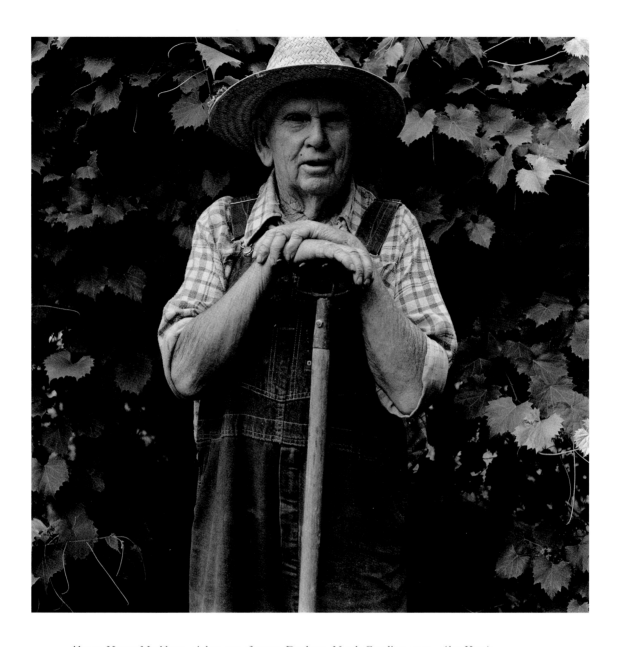

Above: Henry Markham, eighty-one, farmer, Durham, North Carolina, 1990. *Alex Harris*
Opposite: John R. Germano, eighty-two, automotive machinist, Brooklyn, New York, 1994.
Thomas Roma

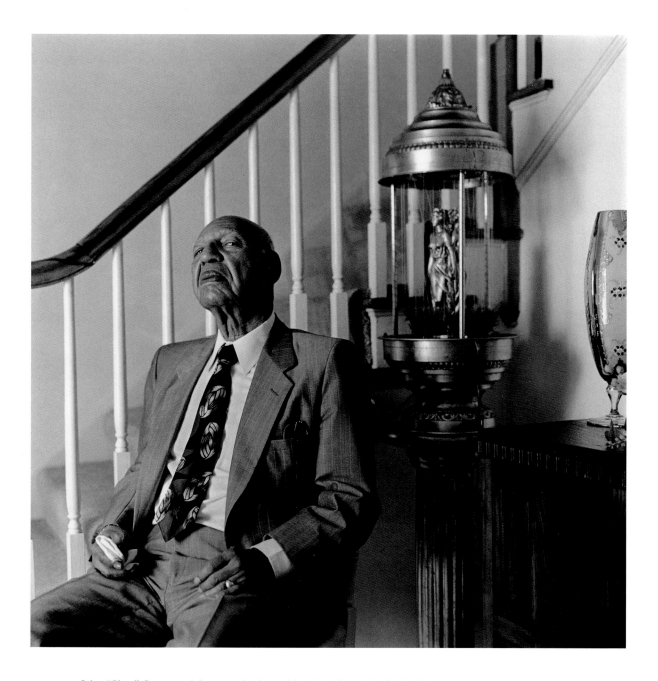

John "Shag" Stewart, eighty-two, bank president, Durham, North Carolina, 1992. *Alex Harris*

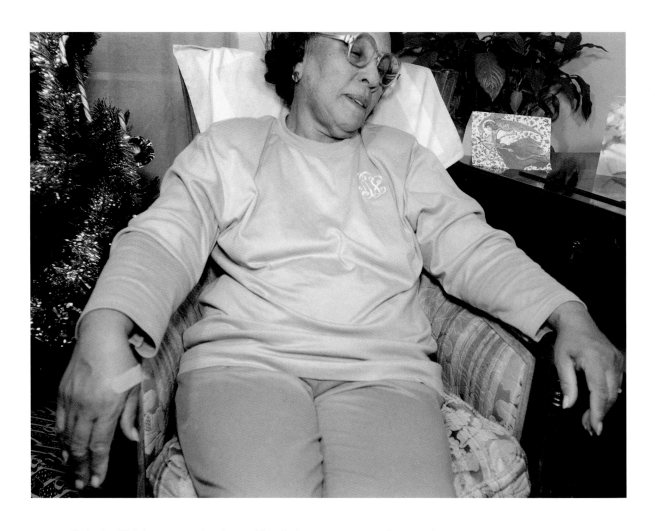

Catherine Wright, seventy-nine, housewife, telephone company employee, and nursery worker, Brooklyn, New York, 1994. *Thomas Roma*

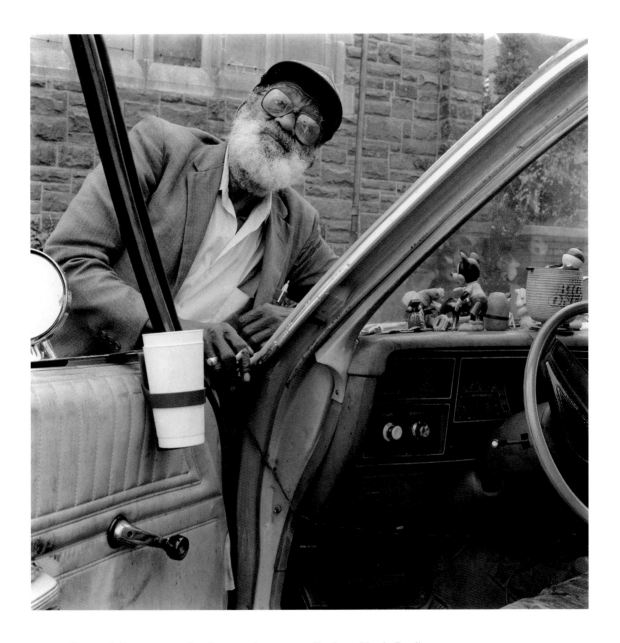

Raymond Corn, seventy-five, boxer and contractor, Durham, North Carolina, 1992.
Alex Harris

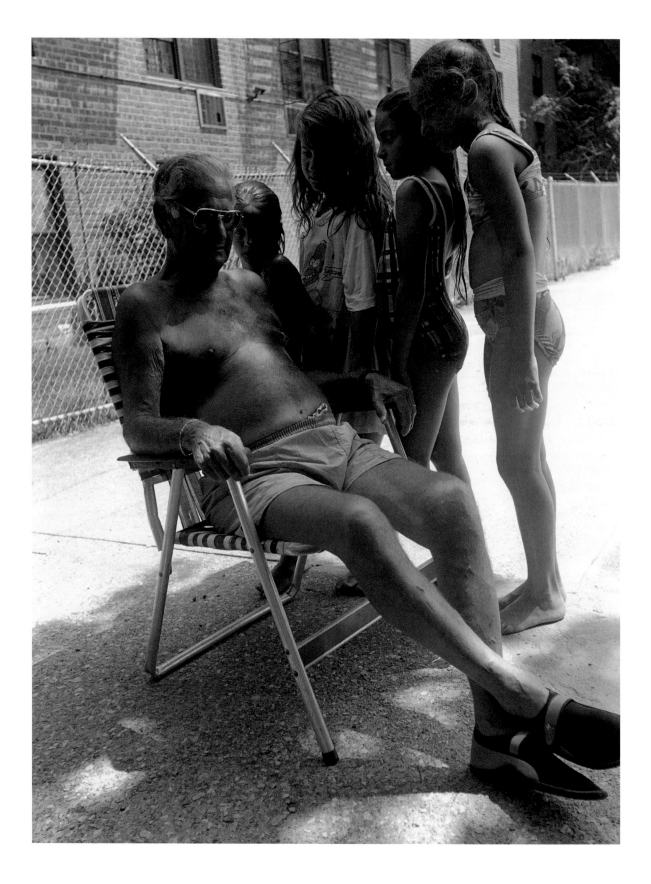

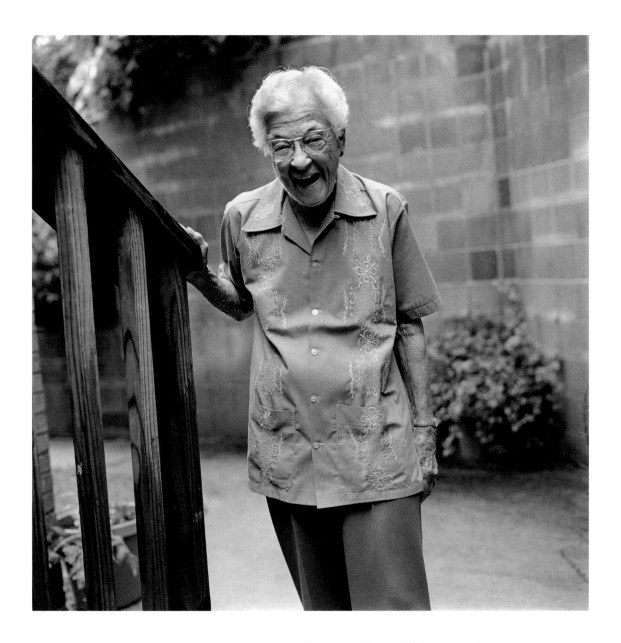

Above: Martha Branscombe, eighty-four, child relief worker, Chapel Hill, North Carolina, 1992. *Alex Harris* Opposite: Martin Lipson, eighty-two, retail store owner, Brooklyn, New York, 1994. *Thomas Roma*

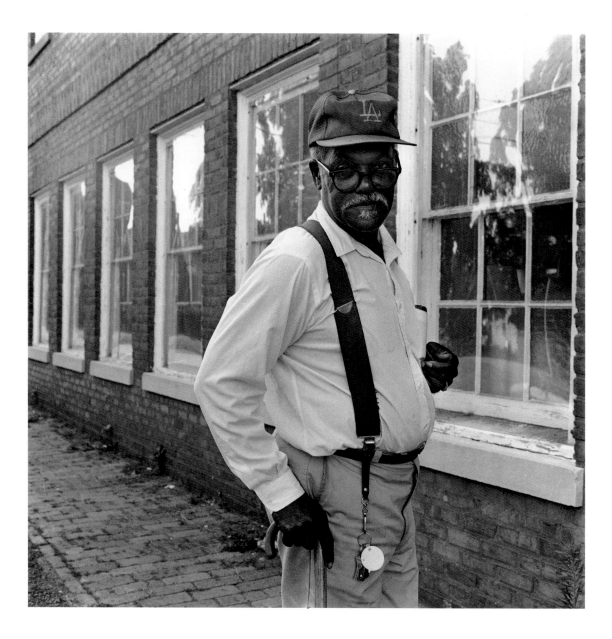

Above: William Evans, sixty-seven, sharecropper, Durham, North Carolina, 1990.
Alex Harris Opposite: Susie Elizabeth Francis, seventy-eight, teacher's aide, Brooklyn,
New York, 1994. *Thomas Roma*

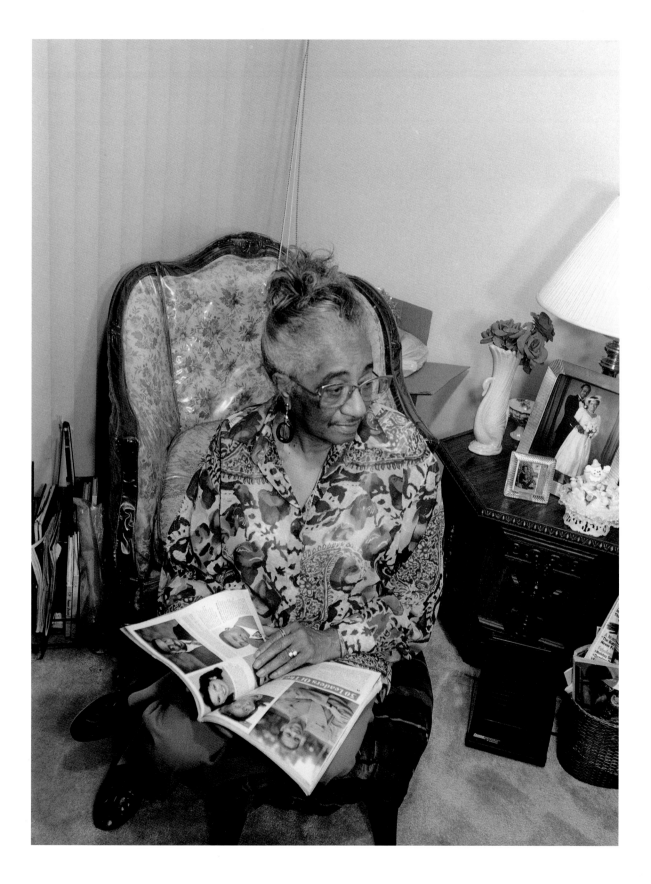

Earvin Bledsoe, eighty-three, tailor and garment worker, Brooklyn, New York, 1994. *Thomas Roma*

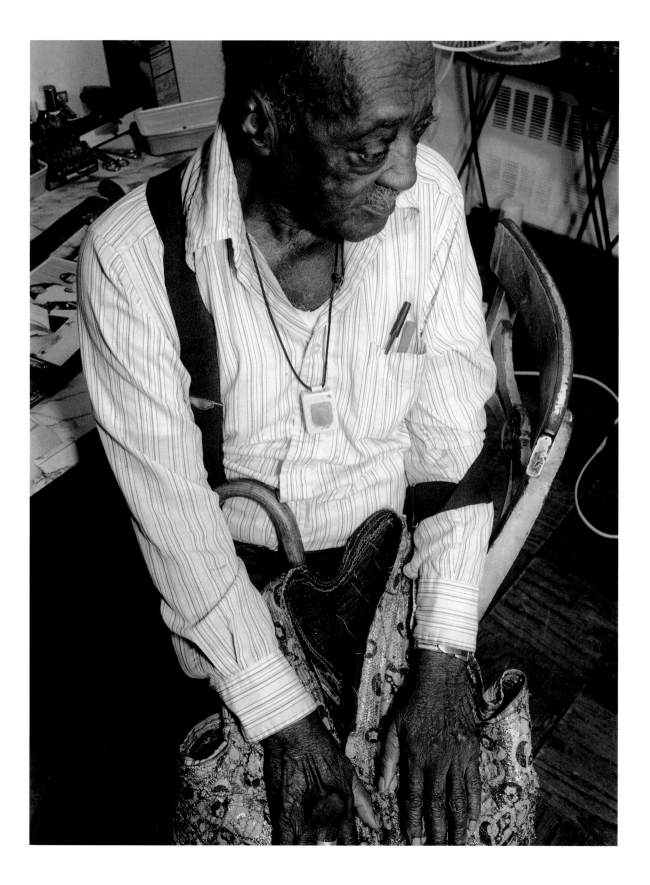

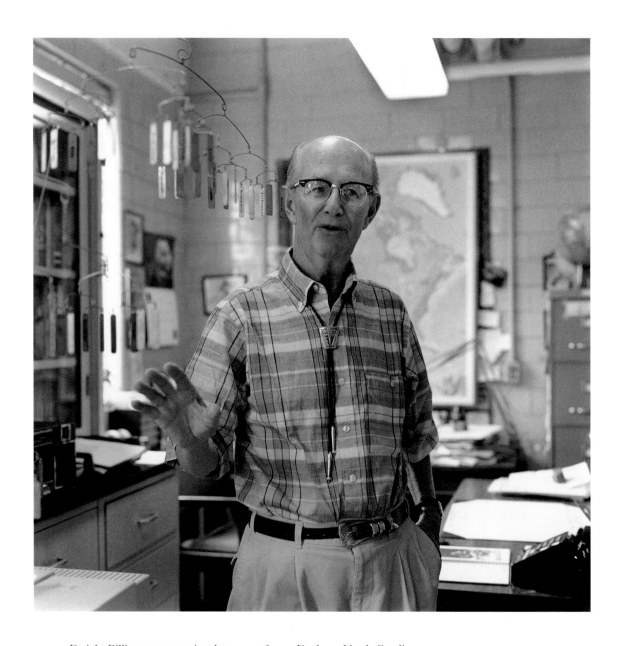

Dwight Billings, seventy-nine, botany professor, Durham, North Carolina, 1990.
Alex Harris

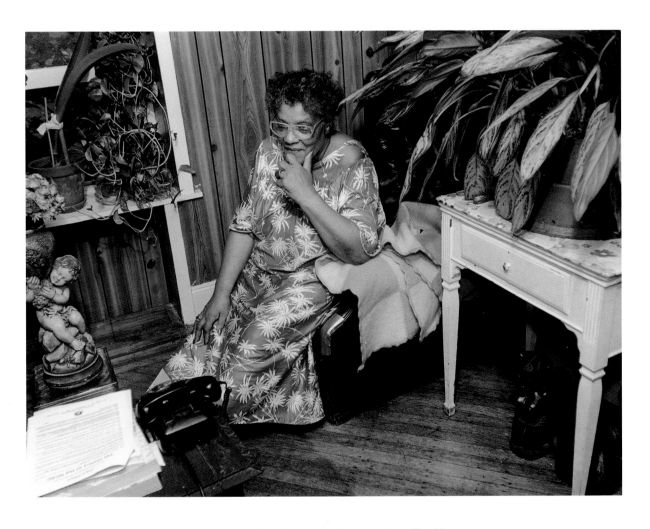

Virginia Anderson, seventy-five, manufacturing production supervisor, Brooklyn,
New York, 1994. *Thomas Roma*

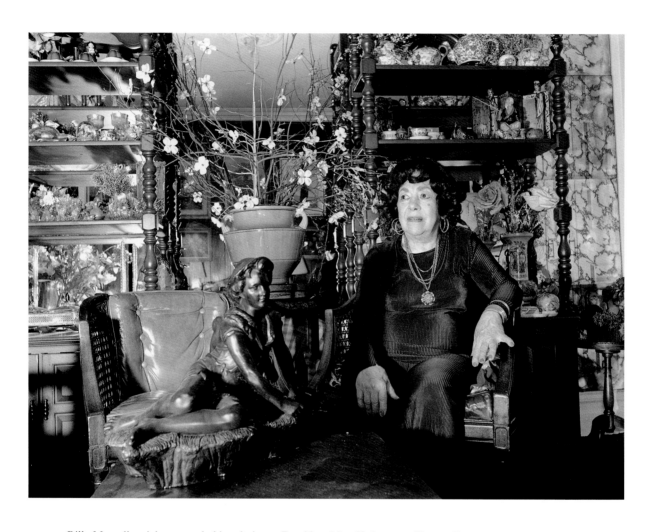

Rilla Marzullo, eighty-one, clothing designer, Brooklyn, New York, 1995. *Thomas Roma*

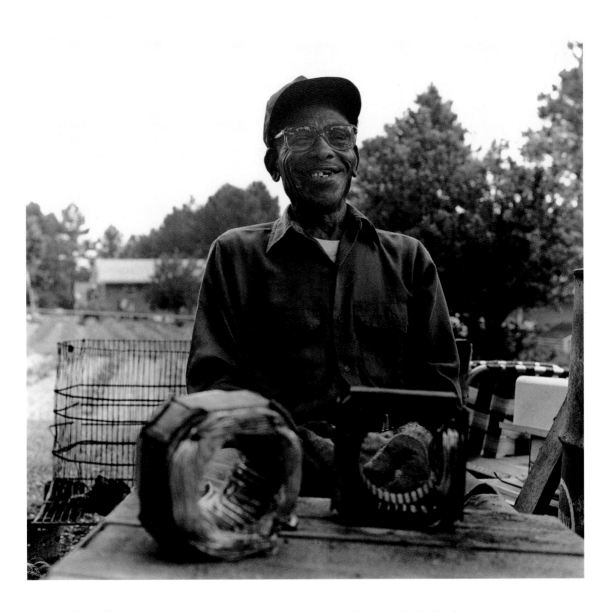

Gilbert Fountain, eighty-six, scrapyard worker and salvager, Durham, North Carolina, 1990.
Alex Harris

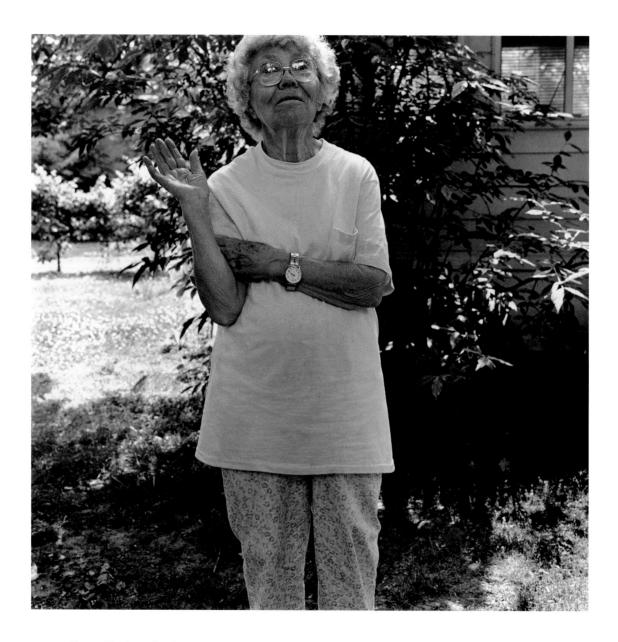

Above: Charlotte Garth Adams, ninety, mediator, Chapel Hill, North Carolina, 1992. *Alex Harris* Opposite: Shuet Ching Lee, seventy-five, seamstress, Brooklyn, New York, 1995. *Thomas Roma*

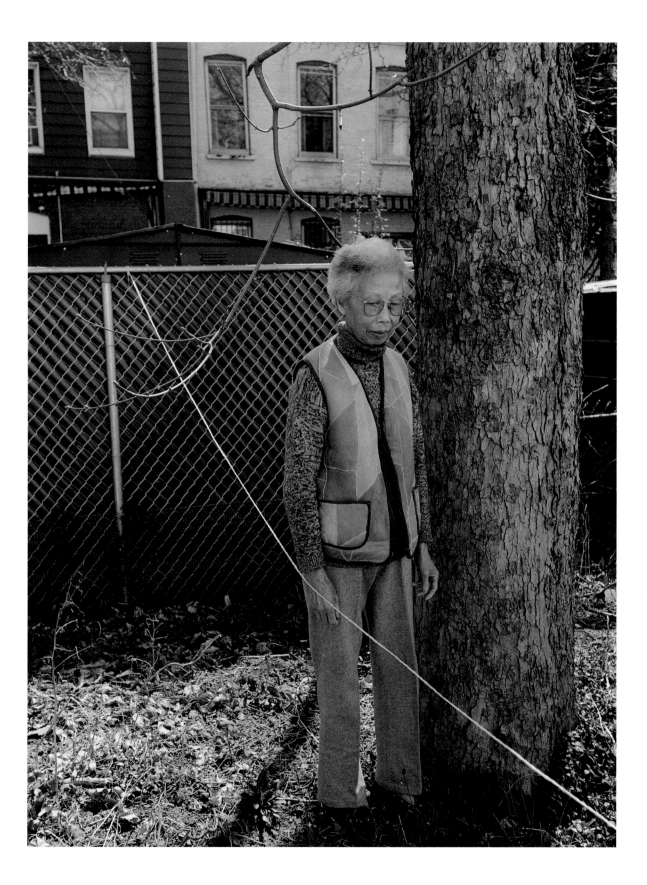

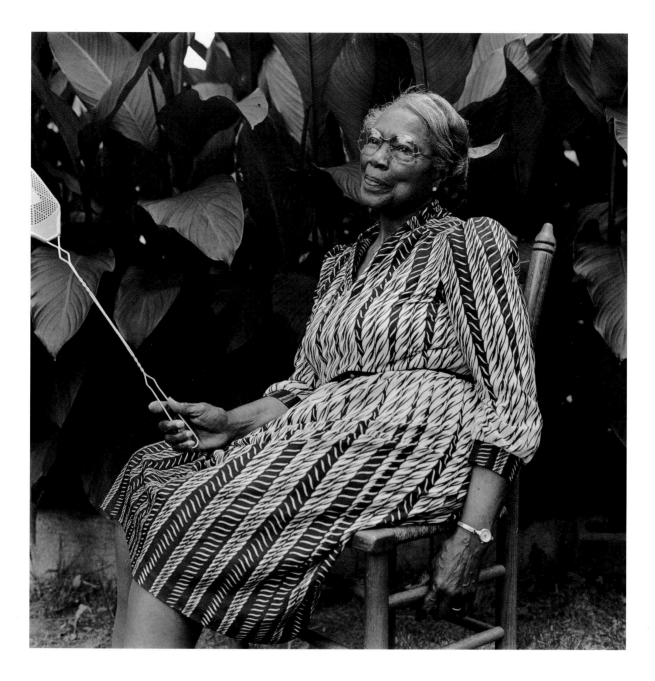

Lillie Vanhook Beasley, eighty-two, sharecropper, Cedar Grove, North Carolina, 1992. *Alex Harris*

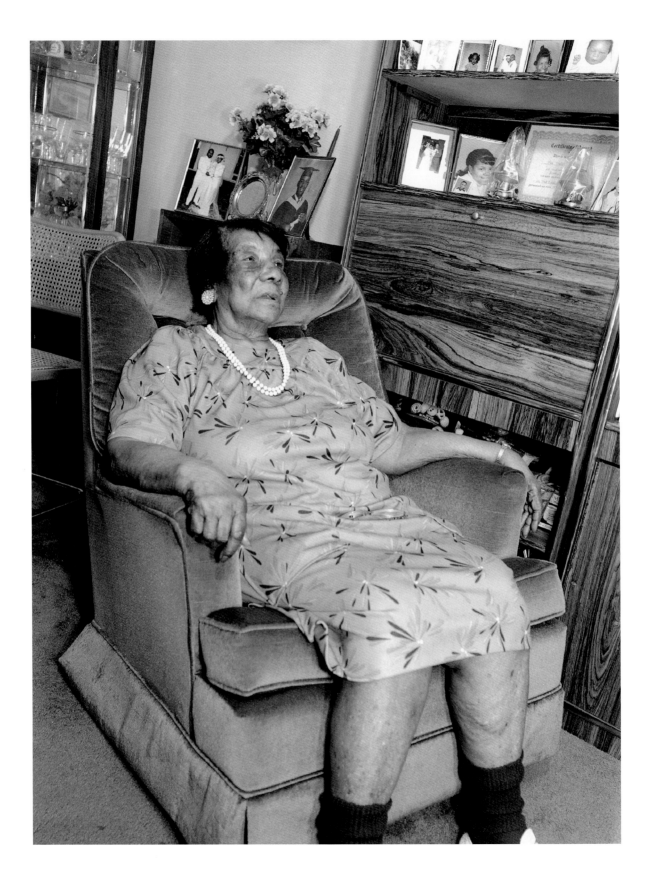

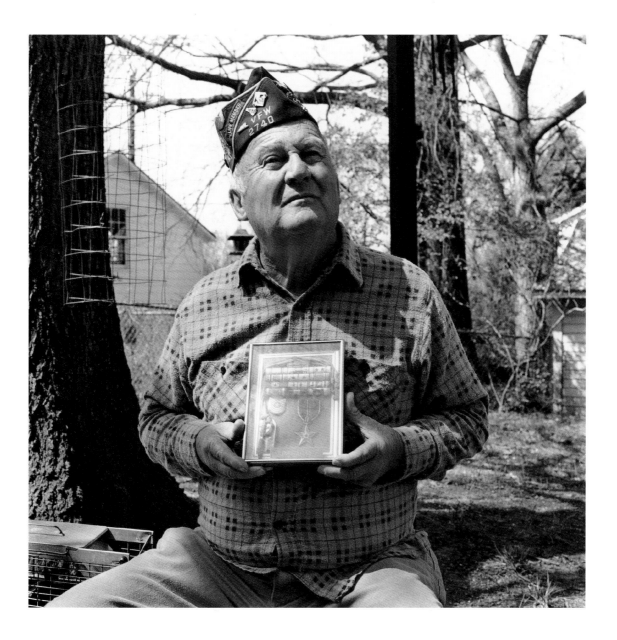

Above: Glenn Pursselley, seventy-six, air force sergeant and prisoner of war, Durham, North Carolina, 1992. *Alex Harris* Opposite: Montese Hill, ninety-four, domestic worker, Brooklyn, New York, 1995. *Thomas Roma*

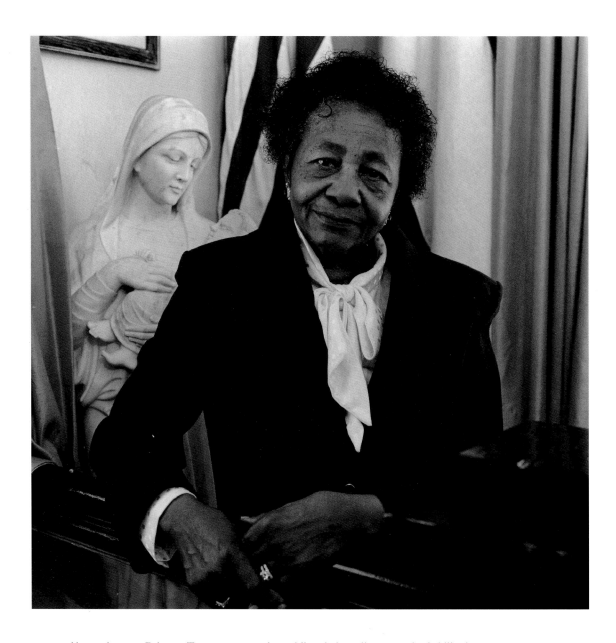

Above: Augusta Brimage Turner, seventy-six, public relations director and rehabilitation counselor, Raleigh, North Carolina, 1992. *Alex Harris* Opposite: Margarita Maria Vaccaro, eighty-nine, office manager, Brooklyn, New York, 1995. *Thomas Roma*

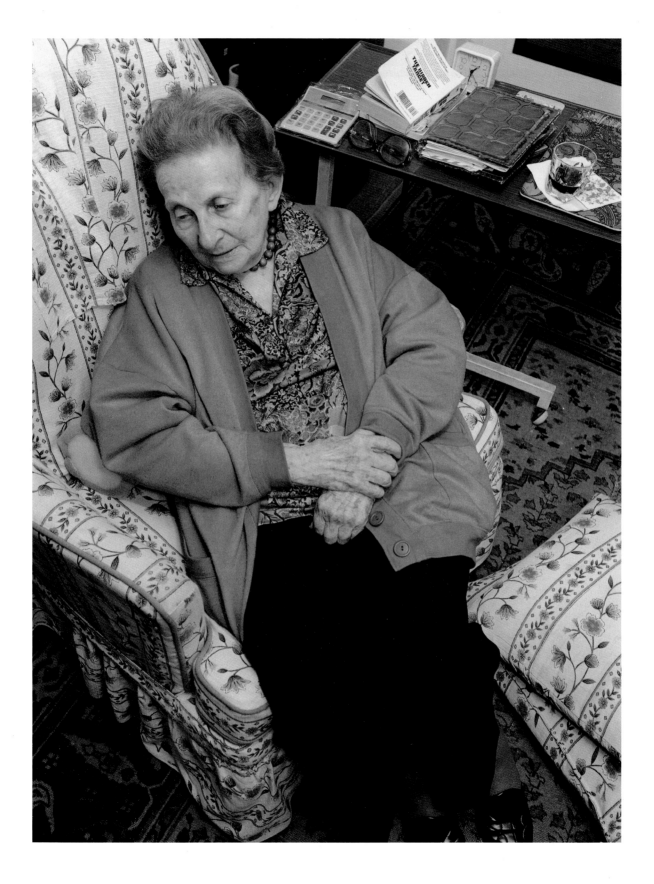

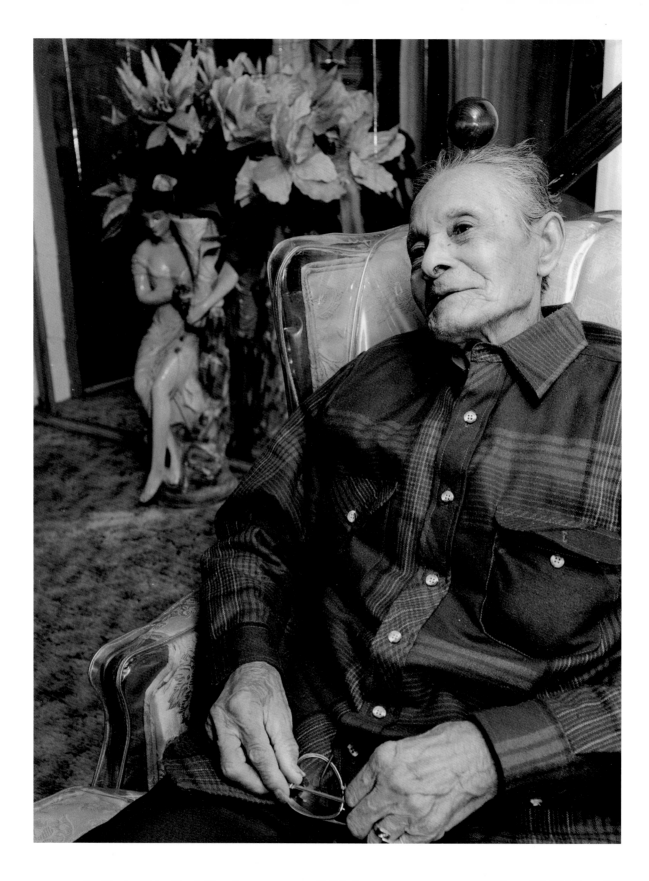

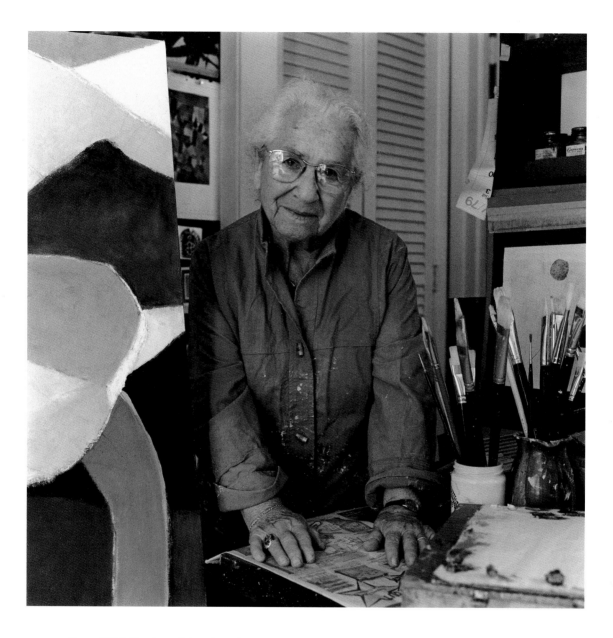

Above: Edith London, eighty-six, painter, Durham, North Carolina, 1990. *Alex Harris*
Opposite: Manuel Maldonado, eighty-eight, construction worker, Brooklyn, New York, 1995. *Thomas Roma*

Gerald T. D'Agastino, seventy-eight, plant manager, Brooklyn, New York, 1995. *Thomas Roma*

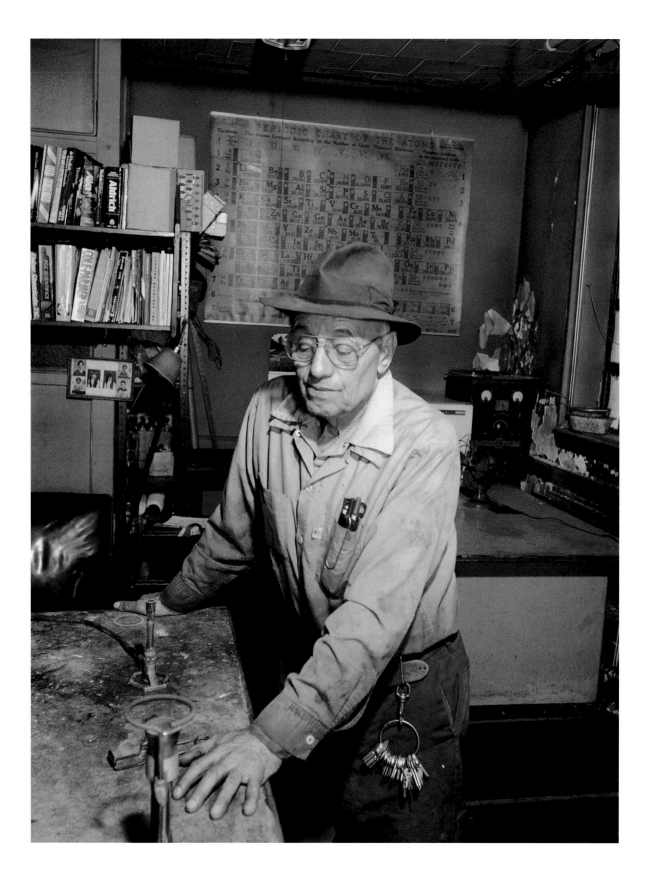

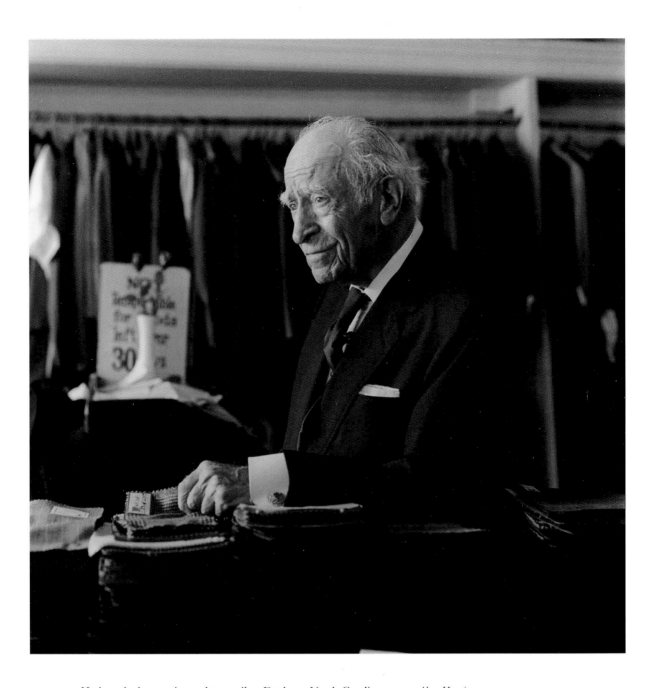

Herbert Andrews, ninety-three, tailor, Durham, North Carolina, 1990. *Alex Harris*

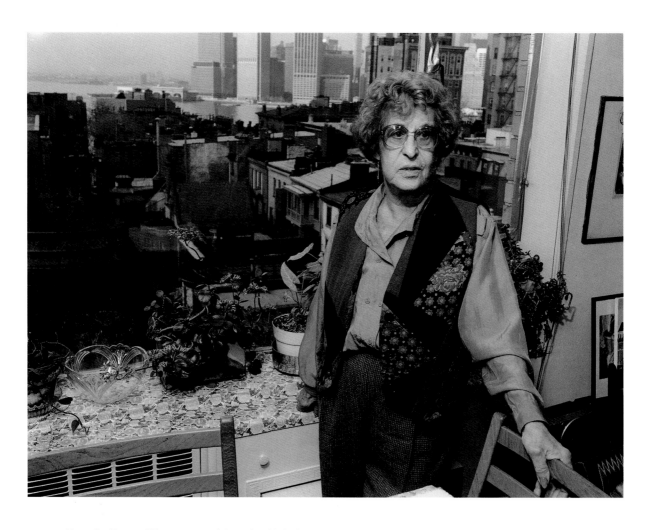

Dorothy Devera Kley, seventy-eight, microbiologist, Brooklyn, New York, 1995.
Thomas Roma

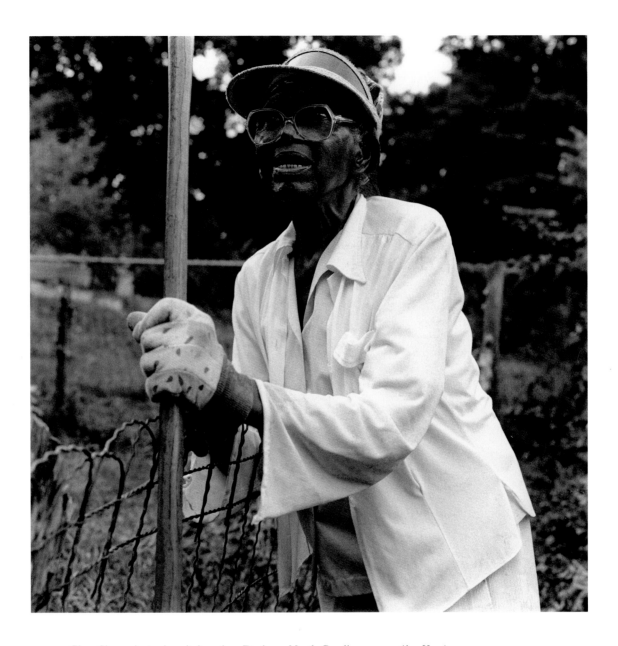

Clara Sims, ninety, hospital worker, Durham, North Carolina, 1990. *Alex Harris*

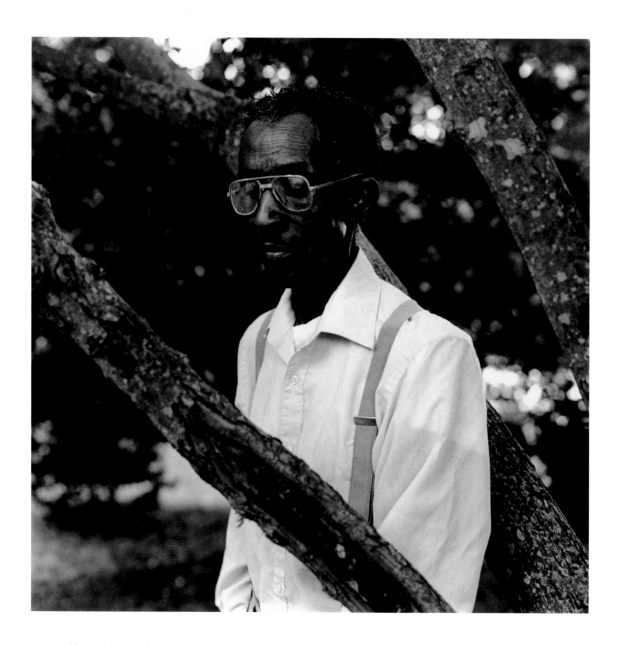

Above: Lorenzo Beasley, seventy-six, sharecropper and custodian, Cedar Grove,
North Carolina, 1992. *Alex Harris* Opposite: Rose Shaff, ninety-one, businesswoman,
Brooklyn, New York, 1994. *Thomas Roma*

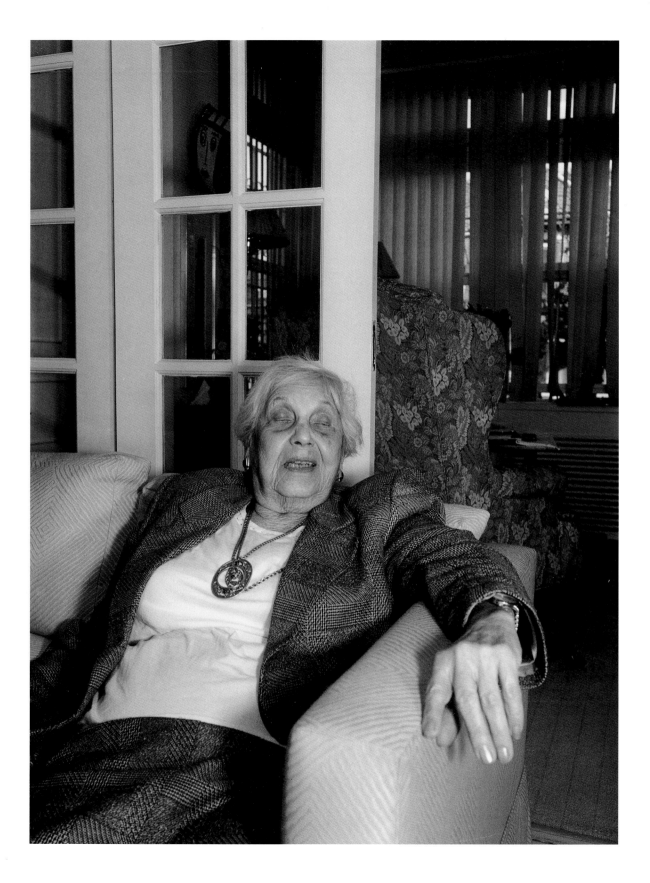

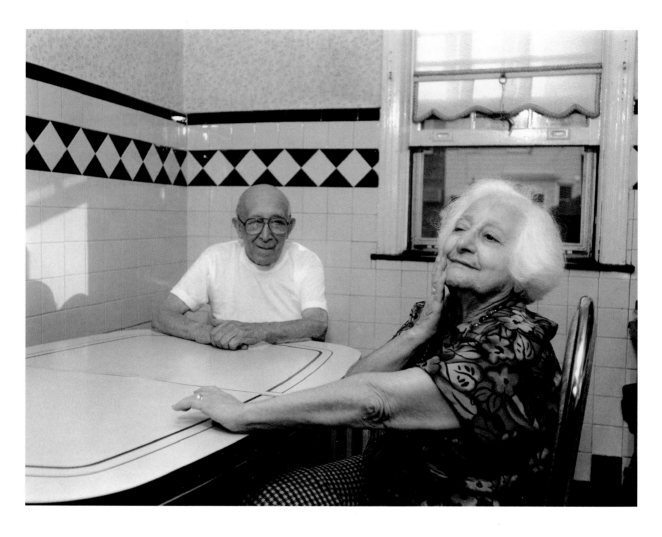

Vincent Pepitone, ninety-five, engineer, and Rose Pepitone, eighty-six, homemaker,
Brooklyn, New York, 1994. *Thomas Roma*

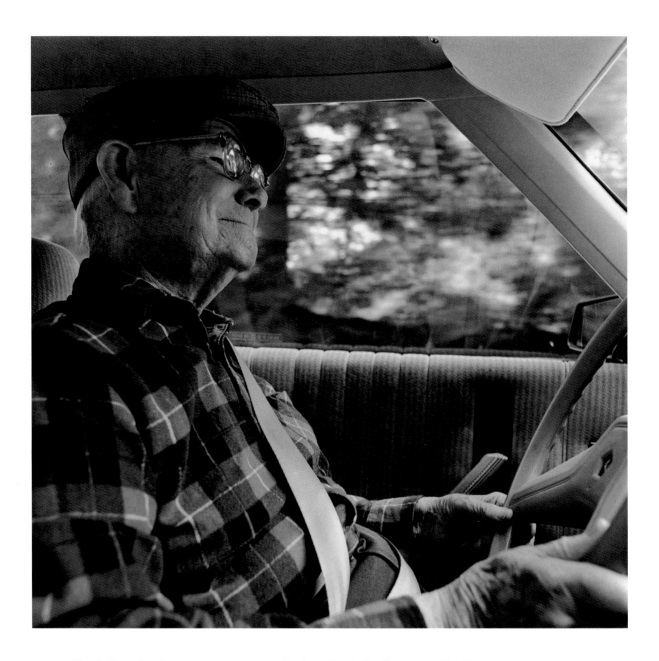

Claude Carmelia, eighty-two, army sergeant, Durham, North Carolina, 1992. *Alex Harris*